HUNGRY?

CHICAGO

THE LOWDOWN ON

WHERE THE

REAL PEOPLE

EAT!

Edited by Courtney Arnold & Michelle Burton

Glove Box guides

Los Angeles, California

First Printing: August, 2006
Printed in the United States of America

10 9 8 7 6 5 4 3 2 1

Library of Congress Cataloging-in-Publication
Data Hungry? Chicago: The Lowdown on Where
the Real People Eat!
by Glove Box Guides
320 p. 8.89 x 22.86 cm.
ISBN-10: 1-893329-26-7
ISBN-13: 978-1-893329-26-3
I. Title II. Food Guides III. Travel IV Los Angeles

Production by Elisa Gonzalez

Visit our Web sites at www.GloveBoxGuides.com and
www.HungryCity.com

To order Hungry? or our other Glove Box Guides,
or for information on using them as corporate gifts,
e-mail us at Sales@HungryCity.com. or write to:
Glove Box Guides
P.O. Box 86121
Los Angeles, CA 90086

Glove Box Guides are available to the trade
through SCB Distributors:
(800) 729-6423
www.SCBDistributors.com

THANKS TO...

All the contributors: Sara Evin Allen, Hunter Arnold, Heather Augustyn, R. Nelson Balbarin, Heidi Barker, Veronica Carolyn Bond, Eliz Breakstone, Paul Breloff, Jelene Britten, Michelle Burton, Jennifer Chan, Victoria Cunha, Lisa Dumich, Melanie Dunlap, Scott Durango, Sarah Eaton, Lydia Ellul, Trisha L. Falb, Falcaō, Jeff Fleischer, Justin Goh, Venita Griffin, Emily Hunt, Kelly Hutchison, Catherine Keich, Beth Kohl, Jen Lawrence, Tal Litvin, Colin Lohse, Mary Lou Mangan, Manuel Marquez, Carol Michael, Toni Miosi, Leah Moyers, Sean O'Connor, Jamie Popp, Robyn Porter, Rich Rainey, Leanne Sharoff, Christopher Stapleton, Kelly Svoboda, Ondy Sweetman, Benjamin Trecroci, Jaime Vazquez, Valerie Wallace, Elsa M. Wenzel, L. Pat Williams, Stefan Woerle, and Claire Zulkey.

Those who lent support, went out of their way, or otherwise helped this project come together: Nágila Hajjar, Jay Johnson, Jim (Shmelg) Arnold, Fred Lagon, Brad Heimann, Ellen Goode, Carol Anshaw, Janet Desaulniers, and especially Heather Augustyn, once again, for being ready, willing, and able at the drop of a hat.

Thanks also to Elisa Gonzalez, David Wegbreit, Linda Branover, Jennifer Chang, Gina Gorman, Jeremy Millington, and Samuel Leonard- who pulled it all together.

—the Hungry? Editors

CONTENTS

KEY TO THE BOOK

ICONS
Most Popular Meals

 Great Breakfast Spot

 Desserts/Bakery

 Great Lunch Spot

 Coffee

 Great Dinner Spot

 Tea

 Fish or Seafood

 Beer

 Vegetarian or Vegan-friendly

 Wine

 Food on the run

 Cocktails

Ambience

 It's early and you're hungry

 Live Music

 It's late and you're hungry

 Patio or side-walk dining

 Sleep is for the weak

 In business since 1969 or before

 Nice places to dine solo

 Editor's Pick

 Get cozy with a date

Cost

HUNGRY?

Cost of the average meal:

$	$5 and under
$$	$9 and under
$$$	$14 and under
$$$$	$15 and over

Payment

Note that most places that take *all* the plastic we've listed also take Diner's Club, Carte Blanche and the like. And if it says cash only, be prepared.

VISA

MasterCard

American Express

Discover

If you can't afford to tip, you can't afford to eat. Remember, if your food is brought to your table, you should probably leave a some sort of tip. Here's a guide to help you out:

Cost of Meal	Scrooge <15%	17.5%	Hungry? 20%	22.5%	Hungry! 25%	27.5%	Sinatra >40%
$ 15	<2.25	2.63	3	3.38	3.75	4.13	>6
$ 25	<3.75	4.38	5	5.62	6.25	6.88	>10
$ 35	<5.25	6.13	7	7.88	8.75	9.63	>14
$ 45	<6.75	7.88	9	10.12	11.25	12.38	>18
$ 55	<8.25	9.63	11	12.38	13.75	15.12	>22
$ 65	<9.75	11.38	13	14.62	16.25	17.88	>26

MAP O' THE TOWN

① DOWNTOWN
- Magnificent Mile
- The Loop
- N. West Loop
- South Loop
- Gold Coast
- River North/Streeterville
- River West/West Loop/West Town
- Printer's Row

② NORTH SIDE
- Lincoln Park
- Old Town
- Lakeview
- Boystown
- Wrigleyville
- Roscoe Village
- Uptown
- Ravenswood/Lincoln Square
- Andersonville
- Edgewater
- Rogers Park/West Ridge

③ NORTHWEST SIDE
- Wicker Park
- Ukranian Village
- Homboldt Park
- Logan Square
- Bucktown
- Irving Park/North Park
- Norwood Park
- East Village

④ WEST SIDE
- Little Italy
- Greektown
- Pilsen

⑤ SOUTH SIDE
- Hyde Park
- Woodlawn
- South Shore
- Avalon Park
- Chatham
- Beverly

⑥ NORTHSHORE
- Evanston

⑦ NORTHWEST
- Rosemont
- Skokie
- Park Ridge
- Des Plaines

⑧ SOUTHWEST
- Oak Park

PLEASE READ

Disclaimer #1
The only sure thing in life is change. We've tried to be as up-to-date as possible, but places change owners, hours and menus as often as they open up a new location or go out of business. Call ahead so you don't end up wasting time crossing town and arrive after closing time.

Disclaimer #2
Every place in Hungry? Chicago is recommended, for something. We have tried to be honest about our experiences of the each place, and sometimes a jab or two makes its way into the mix. If your favorite spot is slammed for something you think is unfair, it's just one person's opinion! And remember, under the Fair Use Doctrine, some statements about the establishments in this book are intended to be humorous as parodies. Whew! Got the legal stuff out of the way.

And wait, there's more!
While we list hundreds of eateries in the book, that's just the beginning of the copious eating and drinking opportunities in Chicago. Visit HungryCity.com for additional reviews, eating itineraries, updates, and all the information you need for your next dining out adventures.

Road Trip!
And, next time you hit the road, check the Glove Box Guides to destinations including: Seattle, Las Vegas, Los Angeles, Boston, New York City, and many, many more!

Don't Drink and Drive.
We shouldn't have to tell you this, but we can't say it enough. Drink responsibly. Don't drive after you've been drinking alcohol, period. If a designated driver is hard to come by, take the bus or call a cab to take you home. Split the costs with your friends to bring the cost down.

Share your secrets.
Know about a place we missed? Willing to divulge your secrets and contribute to the next edition? Send your ideas to "Hungry? Chicago Update" c/o Hungry City Guides, P.O. Box 86121, Los Angeles, CA 90086 or e-mail Updates@HungryCityGuides.com.

INTRODUCTION

Missed the World's Fair of 1893? Born too late to Charleston with Capone in some seedy speakeasy? Never even heard of Mrs. O'Leary's cow? Time goes on, friends, and some key elements of Chicago's culture can only be re-lived in the pages of the history books…but don't let that stop you from getting a taste of the real deal. The City That Works is also the City That Eats—there's good reason for that stereotype of the, a-hem, healthy, Mid-Western physique. And with a rich culture of immigration and diversity, you can bet your bottom dollar there's a cure for every craving somewhere out there in Chicagoland.

But I'm just a regular Joe, you say, with limited funds and no time for trial and error. Never fear! You've got Hungry? here.

Forget the stories of Chicago's mafia ties and shady politicians, we at the Glove Box Guides believe in democracy. That's why our motto is "By The People, For The People". We've picked the brains of over fifty real Chicagoans, from varying backgrounds and walks of life, to unearth this city's unique-yet-affordable eateries and best-kept culinary secrets. Between these modest, green covers you'll find an unparalleled guide to Chicago's real cuisine—not the tourist traps or corporate conglomerates with big PR budgets, just honest recommendations written by everyday folks about the food they know and love. Whoever said you had to be a food critic or trust fund baby to know good eats? We've got everything from cheap chic to holes-in-the-wall, all in one convenient, portable package.

Hungry? Chicago highlights small businesses, often family run mom-and-pop's, with distinct flair. Our only criteria are great food and surprisingly affordable prices. We do include a few, outstanding local chains, and make exceptions for the rare, not-to-be-missed-but-slightly-more-expensive dining dynamos, but for the most part the restaurants you'll find herein are probably not listed in other guide books.

Looking for samosas at two in the morning? A fullyloaded Red Hot on the run? If you're a local, chances are you won't even have to leave your own neighborhood. But where's the fun in that? Aren't pancakes always better at a long counter, with some guy you've never met before telling stories about the old days? And what date won't be impressed by your insider's knowledge and impeccable taste? The secrets of the Windy City are at your fingertips.

So what's the catch, you ask? There isn't one! The only things you need to embark on your own tasty tour of Chicago are this book, a sense of adventure, and ten bucks or less. You can get a high-priced, mediocre meal anywhere in the country. But you're on the Third Coast now so go ahead, hop on the El, and explore the real flavors of the city.

—*Courtney Arnold & Michelle Burton*

DOWNTOWN

MAGNIFICENT MILE

Foodlife

Travel around the world in five, then pick your favorite fare!

$$$

835 Michigan Ave. (Water Tower), Chicago 60611
(between E. Pearson St. and Chestnut St.)
Phone (312) 335-3663
www.lettuceentertainyou.com

CATEGORY	Most people compare Foodlife to an "open-air market."
HOURS	Mon-Thurs: 7:30 AM-8 PM Fri-Sat: 7:30 AM- 9 PM Sun: 7:30 AM-7 PM
GETTING THERE	Street parking is nearly impossible. Parking is available in the Water Tower underground garage, validated after 5 PM.
PAYMENT	VISA MasterCard DISCOVER
POPULAR DISH	Try the fajitas at "Viva Mexicana" or the hearty sides at "Rotisserie and BBQ."
UNIQUE DISH	Stop by "Stir Fry Heaven" where you can create your own stir-fry or "Miracle Juice Bar" to try fresh organic fruit and vegetable juices, wheatgrass, nonfat frozen yogurt shakes, and fruit smoothies.
DRINKS	Sodas, fresh squeezed juices, iced tea, and smoothies
SEATING	Seats 600—huge, HUGE space!
AMBIENCE/CLIENTELE	People from all over the world visit Water Tower on a daily basis along with people from all over the city of Chicago. Anything goes here, so no matter what you wear, you'll fit in just fine.
EXTRAS/NOTES	Foodlife features cuisine from around the world at more than a dozen kiosks throughout the "restaurant." When you enter Foodlife, a cashier will hand you a food "credit" card. Find a table, flip the sign to "reserved," then start your journey. Your card will be swiped each time you order up and you'll pay on your way out, so feel free to roam from country to country for as long as you like. Asian, Mexican, Southern and Italian are just a few of the offerings available. Don't forget to stop by "Sweet Life" for homemade desserts and nonfat frozen yogurt.

—*Michelle Burton*

Wow Bao

After shopping on the Magnificent Mile, instead of the standard Italian or American fare, why not check out this Asian restaurant stand-by?

$

835 N. Michigan Ave., Chicago 60610
(at E. Pearson St.)
Phone (312) 642-5888
www.wowbao.com

CATEGORY	Pan-Asian for the Magnificent Mile shopping crowd
HOURS	Mon-Fri: 10 AM-8 PM Sat: 10 AM-9 PM Sun: 10:30 AM-6 PM
GETTING THERE	On Michigan Avenue???? Street Parking difficult, in fact, good luck! There are plenty of pay lots around, though.
PAYMENT	VISA MasterCard
POPULAR DISH	(Bao) Steamed hot buns filled with Kung Pao Chicken, vegetables, pork, Thai Curry Chicken— you name it!
UNIQUE DISH	The combo specials are a great deal!
DRINKS	Ginger Soda and Ginger Ale are the specialty and norm.
SEATING	Order up your bao then find a seat upstairs at foodlife.
AMBIENCE/CLIENTELE	Clientele? Well, no surprises here. You ARE on Michigan Avenue, so your typical crowd is shoppers. But, I said "typical." So, don't let that fool you. The locals working in the area know that this place is a great deal. Maybe not authentic Chinese, but after a long day of shopping, when Italian, American and sub sandwiches are not cutting it, who can beat this option?
EXTRAS/NOTES	This Lettuce Entertain You restaurant is the country's first Bao shop!

—Marcy Wrzesinski

THE LOOP

Artists' Café

Good food, great location—sketch books optional.
Since 1961
$$$
412 S. Michigan Ave., Chicago 60605
(south of Van Buren St.)
Phone (312) 939-7855

CATEGORY	Café/Historic
HOURS	Mon: 7 AM-8 PM Tues–Thurs: 7 AM–11 PM Fri/Sat: 7 AM–midnight Sun: 7 AM–11 PM
GETTING THERE	Brown, Orange, and Purple lines, Library stop; Red and Blue lines, Jackson stop, or Bus: #1,3,4,6,7, or 126
PAYMENT	AMERICAN EXPRESS ATM also available
POPULAR FOOD	Gyros, burgers, and Greek Chicken
UNIQUE FOOD	Yummy spanakopita, souvlaki, Tequila Alfredo Pasta, Pierre's Tuna Volcano
DRINKS	Wines by the glass or bottle, bottled beers, cocktails, aperitifs, liqueured coffees
SEATING	Over 100 inside, but the sidewalk café tables in the summertime nearly double the capacity.
AMBIENCE	Expect pre- and post-theatre/symphony crowd;

Michigan Ave. hotel guests (and their kids); area college professors, staff, and students.

EXTRAS/NOTES Autographed celebrity photos line the main inner doorway, underscoring the building's important role in Chicago's performing arts history. The Studebaker Theater and Fine Arts movie house (both now closed) formerly drew crowds to this location on a regular basis. Despite changes in the neighborhood, Artist's is still run by the family that originally opened it.

—*Victoria Cunha*

Big Herm's

Hot dog stand with a bar. It doesn't get any better than this!

$

409 Washington, Chicago 60606
(On Riverside Plz.)
Phone (312) 559-0081

CATEGORY Lunch dine in or take outs (hot dogs, burgers, tacos etc..) and after work snacks. Attached is a small bar serving Ice cold beer and the basics. Catch the score of the ballgame or sit outside (seasonal patio) and enjoy the classic rock jukebox while people watching and eyeing the occasional boats cruising down the river.

HOURS Early lunch 'til early evening, they'll stay open as long as the crowd is there…

GETTING THERE Parking very difficult, but Northwestern train station is one block away and the brown line is two blocks away

PAYMENT

POPULAR DISH Hot dogs, burgers and ice cold brew

UNIQUE DISH For this area, this is the one place to get good Chicago fast food staples: burgers, 'dogs, beef….

DRINKS Full bar, but most drink beer (from coolers, nonetheless! And mostly cans!)

SEATING There are a good amount of seats in the dining area… Keep in mind, this is definitely more of a lunch destination. In the bar area, there is limited seating which is usually occupied by a real motley crew of characters. In the summer, you can't miss the outdoor seating right along the river… Plenty of tables….

AMBIENCE/CLIENTELE Come as you are! Traders, office workers, construction workers, professionals…The bar is cozy and the regulars tend to have their territory staked out! To beat the lunch crowd line, belly up for a beer and order lunch from the bar. Smoking is permitted in the bar area. Friendly bar staff and the general mood is casual. If you are looking for a Cosmopolitan or a Cognac you are in the wrong place!

EXTRAS/NOTES Interesting regulars and great service. Where else can you go in this area to get a Chicago-style hot dog, sit outside by the river, have a cold one, and all for under $10?!

—*Marcy Wrzesinski*

Boulevard Treats

Mysteriously cheap Michigan Avenue snack haven.

$

406 S. Michigan Ave., Chicago 60605
(just south of Van Buren St.)
Phone (312) 663-0230

CATEGORY	Hot Dogs/Snacks
HOURS	Mon–Fri: 11 AM–6 PM
GETTING THERE	#3, 4, 145, and 146 busses or metered parking
PAYMENT	Cash only
POPULAR FOOD	Traditional ice cream and popcorn, hot dogs, and candy
DRINKS	Soft drinks, iced tea
SEATING	No seating, but you can stand at ledges by the wall
AMBIENCE	Everyone from college students to office-worker bees
EXTRAS/NOTES	Oddly intimidating, yet ultimately friendly elderly twin sisters serve up Vienna beef hot dogs, macaroni salad, ice cream, root beer floats, and popcorn.

—Catherine Keich

Burrito Buggy

This ain't no Taco Bell.

$$

206 W. Van Buren St., Chicago 60607
(west of Wells St.)
Phone (312) 362-0199 • Fax (312) 362-9222

CATEGORY	Burrito Stand
HOURS	Mon–Fri: 7 AM–3 PM
GETTING THERE	Pay through the nose or just take #37 bus
PAYMENT	*VISA* *MasterCard*
POPULAR FOOD	Burritos, baby! A virtual Mexican smorgasbord
UNIQUE FOOD	Try the great breakfast, served daily: 7 AM–11 AM
DRINKS	Sodas
SEATING	Twenty counter seats
AMBIENCE	This spot can get loud and crazy during the lunch hours
EXTRAS/NOTES	If the mark of a good Mexican restaurant is the urgency with which you seek the nearest restroom after eating, then Burrito Buggy is the King of them all. The burritos they churn out are top notch. At lunchtime, lines are long and packed with traders from the Exchange, but nudge them aside, because the steak burritos are worth it. They're darned stingy on the sides (namely, with guacamole), so haggle for an extra dollop or two. Or, check out the actual "buggy" parked on Canal for an even more authentic experience! Delivery and catering available.
OTHER ONES	• "Buggy" parked on Canal between Madison St. and Monroe St., Chicago 60606
	• 201 N. Clark St., Chicago 60601, (312) 214-8990

—Trisha Falb

Ceres Café

*Liked Trading Places? Watch traders
talk shop over good grub!*
$$$
141 W. Jackson Blvd., Chicago 60604
(at the end of LaSalle St., inside the Chicago Board of Trade Bldg.)
Phone (312) 427-3443 • Fax (312) 435-5447

CATEGORY	Heinz 57
HOURS	Mon–Fri: 6 AM–8:30 PM
GETTING THERE	Metered parking if you're lucky, otherwise Brown line, Chicago Board of Trade stop or #151 bus
PAYMENT	
POPULAR FOOD	Smoked Scottish salmon breakfast plate, steak sandwiches, Reubens, and the grilled chicken Caesar salad
UNIQUE FOOD	Homemade donuts
DRINKS	Full bar, sodas, coffee/tea, and mineral water
SEATING	Seats around 180 inside plus outdoor beer garden with 80 seats open in the summer time
AMBIENCE/CLIENTELE	Noisy and at times gruff, but generally friendly; mostly financial and commodity trader crowd, some tourists.
EXTRAS/NOTES	Good home style breakfasts and rocket fuel coffee. Just say yes to their corned beef and Reuben sandwiches, gravy fries optional. Horrors! They have adjusted their menu to include healthy food, too! Live music on Fridays. In a hurry? Check out the food court in the basement of the Chicago Board of Trade Building, run by the same folks. Both locations offer carry-out, delivery, and catering.
OTHER ONES	• Seller's Market food court, Phone (312) 427-9833

—Lydia Ellul

Exchequer Restaurant & Pub

Al Capone raves, "Best Pizza in the loop!"
Since 1969
$$$
226 S. Wabash Ave., Chicago 60604
(at E. Jackson Blvd.)
Phone (323) 939-5633 • Fax (312) 786-9128
www.exchequerpub.com

CATEGORY	American pub that's perfect for before or after a visit to anywhere in the Cultural Center
HOURS	Mon-Thurs: 11 AM-11 PM Fri/Sat: 11 AM-midnight Sun: noon-9 PM
GETTING THERE	Due to its convenient proximity to so many of Chicago's premier cultural spots, parking lots abound in the following locations: Inter-Parking Adams-Wabash Self Park, Inter-Parking at 55 East Monroe, Millennium Park Parking Garage, Grant Park North, and Grant Park South.

PAYMENT

POPULAR DISH Since it opened in 1969, Exchequer has been known for its deep-dish "Exchequer Pizza." Roger Ebert gives the "Exchequer Pizza" fours stars and the Chicago Tribune names this specialty the No. 1 Pan Pizza in the Loop.

DRINKS Full bar-imported, domestic, featured beers, premium and house wines. Also bottled water.

SEATING Exchequer has a small bar upon entering. After the bar, there are two larger rooms with booths and tables. The restaurant is good both for large groups and couples.

AMBIENCE/CLIENTELE One would easily walk right by the Exchequer Restaurant & Pub without giving it a second glance. From the outside, its location under the L tracks on Wabash makes it immediately unappealing and its drab exterior does nothing to diminish this unfortunate effect. Once you're inside, however, the L seems far away and the narrow entryway widens into three cozy, distinctive rooms. The first and smallest room is the full bar where the owners (the Mullen Brothers) welcome their customers. Past the bar, two larger rooms are decorated with photographs of Marilyn Monroe, Katherine Hepburn, Douglas Fairbanks Junior, and classic movie posters ("Gone With the Wind" is a favorite). Exchequer is equally enjoyable as a lunch or a dinner restaurant. The restaurant's size and large number of tables makes it extremely family friendly; but cozy booths beneath faded photographs of old-time movie stars and the dim, deep burgundy and dark wood atmosphere so conducive to romantic outings supply more than enough shelter for romance.

EXTRAS/NOTES Before it was the Exchequer Restaurant & Pub, 226 S. Wabash housed a number of historically fascinating eateries, the first of which was "226 Club." A "speakeasy" in the 1920s and '30s, the "226 Club" is rumored to have been visited by Al Capone, who lived only a few blocks away. In the 1930s and '40s, after the prohibition period, the restaurant was redesigned around the magnificent bar at the back and appropriately renamed "the Wonder Bar." The restaurant became "Browns" in the 1950s and '60s and was transformed into a casual dining spot with a sandwich menu, peanut shells on the floor and a steam table in the front. In 1969, the building was remodeled, the bar moved to the front, and the sign changed to "Exchequer." The Mannos Family became the restaurant's owners in 1982 and have welcomed diners at the door ever since. Interesting Note: "Exchequer" is the name of the National Treasury of England.

—*Lara Ehrlich*

Heaven on Seven

A piece of New Orleans in the heart of Chicago.
$$$
111 N. Wabash Ave., Seventh Fl., Chicago 60602
(north of Washington St.)
Phone (312) 263-6443 • Fax (312) 263-3777
www.heavenonseven.com

CATEGORY	Cajun
HOURS	Mon–Fri: 8:30 AM–5 PM
	Sat: 10 AM–3 PM
GETTING THERE	Over-priced garages nearby so it might be best to take the Blue and Red lines, Washington stop or Brown, Green, Orange, and Purple lines, Madison stop or #20, 56, 147, 151, and 157 busses.
PAYMENT	Cash only
POPULAR FOOD	Po' Boy sandwiches, gumbo shrimp Avery Island, Louisiana crab cakes
UNIQUE FOOD	Etouffee of the day
DRINKS	The famous Hurricane, a mix of Bacardi rums blended with orange, pineapple, and cranberry juices
SEATING	Room for 110, including a few coveted counter spots
AMBIENCE/CLIENTELE	Enjoy this eclectic, former coffee shop now bedecked year-round in the trimmings of Mardi Gras (movie 'blue collar workers and suits alike' to the beginning)
EXTRAS/NOTES	Hot sauces, t-shirts, hats, and gumbo-by-the-gallon are all available for purchase here at Chicago's home for Louisiana-style cooking. Dinner served first and third Friday of every month: 5:30 PM–9 PM.
OTHER ONES	• River North: 600 N. Michigan Ave., 2nd Fl. (enter on Rush St.), Chicago 60611, (312) 280-7774
	• Wrigleyville: 3478 N. Clark St., Chicago 60657, (773) 477-7818 (live music every Sunday from noon until 2 PM)

—Jennifer Chan

Lou Mitchell's

*Historic Coffee Shop where everything is
fresh, fresh, fresh or forget it!*
Since 1923
$$$
565 W. Jackson Blvd., Chicago 60661
(between Jefferson St. and Clinton St.)
Phone (312) 939-3111 • Fax (312) 939-4400

CATEGORY	Coffee Shop
HOURS	Mon–Sat: 5:30 AM–3 PM
	Sun: 7 AM–3 PM
GETTING THERE	Street parking or #7 and 126 busses
PAYMENT	Cash only
POPULAR FOOD	Fluffy, double-yolk eggs any style served with home fries and Texas toast in a skillet, pancakes, waffles, and French toast, or sandwiches, and meatloaf
UNIQUE FOOD	Apple and cheddar cheese omelets; homemade marmalade
DRINKS	Special blend of coffee, fresh-squeezed orange or

SEATING	grapefruit juice, milkshakes with fruit added
	Room for 120 at booths and long, communal; about 10-15 counter stools, too
AMBIENCE/CLIENTELE	Commodities traders, tourists, kings and queens of commerce, attendees of Old St. Patrick's Catholic church, the occasional celebrity, local politicians on the campaign trail
EXTRAS/NOTES	Lou Mitchell's is located at the beginning of historic Route 66 and has become a true local landmark. Many items are for sale, such as bakery items, including pecan rolls and raisin toast, T-shirts, mugs, and packages of coffee beans.

—Victoria Cunha

The Marshall Fields Walnut Room

(see p. 153)
Historic
111 N. State St., Seventh Fl., Chicago 60602

Miller's Pub

Reliably good food with a Greek twist.
$$$$
34 S. Wabash Ave., Chicago 60603
(at Jackson Blvd.)
Phone (312) 263-4988 • Fax (312) 263-0468
http://millerspub.com/index.php

CATEGORY	Not quite fine dining, not quite a greasy spoon, this is a neighborhood pub frequented by celebrities, local politicians, Loop-area workers and everyone in-between.
HOURS	Daily: 11 AM–2 AM (bar is open 'til 4 AM)
GETTING THERE	Street parking is metered and difficult to obtain, even during weekends due to Miller's close location to all of the shopping on State Street and Grant Park happenings, can take the Red Line El to any of the State Street stops, 36 Broadway bus will also drop you off at any of the State Street stops, Miller's Pub offers discount parking at 55 E. Monroe or 56 E. Adams after 4 PM on the weekdays and all day Saturday and Sunday. Right outside of the restaurant, you can catch the El for the Brown, Orange, or Purple line.
PAYMENT	VISA MasterCard AMERICAN EXPRESS DISCOVER
POPULAR DISH	The Canadian Baby Back Ribs….
UNIQUE DISH	Weiner Schnitzel a la Holstein
DRINKS	Though you will see a beer drinking crowd throughout the restaurant, the bar seems to attract a stiff cocktail crowd as well.
SEATING	This is an ample-sized place, though it is filled to capacity at most times. If you're told that you'll have to wait for a table, don't fret. Service is quick and

dependable, so a table is likely to open up quickly.

AMBIENCE/CLIENTELE The first thing you notice when you walk in is the dark wooden interior, adorned with 50's-era pictures of celebrities (with the occasional more recent celeb, many of which may be considered "semi" famous). The bustling sound of the crowd and clinging of dishes and glassware lets you know that this is a busy place….always a good sign that there is obvious repeat business. There is a wide range of clientele….on any day you may see police officers, lawyers, or judges who have come by for a quick snack after there work at the Daley Center. You will also see families who may be taking a lunch break from their shopping on State Street (or perhaps they've just come from Michigan Avenue and have a little bit of time before they have to catch the train at Union Station).

EXTRAS/NOTES Miller's Pub is an "old-time" classical restaurant. Those "in the know" recognize that this place is where all of the Sun-Times reporters (e.g. Mike Royko) would hang out.

—Marcy Wrzesinski

Monk's Pub

Downtown's coziest burger and brew
$$
205 W. Lake St., Chicago 60606
(at Wells St.)
Phone (312) 357-6665

CATEGORY Burger & brew pub—European aged dark wood and lighting with 20th Century pop culture photos on the walls.

HOURS Daily: 11 AM-9 PM

GETTING THERE Street parking has new two-hour meters, several parking garages exist within a half-block, cabs plentiful.

PAYMENT VISA MasterCard AMERICAN EXPRESS

POPULAR DISH The Monkburger! Straight, with cheese, with olives, mushrooms, jalapenos, etc.—or all of the above! Even by itself, the Monkburger may be the most manageable and satisfying half-pound burger within the city limits.

UNIQUE DISH It's a mixture of European brew pub, Marilyn Monroe and Beatles 8x10s hanging up, great cheeseburgers, and (during the day) CNBC on the TVs behind the bar.

DRINKS Monk's has a full bar, but I've never seen anyone order anything harder than a pint of dark ale…unless you count those after-work shots of Jager or Jameson.

SEATING There are a dozen or so bar-top tables, twice than many barstools, plus 50 or more tables.

AMBIENCE/CLIENTELE Conspicuousness may be frowned upon, but probably no one cares. Business casual is most common here. Patrons are usually either taking a long lunch break or meeting up for a few after work.

EXTRAS/NOTES Monk's originally existed at a different location, where it was supposedly a true dive. Upon moving to a much bigger space on Lake St. years ago, it aimed to keep the same crumbling warmth of a European brew pub. It's cozy without being a mess.

—*Mark Vickery*

My Thai Restaurant
Traditional Thai for impoverished students and corporate crunchers alike.
$$

30 S. Michigan Ave., Chicago 60603
(just north of Monroe St.)
Phone (312) 345-1234 • Fax (312) 345-0009

CATEGORY	Thai
HOURS	Mon–Fri: 10:30 AM–8 PM
	Sat: 11:30 AM–8 PM
	Sun: noon–7 PM
GETTING THERE	Several pay lots in area— try Millennium park garage (entrance on Columbus Dr.) for cheapest parking around; Brown, green, orange, and purple lines, Madison or Adams stops, Red and blue lines, Monroe stop; #3, 4, 6, 14, 60, 145,147, 151 busses
PAYMENT	VISA MasterCard AMERICAN EXPRESS DISCOVER
POPULAR FOOD	Pad Thai, satay, Thai curries (red, green, yellow, and brown)
UNIQUE FOOD	Siam catfish or Red Snapper Filet Deluxe
DRINKS	Thai iced coffee/tea, sodas, beer, and wine
SEATING	Around 50 tables
AMBIENCE/CLIENTELE	Not a masterpiece of interior design, but nicer than Mc-you-know-what; crowd's mostly office worker types and students from nearby colleges and universities
EXTRAS/NOTES	Play it safe and stick with the traditional dishes like Tom Kha Kai soup—and you can't go wrong with the pad Thai! My Thai is an affordable alternative for the student on a limited budget and the businessperson who can't leave the office for lunch. They'll deliver for an extra $1.50 and a minimum purchase of $10. Or, if you are dining in, you can easily have a two-course meal for under ten bucks. Bring a friend—most portions are large enough to feed two!
OTHER ONES	• Loop: 333 S. State St., Chicago, 60604, (312) 986-0999
	• Loop: 555 W. Madison St., Chicago, 60661, (312) 669-1999 (in Presidential Towers building)

—*Ondy Sweetman*

"One cannot think well, love well, sleep well, if one has not dined well."
—*Virginia Woolf*

Soprafina Market Caffè

Italian café-style lunch place.
$$
10 N. Dearborn St., Chicago 60602
(north of Madison St.)
Phone (312) 984-0044 • Fax (312) 984-1525
www.soprafina.com

CATEGORY	Italian-General/Café
HOURS	Mon–Fri: 11 AM–4 PM
GETTING THERE	Parking? Ha! Take the Brown, Green, Orange, and Purple lines, Madison stops, Blue and Red lines, Washington stop or #14, 20, 22, 24, 36, 56, 62, and 157 busses
PAYMENT	
POPULAR FOOD	Great pizzas—try the Margherita
UNIQUE FOOD	Boxed lunches
DRINKS	Sodas
SEATING	Lots and lots
AMBIENCE/CLIENTELE	This is a big, busy, bustling place with plenty of suits
EXTRAS/NOTES	At Soprafina you'll find most of your Italian standards—pizza, pasta, salad, sandwiches. It's all pretty good and not terribly expensive, at least by downtown standards. If you want something more palatable than your average McBurger, Soprafina is a fine option. Oh, and if you need an attorney, you could probably just go in, stand on a table, and ask for one in a loud but reasonable voice. There's almost sure to be one dining thereabouts.
OTHER ONES	• Loop: 222 W. Adams St., 60606, (312) 726-4800 • 200 E. Randolph St., 60601, (312) 729-9200 • 175 W. Jackson, 60604, (312) 583-1100 • 111 E. Wacker, 60601, (312) 861-1898

—Colin Lohse

Taco Fresco

A hot spot for those health-conscious Loop workers seeking a quick Mexican lunch.
$$
180 N. Wells St., Chicago 60606
(between Randolph St. and Lake St.)
Phone (312) 917-1007, (888) LITE-MEX • Fax (312) 917-1008
www.tacofresco.com

CATEGORY	Health Conscious/Cal-Mex
HOURS	Mon–Fri: 10:30 AM–4 PM
GETTING THERE	Pay lots nearby or take Brown, Orange, and Purple lines, Washington stop, or Blue, Brown, Green, Orange, and Purple lines, Clark St. stop, or #37 bus.
PAYMENT	
POPULAR FOOD	Burritos, taco salad, quesadillas made with low-fat ingredients
UNIQUE FOOD	Grilled yellow fin tuna available in tacos and burritos
DRINKS	Grab sodas and/or water from the refrigerator before you order
SEATING	Only 25 seats so there's often a wait around lunch time.

AMBIENCE	High-energy establishment catering to Loop workers
OTHER ONES	• 218 S. Clark St., Chicago 60604, (312) 641-9912
	• 41 E. Chicago Ave., Chicago 60611, (312) 951-9952
	• 29 N. Wacker Dr., Chicago 60606, (312) 920-0077
	• 335 S. Franklin St., Chicago 60606, (312) 939-1548
	• 25 E. Adams St., Chicago 60603, (312) 939-2877

—*Jennifer Chan*

Wishbone Restaurant

(see page p. 70)
Southern American
1001 W. Washington Blvd., 60607
Phone (312) 850-BONE (2663)
(Rumored to be the lunch spot of Oprah staffers from nearby Harpo Studios.)

Sweet Cone Chicago

Believe it or not, Chicago is not always cold and windy. In fact, sometimes it can get downright, hellishly hot. That's when it's time to head to one of the city's best ice cream joints! Here are some favorites:

Margie's Candies
The doll collection inside this throwback from 1921 is a bit off-putting, but the selection and quality of the sundaes will knock your bobby socks off. Enough calories and worn furniture to remind you of Grandma's house—but hey, if it was good enough for the Beatles to stop by after their 1965 Chicago concert, it's good enough for you. *(Bucktown 1960 N Western Ave., Chicago 60647, (773) 384-1035)*

Gertie's Ice Cream
The ice cream is rich and fattening—but that's what you want in good ice cream, right? Gertie's is a time machine to 1950s Chicago. While you're looking at the memorabilia, don't forget one of their over-the-top banana splits. *(City Southwest 7600 S. Pulaski Rd., Chicago 60652, (773) 582-2510, City South 3685 S. Archer Ave., Chicago 60609, (773) 927-7807, 11009 S. Kedzie Ave., Oak Lawn, IL. 60655, (773) 779-7236)*

Original Rainbow Cone
For 79 years the Original Rainbow has been known to many Chicagoans as a rite of summer. Trek over, stand in a fast-moving line, enjoy slabs of chocolate, orange sherbet, Palmer House cherry, pistachio (even pistachio-doubters love it), and strawberry ice cream, stacked on a durable cone. Then eat it in the parking lot and think, "Aah, summer in the city." *(Chatham 9233 S. Western Ave., Chicago 60620, (773) 238-7075)*

Zephyr Cafe
Customers dig the art deco décor, the old fashioned sundaes and

malts, and the kid-friendly tables and chairs, encouraging you to enjoy the luxury of your ice cream. *(Ravenswood: 1777 W. Wilson Ave., Chicago 60640, (773) 728-6070)*

The Bunny Hutch Restaurant, Novelty and Games
You don't go to the Bunny Hutch for ice cream. You go to play uneven but entertaining miniature golf, listen to oldies, play video games, take a few swings in the batting cages, and THEN, when it's all said and done, enjoy a cone of soft-serve. Do it with your honey for a true romantic date. *Lincolnwood: (6438 N. Lincoln Ave., Chicago 60712, (847) 679-9464)*

Treats Frozen Desserts
What good is ice cream without the fat you say? Ask the folks at Treat Frozen Dessert and their loyal fans and the answer will be "damned good!" One gram of fat is all you get along with all the decadence of the ice cream you ate as a kid. Feeling creative? Make a mini, medium, large or mega mess from a variety of syrups, fudge, fruits, nuts, dips, sprinkles, granola and candies. Name it and they just might make it the "Mess of the Month!" Angel food cake, green tea, chocolate hazelnut and pumpkin pie are just a few of the 60+ flavors to choose from. So go ahead— Treat yourself right! *(Lakeview/Boystown: 3319 N. Broadway, Chicago, (773) 525-0900, Lincoln Park: 2224 N. Clark, Chicago, (773) 472-6666, 657 Vernon Avenue, Glencoe, (847) 835-9400)*

Finnegan's Ice Cream Parlor
There is really no good way to explain why there's an old-fashioned ice cream parlor in the middle of the Museum of Science and Industry; but take a turn onto the dimly lit Yesterday's Main Street and there it is, in all its turn-of-the-century goodness, next to a penny cinema. You'll have to fight cranky rugrats to get to enjoy your sundae, served in a tall glass with a long spoon—but hey, it's better than your average museum food! *(Hyde Park: 5700 S. Lake Shore Dr., Chicago 60637, (773) 684-1414)*

—*Verloren Perdido*

"It seems to me that our three basic needs, for food and security
and love, are so mixed and mingled and entwined
that we cannot straightly think of one without the others.
So it happens that when I write of hunger, I am really
writing about love and the hunger for it, and warmth
and the love of it and the hunger for it; and then the
warmth and richness and fine reality of hunger satisfied;
and it is all one."
—M. F. K. Fisher, *The Art of Eating*

N. WEST LOOP

Avec

Small bites bombard at late-night industry hangout
$$$$
615 Randolph St., Chicago, 60661
(at Jefferson St.)
Phone (312) 377-2002 • Fax (312) 377-2008
www.avecrestaurant.com

CATEGORY	Industry scene/tapas bar
HOURS	Mon-Thurs: 3:30 PM-11:45 PM (bar open 'til 2 AM)
	Fri/Sat: 3:30 PM-12:24 AM (bar open 'til 2 AM)
	Sun: 3:30 PM-9:45 PM (bar open 'til midnight)
GETTING THERE	Metered parking very difficult: valet is available.
PAYMENT	VISA MasterCard AMERICAN EXPRESS DISCOVER
POPULAR DISH	The homemade Chorizo stuffed Medjool dates, wrapped in smoked bacon and piquillo pepper tomato sauce make for a breakfast/lunch/dessert treat all wrapped up into one. The Deluxe Foccacia stuffed with taleggio cheese, truffle oil and fresh herbs is like a gourmet deep dish pizza, with a million dollar wrist tossing the dough.
UNIQUE DISH	A seasonal menu, with items that show up daily pending on what "Chef" found at the market. All restaurants should cook this way. It's very throwback to the style of tapas bar that is on every street corner in Spain's most beautiful towns.
DRINKS	Wine is king here, with many coming in carafinas (about 1/3 of a bottle).
SEATING	40 at the communal tables, fourteen at the bar
AMBIENCE/CLIENTELE	With names like Fluffy, the staff of beauties that populate this insanely popular West Loop tapas and wine bar are some of the most knowledgeable waiters around. The interior feels organic and sleek, and though they try to come off as "we invite everyone to dine here," the vibe reads more, be-pretty-or-get-out. Don't let that stop you though, as the food here is some of the best the city has to offer. Folks trek from around the world to sample the small plates of reasonably priced cuisine and write-up after write-up makes for headlines galore. Good luck finding parking, and even better luck to you trying to score a table. They take no reservation's, so be prepared to stand crammed in the tiny doorway looking on longingly as the lucky few who got there early are jammed into even tighter spaces, shoulder-to-shoulder with strangers…but at least they get to eat food made for the God's.

— *Misty Tosh*

"Sharing food with another human being is an intimate act that
should not be indulged in lightly."
—*M.F.K. Fisher*

SOUTH LOOP

Chef Luciano

"When the moon hits your eye...that's amore!"
$$$
49 E. Cermak Rd., Chicago 60616
(at S. Wabash Ave.)
Phone (312) 326-0062 • Fax (312) 326-3042

CATEGORY	Italian/Caribbean
HOURS	Mon–Sat: 10 AM–7 PM
GETTING THERE	Street parking or take #1, 21, and 29 busses
PAYMENT	Cash only
POPULAR FOOD	Tilapia white fish, tiramisù
UNIQUE FOOD	Jerk and curry dishes
DRINKS	Iced tea, soft drinks, and lemonade
SEATING	Carry-out only, unless you're friends with the chef!
AMBIENCE/CLIENTELE	Workers, professionals, and the occasional couple
EXTRAS/NOTES	The chicken and fish is so well seasoned! Only 100% imported olive oil and fresh herbs are used. Finish with a small serving of tiramisu, wash it down with a gulp of "killer" lemonade, and stick a fork in yourself—you're done!

—*L. Pat Williams*

Kitty O'Shea's

(see p. 154)
Bar & Grill
720 S. Michigan Ave., Chicago 60605

Pompei Bakery

(see page p. 61)
Pizzeria/Italian
1531 W. Taylor St., Chicago 60607
Phone (312) 421-5179 (Original location; banquet facilities available)

Lalo's

(see page p. 20)
Fun tourist trap
733 W. Maxwell St., Chicago 60607
Phone (312) 455-9380

GOLD COAST

P.J. Clarke's

It won't take long to feel like a regular at this long-time neighborhood joint where the seasoned bartenders are sure to remember your name.
$$

1204 N. State Parkway., Chicago
Phone (312) 664-1650 • (312) 664-9329

CATEGORY	Restaurant bar that's casual enough to feel comfortable bringing the whole family. They seem rather kid-friendly and their menu looks as if there is something for everyone. To others, this is definitely a bar hang-out. The front bar area can get jam-packed with those reconvening after a long days work, whether to just catch up, to split some appetizers, to catch the game…or all three.
HOURS	Mon-Fri: 11:30 AM-2 AM Sat: 11:30 AM-3 AM Sun: 10 AM-2 AM
GETTING THERE	Street parking is difficult, but it is only a couple of blocks away from the red line Division stop. One could also take the 36 Broadway bus, with a bus stop right around the corner on Division.
PAYMENT	VISA MasterCard AMERICAN EXPRESS DISCOVER
POPULAR DISH	Jack Daniel's pork chop or mini cheeseburgers
UNIQUE DISH	Meatloaf!
DRINKS	They do have a full bar, but you will mainly see the women drinking wine or Miller Lite, while the guys stick to imports or Microbrews.
SEATING	Three levels: garden level, ground level, second floor. The garden level (towards the back) and the second floor are mainly for lunch and/or dinner; whereas the front ground level is more of a bar.
AMBIENCE/CLIENTELE	In the summer, due to its close location to the Division Street/Lake Shore Drive underpass walkway, this place will be occupied by many either on their way to or from the beach. During the week, year round, you will find many people stopping off after work to enjoy a cocktail or two before heading home. The atmosphere is on the dark side, which gives off a warm atmosphere. The sound of the place has quite a range. You may hear Sinatra or jazz on one night, modern rock on another, and perhaps the sounds of a Cubs or Sox game.
EXTRAS/NOTES	While Division street will get tourists and suburban patrons, P.J. Clarke's will miss this since, as those mentioned wouldn't know, it's right around the corner. So, they clientele here are mostly Chicagoans.
OTHER ONES	• 302 E. Illinois Street, Chicago 60611

—Mark Vickery

"When a man's stomach is full it makes no difference
whether he is rich or poor."

—Euripides

Pump Room

*If cigars, martinis and jazz are
what you are looking for, then
this is the place for you!*

$$$$

**1301 N. State Parkway (in the Omni Ambassador East Hotel),
Chicago 60610**

(at Goethe)

Phone (312) 266-0360 • Fax (312) 266-1798

www.pumproom.com

CATEGORY	Even though the Pump Room is open for lunch, this still seems like more of a dinner place. This is a historic restaurant because in the '30s and '40s, this was THE restaurant of choice for the rich and famous.
HOURS	Mon-Fri: 6:30 AM -11 AM; 11:30 AM -2 AM; 6 PM-10 PM Sat/Sun: 7 AM -11 AM; 11:30 AM -2 AM; 6 pm-10 PM
GETTING THERE	Valet for $10, may be able to find street parking depending on the time of day, pay lot across the street, three city blocks walk from red line Division stop.
PAYMENT	VISA · MasterCard · American Express · Discover
POPULAR DISH	Still maintaining its "old Chicago" feel, one feels compelled to dine as if it were the 1930s… red meat.
UNIQUE DISH	I don't know of any other place where one can eat foie gras with kumquat marmalade, truffled pear and ice wine gelee!
DRINKS	Full-service bar. The drinks are pricey, you mainly see people drinking martinis or sipping wine.
SEATING	Pump Room's one square room has several different levels to it. Upon walking up the ramp to the hostess station, you will turn to see that the main dining room is "sunken" in the middle of the room. The large booths with high backs are the prized seats here. There are also tables and booths a slight level higher behind the main dining area. Along the windows are tables for two, perfect for viewing the gorgeous Gold Coast mansions in the area.
AMBIENCE/CLIENTELE	This is an upscale restaurant where you will definitely feel underdressed if you are wearing anything other than a suit. The vibe is that of our Chicago of yesteryear…..impeccably dressed celebs drinking scotch on the rocks, booming steel industry…
EXTRAS/NOTES	Booth No. 1. In its heyday, EVERYONE who was ANYONE requested the most popular table in the house, Booth No. 1. The entrance to the Pump Room is adorned with mostly black and white pictures of celebrities dining at the famous booth. Also, Petterino's (a Lettuce Entertain You restaurant in the Loop) is named after Pump Room's famous Maitre 'D who also now works at his namesake.

—Marcy Wrzesinski

"Shallots are for babies. Onions are for men. Garlic is for heroes."

—*Anon*

RIVER NORTH/STREETERVILLE

America's Dogs

(see p. 153)
Hot Dog Stand
700 E. Grand Ave. #123, Chicago 60611
Phone (312) 595-5541

Carnelli's Deli

(see p. 153)
Deli
700 E. Grand Ave., Chicago 60611
Phone (312) 595-5540

Greek Express

(see p. 153)
Greek
700 E. Grand Ave., Chicago 60611
Phone (312) 245-9994

Klay Oven

Tandoori—with Tablecloths!
$$$
414 N. Orleans St., Chicago 60610-4421
(at Hubbard St.)
Phone 312-527-3999

CATEGORY	Relatively upscale Indian restaurant. Caters to businesspeople as well as interior designers and other Merchandise Mart customers.
HOURS	Daily: 11:30 AM-2:30 PM; 5:30-10:00 PM
GETTING THERE	Limited street parking, but several lots exist within a block. Orleans St. is also a main cab route.
PAYMENT	VISA MasterCard AMERICAN EXPRESS DISCOVER
POPULAR DISH	The lunch buffet—consisting of tandoori chicken, lamb curry, nan, rice, veggie fritters, etc.—is extensive and decent, though a couple dollars more expensive than most Indian buffets in Chicago.
UNIQUE DISH	Though this place has nothing on Devon Ave. (where inexpensive and terrific food can be had almost anywhere between Western Ave. and California Ave.), a craving for Indian food can be sated here. Where Klay Oven excels over Devon Ave., however, is in its clean, well-cared-for environment. Patrons and buffet dishes alike are nicely catered-to.

DRINKS	The restaurant has a fully stocked bar. The food goes down best, however, with a hearty red wine or a tall bottle of Taj Mahal lager.
SEATING	Klay Oven has roughly two dozen tables—with tablecloths!—including several booths.
AMBIENCE/CLIENTELE	Indian businessmen in three-piece suits tend to frequent here. Those lucky enough to live in the River North neighborhood without having to hold down a 9-to-5 job can also be found here during the day. Even when dressed casually, one can sense the clientele is rather well-heeled. This may explain the absence of Indian music in favor of "lite jazz"— actually, the music more resembles that of John Tesh. While the prime River North Indian dining experience can be had at Gaylord of India (for a somewhat larger bill) about a mile away, the comfortable, relatively upscale environment of Klay Oven provides a nice environment with authentic cuisine.
EXTRAS/NOTES	Klay Oven has been around for over ten years, which is fairly exceptional for an ethnic restaurant in such a high-rent area. Its pleasant hotel-lobby environment is probably just as responsible for this as its authentic food and somewhat varied menu.

— *Mark Vickery*

Lalo's

Fun, party, let's start a conga line!
$$$
500 Lasalle, Chicago
(at Grand Street)
Phone 312.329.0030
www.lalos.com

CATEGORY	This is a very fun place, but it may be more of a tourist trap due to its location. It is situated very closely to other tourist traps (Rock and Roll McDonald's, Rain Forest Café, Hard Rock, Ed Debevic's, Gino's East).
HOURS	Mon-Tues: 11 AM- 9 PM Wed-Thurs: 11 AM-11 PM Fri-Sat: 11 AM-1 AM Sun: noon-9 PM
GETTING THERE	Valet parking is $10, street parking difficult, on the route of the 156 Lasalle bus, the bus stop is right in front of the building, pay garage parking a couple of blocks away.
PAYMENT	VISA MasterCard AMERICAN EXPRESS DISCOVER
POPULAR DISH	There seafood selections are very good, especially the red snapper. Mostly, however, people seem to order the standard American-Mexican fare (tacos, burritos, enchiladas).
UNIQUE DISH	Everyone gets a complimentary bowl of hearty, chicken noodle soup. Also, besides the standard chips and salsa placed on the table upon arrival, they also give you a bowl of marinated carrots, peppers and garlic.
DRINKS	If one doesn't drink alcohol, he/she would probably

have an iced tea or soda. But for those wanted to indulge in libations, margaritas are the way to go here. They give you the option of choosing which tequila you want for your drink.

SEATING The building is very spacious. There is a huge bar area with a wall of TVs. The second floor has a lot of seating, and there's a third floor available for private parties.

AMBIENCE/CLIENTELE This is a casual, fun restaurant. With the colorful decorations and upbeat Spanish music, it feels like a party. In the summer, one would feel very comfortable wearing a t-shirt and shorts.

OTHER ONES
- 3011 S. Harlem Ave., Berwin 60402, (708) 484-9311
- 1432 Waukegan Rd., Glenview 60025, (847) 832-1388
- 804 S. Oak Park Ave., Oak Park 60304, (708) 386-3386
- 3515 W. 26th St., Chicago 60623, (773) 522-0345
- 4126 W. 26th St., Chicago 60623
- 1960 N. Clybourn, Chicago 60610, (773) 880-5256
- 425 Roselle Rd., Schaumburg 60193, (847) 891-0911
- 5757 S. Cicero Ave., Chicago 60638, (773) 838-1604

Leona's

Middle-of-the-road Italian fare with big portions that won't hurt your pocketbook....

$$$

646 N. Franklin, Chicago 60610

(at W. Erie St.)

Phone (312) 867-0101

www.leonas.com

CATEGORY Leona's is a Chicago Staple that has been serving up hearty Italian fare since 1950.

HOURS Sun: noon-10 PM
Mon-Thurs: 11 AM-10 PM
Fri: 11 AM-11 PM
Sat: noon-11 PM

GETTING THERE Street parking is possible. They do not have valet service.

PAYMENT VISA MasterCard AMERICAN EXPRESS

POPULAR DISH Pizza, traditional style with your choice of Italian meats

UNIQUE DISH Chopped antipasto salad

DRINKS Full bar-beer, cocktails and wine

SEATING Good for couples or families small and cozy. Some locations have 2 levels.

AMBIENCE/CLIENTELE The ambience here is pretty casual. One would feel perfectly comfortable in shorts and a T-shirt

OTHER ONES
- 3215 N. Sheffield, Chicago 60657, (773) 327-8861
- 6935 N. Sheridan, Chicago 60626, (773) 764-5757

- 1936 W. Augusta, Wicker Park 60622, (773) 292-4300
- 3877 N. Elston, Chicago 60618, (773) 267-7287
- 7443 W. Irving Park, Irving Park 60634, (773) 625-3636
- 1504 Miner St., Des Plaines 60016, (847) 759-0800
- 1455 Ring Road, Calumet City 60409, (708) 868-4647
- 17501 Dixie Highway Homewood 60430 (175th & Dixie Highway , (708) 922-9200
- 1419 W. TaylorChicago 60607, (312) 850-2222
- 1236 E. 53rd St Chicago 60615 (53rd & Woodlawn), (773) 363-2600
- 11060 S. Western Ave., Chicago 60643 (111th & Western), (773) 881-7700
- 848 W. Madison, Oak Park 60302, (708) 445-0101
- 4431 W. Roosevelt Rd., Hillside 60162, (708) 449-0101
- 6616 W. 95th St, Oak Lawn 60453, (708) 430-7070
- 7601 S. Cicero, Chicago 60652 (In Ford City Mall), (773) 838-8383
- 9156 S. Stony Island, Chicago 60617

— *Marcy Wrzesinski*

Mr. Beef on Orleans

Chicago's hometown favorite Italian beef sandwich. A real institution!

$

666 N. Orleans St., Chicago 60610

(north of Erie St.)

Phone (312) 337-8500

CATEGORY	Sandwich Shop
HOURS	Mon–Fri: 7 AM–4:45 PM
	Sat: 10:30 AM–2 PM
GETTING THERE	Enough for your Lincoln Town Car, but don't scratch the Don's. Might just want to take the #37 bus.
PAYMENT	Cash only
POPULAR FOOD	Succulent Italian Beef and Combo sandwiches— don't forget to ask for yours dipped and with hot or sweet peppers; Italian sausage
DRINKS	Fountain soda, coffee
SEATING	About 50 in dining room; 5 stools at counter, and room for 15 more to stand
AMBIENCE/CLIENTELE	Taxi drivers, locals, celebrities, and a certain late-night L.A. talk show host hob-nob frequently
EXTRAS/NOTES	The dining room walls are covered with autographed photos of local celebrities and movie posters with your favorite Italian stars. For 20 plus years this place has been packing the customers in for some of the best tasting Chicago sandwiches one can find. Not to be mistaken for its imposters!

—*Tal Litvin*

Papa Milano

An old school Chicago pizza place…
951 N. State, Chicago 60610
(at Oak St.)
Phone (312) 787-3710 • Fax (312) 787-3715

CATEGORY	This is a neighborhood joint with much local flavor to it.
HOURS	Mon-Thurs: 11:30 AM-10:30 PM Fri: noon-11:30 PM Sat: noon-11:30 PM Sun: noon-10:30 PM
GETTING THERE	Pay lot, street parking is impossible, the 36 Broadway bus will drop you off practically in front of the place
PAYMENT	VISA MasterCard AMERICAN EXPRESS
POPULAR DISH	You will find many of the popular Italian-American dishes on the menu: spaghetti, lasagna, pizza.
UNIQUE DISH	Since Papa Milano wants to maintain its simplicity, the most complex dish you will find is eggplant parmagiana or veal parmagiana.
DRINKS	They have a full-service bar, but this is not the martini crowd. The clientele are those who want casual, fast, simple Italian food. This place is family-friendly, so you will see tables ordering pitchers of soda. This is not a 20-30 something hangout, as there are many of those in the area. Instead, you may find older couples drinking Sidecars or Manhattans.
SEATING	This place is small and the tables are somewhat cramped.
AMBIENCE/CLIENTELE	The ambience here is minimal. The customers here are regular folks who are looking to get more "bang for their buck" in this otherwise expensive, River North area.
EXTRAS/NOTES	Jay Leno has mentioned Papa Milano several times. He has said "I like Papa Milano. One of those old Italian places, been around for years and years, looks like a little family restaurant. I order the same thing every time I go there. They have these giant meat raviolis. They look like pancakes. I have, like, five of them. So, I tell people, 'I just had five raviolis—that's all I ate.' But they're as big as your head! I'm not much for the fancy, you know, the fried quail on a bed of leeks or something. Just regular old cooking."

— *Marcy Wrzesinski*

Reza's Restaurant

(see page p. 111)
Persian
432 W. Ontario St., Chicago 60610
Phone (312) 664-4500 (free valet parking)

Star of Siam

Fast, fresh Thai time and time again

$$$

11 East Illinois, 60611

(at State Street)

PHONE (312) 670-0100

CATEGORY	This is a popular lunch spot during the week and locals and tourists mingle here on weekends. No worries though, the locals always outnumber out-of-towners.
HOURS	Sun-Thurs 11 AM – 9:30 PM, Fri-Sat 11 AM-10:30 PM
GETTING THERE	Parking is definitely a nightmare, but there are plenty of parking structures around and they also have valet.
PAYMENT	VISA MasterCard AMERICAN EXPRESS DISCOVER
POPULAR DISH	The Pad Thai really IS the greatest here. Start with some spring rolls or shrimp pot stickers.
UNIQUE DISH	Rama Broccoli with tofu. This super-healthy dish is filling, flavorful and guilt-free.
DRINKS	Full bar—beer, wine, cocktails… the Thai iced tea is pretty popular if you're not in the mood for drinks.
SEATING	With two levels and enough space to throw a party for nearly 1,000, you won't having a problem bringing a large group of friends, but you won't feel out of place if it's just you and your sweetheart or a few of your closest friends.
AMBIENCE/CLIENTELE	The atmosphere is upbeat and festive without being too over the top. It's still great for conversation and patrons can feel free to come in jeans and a t-shirt or their trendiest threads.
EXTRAS/NOTES	Located in the building that houses the Chicago Reader, one of the most popular alternative weeklies in the city, Star of Siam attracts locals, downtowners and tourists alike all in search of fresh fare, a festive atmosphere and reasonable prices. Choose from several seating options in the upstairs or downstairs dining rooms or try the popular "tea room"—that's seating in the middle of the room featuring "raised" benches similar to traditional Asian seating.

— *Michelle C. Burton*

Bulk Eating

Who among us doesn't need a fifteen-gallon vat of mustard? Or ten pounds of herring? Or a box containing one hundred ice cream sandwiches?

That's right. Keep your hand raised. We all need that stuff. Which leads us to the most important haven for cheap eating not listed in ye olde pages. Costco. Five steaks for sixteen bucks. Boxes of fresh baked cookies for five bucks. Cheez Whiz in a fire extinguisher. If you have to eat at home because of your precarious financial situation, Costco is about as close to Paradise as your poor ass is gonna get.

Ah, but the real thrill about going to Costco is not what you can purchase and then fix for yourself (I recommend the boxes of baked ziti and the bomb-ass pot roast), but what the fine chefs at Costco prepare for you in their executive dining hall, also known as the area behind the registers where the smell of pizza and hot dogs emanate like the siren's song. For two bucks, you've got yourself a hot dog and (the tension is mounting here…) a refillable soft drink of your choice. But wait, there's more. Plop down three bucks (really, $2.99) and you've got yourself a slab-o-pizza and a soda. And the pizza is pretty gosh darn good. Not in the mood for pizza? Those same three bucks will get you a chicken sandwich and soda.

Lincoln Park
> 2746 N. Clybourn Ave.
> Chicago, IL 60614
> (773) 360-2053

Bedford Park, IL
> 7300 S. Cicero Ave 60629
> (708) 552-9010

Niles, IL
> 7311 Melvina Ave. 60714
> (847) 972-3003

Oakbrook, IL
> 1901 W. 22nd St, 60523
> (630) 928-0235

Glenview, IL
> 2900 Patriot Blvd, 60026
> (847) 730-1003
> www.costco.com

RIVER WEST

The Breakfast Club

The early bird gets the French toast at this come-as-you-are haunt
$$$
1381 W. Hubbard St., Chicago 60622
(at Noble St.)
Phone (312) 666-3166

CATEGORY	Breakfast/Lunch Diner
HOURS	Mon-Fri: 6:30 AM- 3 PM
	Sat-Sun: 7 AM-3 PM
GETTING THERE	Free street parking abound
PAYMENT	Cash only
POPULAR DISH	Stuffed French Toast, served perfectly crispy, doused with maple syrup and gobs of butter, is the house winner.

UNIQUE DISH	No frills diner food that is always guaranteed to be delicious. Very popular hangout for those in-the-know.
DRINKS	Loads of coffee, Mimosa's, Bloody Mary's, and Bellini's are served as well. Very brunchish.
SEATING	Seating for 70
AMBIENCE/CLIENTELE	This off-the-beaten-path hideaway on the Westside is smack in the middle of a residential neighborhood and could easily be missed, if not for the cherry awning over the entrance. The cozy tables are perfect for kickin' back with a piping hot cup of coffee and a spreading out the Sunday paper. The made-from-scratch favorites, like bacon, eggs and hash browns, French Toast and thick, fluffy omelettes pack the belly's of local politicians, firemen, and city workers, especially those just coming off the third shift. The old-school wait staff brings to mind Grandma's kitchen, where friendly chatter, small-town gossip and the day's headlines dominate the conversation.

—*Misty Tosh*

Iguana Café

*European Coffeehouse with a
kickback-and-chill-a-minute vibe*
$$$

517 N. Halsted St., Chicago 60622
(at Grand Ave.)
Phone (312) 432-0668 • Fax (312) 432-1609
www.iguana-café.net

CATEGORY	European Coffeehouse/Lounge
HOURS	Mon-Thurs: 7 AM-12:30 AM
	Sat: 8 AM-2 AM
	Sun: 9 AM-1 AM
GETTING THERE	Metered, somewhat difficult parking
PAYMENT	VISA MasterCard AMERICAN EXPRESS
POPULAR DISH	Grilled Panini sandwiches are delicious and hearty, especially the grilled veggie version. They taste even better cold, if you can imagine and you could easily split the sandwiches. The brownie ice cream sundae, topped with hot chocolate sauce, is an out of this world, one-dish-wonder.
UNIQUE DISH	Crepes doused in Nutella and served with a huge scoop of vanilla ice cream
DRINKS	Full Bar with very reasonable prices and nice selection of wines
SEATING	Seating for 50
AMBIENCE/CLIENTELE	Trendy hipsters, Greek mafia, River West yuppies and philosophical daydreamers all meld together in this European melting pot. The light fare is cheap, generous and always delicious and it's perfect for a first date, a business meeting, a day at-the-office (utilizing the wi-fi connection) or for a quick lunch. The music does get to be a bit much at times, but the devil-may-care attitude of the staff and the urban vibe makes it all worth it.

—*Misty Tosh*

Pizza? Get outta (down)town!

Chicago pizza is not a delicacy to be taken lightly, or a light delicacy for that matter. While New York pizza is a floppy, foldable portable delight, and there are plenty of thin-crust treats in the Big Windy, you need to set aside some time to enjoy Chicago-style. First, to decide which kind you want. Then, to wait for it to be made—if yours is ready-made and sitting under a warmer, you're not even close. Next, to dig in and savor every experience of flavors and textures, and, finally, time to digest it all! Real Chicago-style pizza is deep-dish, made with fresh sauce, generous helpings of ropey cheese and embraced by a thick, hearty crust. It's not for dieters; it's for people who love life.

To get the most out of your Chicago pizza experience you must remember one thing, even though it seems to go against common sense: avoid, repeat, avoid the "famous," "original," large pizza places downtown whose names you've heard of. They cater to tourists who don't know what real Chicago pizza tastes like, and thus can get away with cheap cheese, watered-down sauces, and skimpy crusts. Worse yet, they overcharge and make you wait.

For the best pizzas, you've got to explore, ask locals, and move out of the immediate downtown hub. To get you started, here are some of the local, lesser-known favorites:

Carmen's Chicago Pizza
Carmen's has perhaps found the golden ratio of cheese, sauce and crust and their fresh toppings make each pie a work of art. Baby-sized pizzas are perfect size for anybody who wants more than a slice but doesn't have time to sit around and digest. (*Edgewater: 6568 N. Sheridan Rd., Chicago 60626, (773) 465-1700 or Evanston: 1014 Church Street, 60201, (847) 328-0031*)

Edwardos Natural Pizza
While not as famous as its downtown counterparts, many Chicagoans swear by Edwardos as the best stuffed pizza in town. The spinach and garlic earns its reputation as an Edwardo's favorite with a spicy garlic kick. (*Hyde Park:1321 E. 57th St., Chicago 60637, (773) 241-7960, Printer's Row: 521 S. Dearborn St., Chicago 60605, (312) 939-3366, Old Town: 1212 N. Dearborn St., Chicago 60610, (312) 337-4490, or Lincoln Park: 2662 N. Halsted St., Chicago 60614, (773) 871-3400 (carry-out only), suburban locations as well*)

Lou Malnati's Pizzeria
Lou's is gradually becoming one of the more famed pizzerias in Chicago, but it still serves up fresh-ingredient pies with a signature yellow, buttery crust. The vegetarian-friendly "Lou" and the sausage pizzas always please. (*Little Village: 3859 W. Ogden Ave., Chicago 60623, (773) 762-0800, River North: 439 N. Wells St., Chicago 60610, (312) 828-9800, or Lincoln Park: 958 W. Wrightwood Ave., Chicago 60614, (773) 832-4030, suburban locations as well*)

Connie's Pizza
The pizza of choice for many of the arenas in Chicago, Connie's is loved by sports fans and Southsiders, so you know it passes the test of the critical pizza eater. It comes piled high with toppings and gooey cheese, so be sure to come hungry. (*South Loop: 2373 S. Archer Ave., Chicago 60616, (312) 808-0289*)

D'Agostino Pizzeria

For those who like their pizza experience no-frills, D'Agostino's is a homey neighborhood joint (resolutely non-yuppie) with a popular, half-price special on their hot, sweet-sauced, large pizza on Wednesday nights. (*Wrigleyville: 1351 W Addison St., Chicago 60613, (773) 477-1821, or River West: 752 N. Ogden, Chicago 60622, (312) 850-3247*)

Bacino's

At Bacino's it's the crust and the cheese, and lots of it. Of course, if you're conscious about your figure, go with their heart-healthy, light on the cheese, heavy on the veggies pizza. But if you want the real thing, well, then get the real thing! (*Loop: 75 E. Wacker Dr., Chicago 60601, (312) 263-0070, Loop: 118 S. Clinton St., Chicago 60661, (312) 876-1188, or Lincoln Park: 2204 N. Lincoln Ave., Chicago 60614, (773) 472-7400*)

—Claire Zulkey

Twisted Spoke

Can't afford the bike but you've got the Harley shirt and like hummus?

$$$

501 N. Ogden Ave., Chicago 60622
(at Grand Ave.)
Phone (312) 666-1500
www.twistedspoke.com

CATEGORY	Biker bar that's touted for their Sunday brunch.
HOURS	Mon-Fri: 11 AM–2 AM Sat: 9 AM-3 AM Sun: 9 AM-2 AM
GETTING THERE	At best, you'll find street parking just steps from the building. At worst, you'll either have to drive around for 20 minutes to still get pretty good parking, or you'll have to park further away and walk. You could also take the 65 Grand bus.
PAYMENT	VISA MasterCard AMERICAN EXPRESS
POPULAR DISH	Sandwiches are the food of choice (though frankly, there's not too much more offered on this limited menu).
UNIQUE DISH	Sloppy Joe. Besides mom's kitchen, where else can you get one of these?!
DRINKS	They swear by their Bloody Mary's (served with a shot of beer). They add slices of salami on a stick to them…seems like it's about a 1/4 pound of meat. Others seem to like it. But, you gotta love a place with Jim Beam on tap!
SEATING	This is an average sized place. The dining area is surrounded by windows, so everyone's got a good view, especially if you're one of the lucky ones to get a picnic table on the rooftop!
AMBIENCE/CLIENTELE	Some call this a yuppie biker hangout, though you'll definitely see more yuppies than bikers. In fact, you'll probably see more kids than bikers at Sunday brunch. Since it does tout itself as a biker-themed restaurant, you can pretty much wear whatever you

want. That said, you'll still see more "Old Navy" than "Harley-Davidson" gear.

EXTRAS/NOTES Well, Smut N' Eggs… They ACTUALLY show X-rated films while you eat off of their brunch menu. Though, this is not during your regular "brunch" hours. Smut N' Eggs is after midnight on Saturdays.

OTHER ONES • Lakeview: 3369 N. Clark St., Chicago 60613, (773) 525-5300

—*Marcy Wrzesinski*

PRINTER'S ROW

Edwardo's Natural Pizza Restaurant

(see page p. 160)
Pizza
521 S. Dearborn St., Chicago 60605
Phone (312) 939-3366

Hackney's

You'll feel like a regular on your first visit!
Since 1939
$$$
733 S. Dearborn St., Chicago 60605
(north of Polk St.)
Phone (312) 461-1116 • Fax (312) 461 1117
www.hackneysprintersrow.net

CATEGORY	Heinz 57/Historic
HOURS	Mon: 10:30 AM–11 PM
	Tues-Thurs: 10:30 AM–midnight
	Fri: 10:30 AM–1:30 AM
	Sat: 8 AM–1 AM
	Sun: 8 AM –11 PM
GETTING THERE	Street parking; Red line, Harrison stop; #22, 24, 36, and 62 busses
PAYMENT	VISA MasterCard AMERICAN EXPRESS DISCOVER
POPULAR FOOD	The award winning and locally revered Hackney Burger, Signature Onion Loaf, extensive menu of burgers, sandwiches, salads, and great daily specials)
DRINKS	Prohibition-style brew-kettle Sprecher Root Beer, Green River local lime soda, soft drinks, coffee, and a full bar with a good selection of European and local beers on tap (Stiegl Pils, Hofbräuhaus, Tucher Hefe Weiss, Old Speckled Hen, Goose Island Honker's Ale, and more).
SEATING	About 90 year-round, with outdoor seating for 40 in the summertime
AMBIENCE/CLIENTELE	The crowds at this Irish pub is mostly the after-work set looking for a hearty meal and a good conversation.
EXTRAS/NOTES	Hackney's Restaurants are family-owned and operated (check the history on the web site) with an

easy-going manner and welcoming smile. Delivery is available within a limited area. Check the website for daily specials!

OTHER ONES
- Glenview: 1514 E. Lake Ave., Glenview 60025, (847) 724-7171
- Glenview: 1241 Harms Rd., Glenview 60025, (847) 724-5577
- Lake Zurich: 880 N. Old Ranch Rd. Lake Zurich, 60047, (847) 438-2103
- Wheeling: 241 S. Milwaukee Ave., Wheeling 60090, (847) 537-2100
- Palos Park: 12300 S. La Grange Rd., Palos Park 60464, (708) 448-8300

—Lisa Dumic

Standing Room Only

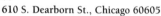

For the sports fan with a discriminating palate.
$$

610 S. Dearborn St., Chicago 60605
(south of Harrison St.)
Phone (312) 360-1776 • Fax (312) 360-0045

CATEGORY	Burger Joint/Heinz 57
HOURS	Mon–Fri: 11 AM–9 PM Sat: 11:30 AM–8 PM
GETTING THERE	Metered street parking, Red line, Harrison stop, or #22, 24, 36, and 62 busses
PAYMENT	Cash only
POPULAR FOOD	Awesome turkey burgers, Cajun chicken sandwich, 1/3 lb. burgers, and onion rings
UNIQUE FOOD	Veggie kebobs on a bed of rice, tuna steak salad, falafel, and hummus
DRINKS	Specialty sodas and bottled juices
SEATING	Plenty of room for 60 or so indoors; in warm weather the outdoor patio seats another 50 people
AMBIENCE/CLIENTELE	Largely male clientele; mid-level corporate types, teachers and administrators from nearby colleges and public schools
EXTRAS/NOTES	Democracy reigns at SRO, since all customers must place their orders with the "referees" and pay before their food is served up. Chances are you may be pushing past a local celebrity on your way to the front of the line. Catering available.

—Victoria Cunha

"Almost every person has something secret he likes to eat."
—M.F.K. Fisher

Trattoria Caterina

Cozy, inviting restaurant serving generous portions of Italian favorites.

$$$

616 S. Dearborn St., Chicago 60605
(south of Harrison St.)
Phone (312) 939-7606 • Fax (312) 939-7281

CATEGORY	Italian
HOURS	Mon–Thurs: 11 AM–9 PM
	Fri: 11 AM–10 PM
	Sat: 5 PM–9 PM
GETTING THERE	Metered street parking, Red line, Harrison stop, or #22, 24, 36, and 62 busses
PAYMENT	VISA MasterCard AMERICAN EXPRESS DISCOVER
POPULAR FOOD	Lasagna rolls, ziti broccoli and carrots, chicken Vesuvio, portobello ravioli
DRINKS	BYOB
SEATING	Fifty inside, 32 additional seats outdoors in summer
AMBIENCE/CLIENTELE	This family friendly restaurant has a comfortable and welcoming neighborhood atmosphere and the noise level makes conversation easy.

—Heidi Barker

RIP
The Berghoff Restaurant
Downtown

A Chicago institution as revered by some as much as the Cubbies or the red hot, The Berghoff finally put up its last closed sign after 107 years in business. What started as Chicago's first brewpub is now history, but if you live in the Chicago area, you can still buy bottled Berghoff beer and their very popular root beer at select retail locations.

Originally a brewer, founder Herman Berghoff introduced his wares at the Chicago World's Fair of 1893 and then set up shop on State and Adam streets, where he became the proud recipient of Chicago Liquor License #1. Over the years, The Berghoff became a full-service restaurant—and a Chicago tradition—serving hearty American far alongside traditional German fare. Family run until the very last day, local businesspersons dined alongside reminiscing seniors, Loop employees, students, and visiting tourists who were often encouraged to "try the creamed spinach," or "get the wiener schnitzel." Decades-long employees kept the pace professional, and the 4 floors of table space was rarely empty, as diners piled in to the slice of old Chicago, replete with hand-painted murals, stained glass, and an amazing array of photographs from "back when."

The Berghoff Café at O'Hare will remain operational, but the closing of its landmark location chips away a little bit more of the city's heart. After a century, we thought they'd be around forever.

—Astrid Frank

Want Fish with your Chips?
A Guide to Making the
Riverboat Casinos Work for You

Let's face it—nothing works up an appetite like a couple hours of hard labor pulling the handle of a slot machine. Whatever your poison, there's only one thing high rollers like almost as much as gambling…and that's eating.

The good news is that, thanks to riverboat gaming, Chicagoland is overflowing with places to gamble; and since the casino operators want you to stay one you're at the tables, each of the local "boats" has a host of eateries to satisfy each and every palette. The even better news is that, if you're willing to lay enough money on the line, the casinos will comp your meals at any of the restaurants they have to offer—so even if luck hasn't been a lady tonight, at least you won't go home hungry!

The down side to this whole equation is that you've got to gamble to earn those "comp dollars". Casinos calculate the amount of comps they'll let you spend based on a small percentage of the total amount of money you bet (win or lose). So, if you're playing $5 a hand at blackjack and the tables pace at three hands a minute, the casino calculates your total bet at $900 per hour. Win or lose, you eat free—yet we all know whose pocketbook the odds really favor: the casino owner's.

Trump Casino

> *Buffington Station, Gary, IN 46406, (219) 977-7000.*
> *www.trumpindiana.com*
> • *Top Deck Deli: "Best Bet" is the Italian Cold Cut Sandwich—*
> *average $$ spent gambling (i.e. lost, unless you're lucky)*
> *required: $134.*
> • *Skyline Buffet: "Best Bet" is the Adult Buffet Pass—*
> *average $$ loss required: $181*

Majestic Star Casino

> *Buffington Station, Gary, IN 46406, (219) 977-7700.*
> *www.majesticstar.com*
> • *The Snackery: "Best Bet" is the Double Fudge Brownie—*
> *average $$ loss required: $52*
> • *Miller Pizza Co.: "Best Bet" is the Supreme Pizza Slice—*
> *average $$ loss required: $98*

Harrah's

> *777 Harrahs Blvd., East Chicago, IN 46312, (219) 378-3000.*
> *www.harrahs.com*
> • *Club Cappuccino: "Best Bet" is the Mocha Freeze—average*
> *$$ loss required: $60*
> • *Winning Streaks Café: "Best Bet" is the Bacon*
> *Cheeseburger—average $$ loss required: $147*

Horseshoe Casino

> *777 Casino Center Dr., Hammond, IN 46320, (866) 711-*
> *SHOE or (219) 473-7000. www.horseshoe.com*
> • *Lake Michigan Deli: "Best Bet" is the Hot Dog—average $$*
> *loss required: $103*
> • *Village Square Buffet: "Best Bet" is the Buffet Pass—average*
> *$$ loss required: $200*

Grand Victoria Casino

> *250 S. Grove Ave., Elgin 60120, (847) 468-7000.*
> *www.grandvictoria-elgin.com*
> • *Buckingham's Steakhouse: "Best Bet" is the Six Course*
> *Gourmet Chef's Menu—average $$ loss required: $2,910.*

—Hunter Arnold

NORTH SIDE

Aladdin Falafel House

Generous portions, generous proprietor.
$$

2269 N. Lincoln Ave., Chicago 60614
(south of Belden Ave.)
Phone (773) 871-7327 • Fax (773) 871-1314

CATEGORY	Mediterranean
HOURS	Mon–Sat: 11 AM–10 PM Sun: 11 AM–9 PM
GETTING THERE	Drive around long enough, you'll find a metered spot. Also brown, purple, and red lines, Fullerton stop, #11 bus.
PAYMENT	VISA MasterCard AMERICAN EXPRESS DISCOVER
POPULAR DISH	Falafel, meat, and seafood pitas, traditional salads and appetizers
UNIQUE DISH	Syria Dish—a layered casserole featuring ground lamb and beef, eggplant, yogurt, and tomato sauce.
DRINKS	Sodas, juices, coffee, and tea
SEATING	Two rooms, each with about seven tables
AMBIENCE/CLIENTELE	They just moved into a much larger, fancier place that has tiled walls and floors, bay windows, rugs and pictures on the walls, and a great, beveled tin ceiling. Soft Arabic music punctuates your meal, making this the kind of place you could stay in for a long time.
EXTRAS/NOTES	Don't be surprised if, once you've established yourself as a return customer, you start getting little extras with your meal. A dish of hummus here, a square of baklava there. The owner is extremely friendly. His repeated greetings and well-wishes ring out every time someone enters or leaves.

—*Sarah Eaton*

Asiana

Ly and friends have an enviable talent for spicy, fresh fare.
$$

2546 N. Clark St., Chicago 60614
(north of Deming Pl.)
Phone (773) 296-9189

CATEGORY	Vietnamese
HOURS	Tues–Sun: 11:30 AM–9:30 PM
GETTING THERE	Metered street parking or #22, 36 busses
PAYMENT	VISA MasterCard AMERICAN EXPRESS DISCOVER
POPULAR DISH	Check out the $4.75 lunch specials, which include egg rolls and soup, Asiana Chicken Salad, Spicy Noodle Soup, and fried bananas.
UNIQUE DISH	Vietnamese crepes, roasted quail, eggplant, or catfish in a hot pot
DRINKS	Tropical fruit drinks, Vietnamese-style coffee, Jasmine tea, and soft drinks

SEATING	Twelve small tables
AMBIENCE/CLIENTELE	Neighborhood regulars keep coming back for the fresh food and uplifting service.
EXTRAS/NOTES	Delivery is available, with a $10 minimum, but come in for the lunch special—they won't deliver that delicious soup!

—Leah Moyers

Athenian Room

Lincoln Park's neighborhood Greek restaurant—always a homecoming
$$

807 W. Webster Ave., Chicago 60614
(just West of Halsted St.)
Phone (773) 348-5155

CATEGORY	Greek
HOURS	Mon–Sat: 11 AM–10 PM
	Sun: 11 AM–9 PM
GETTING THERE	Valet or street parking, Brown, purple, and red lines, Fullerton stop, or #8 bus
PAYMENT	VISA MasterCard Their menu says they accept gold coins, too!
POPULAR DISH	Chicken Kalamata Style, Gyros
UNIQUE DISH	Skirt Steak Alexandros Style
DRINKS	BYOB—bar next door offers drinks for diners.
SEATING	Accomodates 68 comfortably plus outdoor dining for 48 from April 1st through October 31st, weather permitting.
AMBIENCE/CLIENTELE	Watch the neighborhood go by. This place is child friendly.
EXTRAS/NOTES	In 30 years, nothing has changed—the food still makes you salivate!

—Tal Litvin

Burgundy Inn

*1960s dive bar touts juicy chops and
seasoned locals.*
Since 1965
$$$

2706 N. Ashland Ave., Chicago 60614
(at Diversey Pkwy.)
Phone: (773) 327-0303
www.burgundy-inn.com

CATEGORY	Hole in the wall, serving dinner only
HOURS	Mon–Sat: 4:30 PM-11 PM
GETTING THERE	Metered and street parking is very easy to find.
PAYMENT	VISA MasterCard AMERICAN EXPRESS DISCOVER
POPULAR DISH	Juicy broiled thick-cut pork chops, served with soft, homemade bread and a crisp house salad. All salad dressings are made from scratch and the ranch is especially delicious. Even the baked potatoes are cooked to perfection. Tender baby back ribs served with homemade BBQ sauce. Crab legs, drenched in loads of butter.

UNIQUE DISH	Smoked Duck, which is cooked for five hours in a smoker bought specifically for the duck preparation. It's then finished off in the oven and served with a tart plum sauce. Everyone who tries it claims that it's "the BEST duck they have ever tasted."
DRINKS	Full bar, carafes of wine, cheap cocktails
SEATING	Eleven tables, seats about 60
AMBIENCE/CLIENTELE	Mixed with dapper, no-nonsense oldies and young, up-and-coming, jeans-wearing regulars, the tavern like atmosphere makes for an awesome first date. The charm behind the staff and the low lighting are key in making everyone who happens through the door feel welcome and the scent of charred meat resonates throughout the joint. The best place to park for the evening is in one of the booths up front; these seats are quite coveted though, so come early, sip slowly and try not to loiter. With food like this, it's pretty damn standard.
EXTRAS/NOTES	Regulars and first timers take advantage of weekly coupons offering a buy one get one free entrée (up to $12.95). You can download them off their website and use them every Monday or Tuesday, to your hearts content (or just grab a few off your table, they're all over the place). They also have a little postcard on every table that you can fill out and mail in, so come birthday time next year, they send you a coupon for a free carafe of wine or a free dessert.

—*Misty Tosh*

Dee's

Traditional Chinese food elevated to a higher level.
$$$$
1114 W. Armitage Ave., Chicago 60614
(west of N. Seminary St.)
Phone (773) 477-1500
www.deesrestaurant.com

CATEGORY	Mandarin/Szechuan Chinese
HOURS	Mon–Thurs: 4:30 PM–10:30 PM
	Fri–Sat: 5 PM–11:30 PM
	Sun: 4:30 PM–10 PM
GETTING THERE	Valet, limited street parking or #73 bus
PAYMENT	VISA MasterCard AMERICAN EXPRESS
POPULAR DISH	Mongolian beef, fried rice, and crab rangoon, General Tso's Chicken
UNIQUE DISH	Kung pao whole Fish; Lucky Shrimp Family
DRINKS	Full bar
SEATING	Room for 150
AMBIENCE/CLIENTELE	Caters to a neighborhood crowd, yet much more upscale than your typical Chinese restaurant.
EXTRAS/NOTES	Stick with noodle and rice dishes to save money. If you can't make it to dine in, take-out and delivery are exceptional, especially on a cold winter's night.

—*Jennifer Chan*

Demon Dogs
Hot dog hot-spot for DePaul students on a budget.
$
944 W. Fullerton Pkwy., Chicago 60614
(at N. Sheffield Ave.)
Phone (773) 281-2001 • Fax (773) 281-2244

CATEGORY	Hot Dog Stand
HOURS	Mon–Fri: 6 AM–10 PM
	Sat/Sun: 10 AM–8 PM
GETTING THERE	Plenty of parking in the lot or take Brown, purple, and red lines, Fullerton stop, or #74 bus
PAYMENT	Cash only
POPULAR DISH	Hot dogs and milk shakes
DRINKS	Sodas and shakes
SEATING	Small seating area can fit up to 22, but it gets crowded.
AMBIENCE/CLIENTELE	Mostly frequented by high school and college students.
EXTRAS/NOTES	Owned by the manager of the '80s group Chicago, so it's full of Rock memorabilia. Lots of sports stuff, too, though I'm not sure how that fits in… Named for the DePaul University Blue Demons.

—Hunter Arnold

Essence of India
Not Devon Ave., but a serviceable addition to Lincoln Square.
$$$
4601 N. Lincoln Ave. Chicago 60625
(at W. Wilson Ave.)
Phone (773) 506-0002

CATEGORY	Family- friendly Indian
HOURS	Sun-Thurs: 5 PM-10:30 PM
	Fri/Sat: noon-2:30 PM; 5 PM-9:30 PM
GETTING THERE	Fairly easy to find street parking, less so on the weekend. Close to CTA Brown line.
PAYMENT	
POPULAR DISH	Tandoori Chicken
UNIQUE DISH	Naan stuffed with cottage cheese
DRINKS	BYOB
SEATING	Seating for about 30. Good for couples and small groups (up to five).
AMBIENCE/CLIENTELE	A taste of Devon Ave. Family friendly, attractive location for dates or a group of friends.
EXTRAS/NOTES	The Lincoln Square area was long in need of a decent spot for Indian food, and while some purists may scoff, Essence of India will fit the bill for most. As the area increasingly becomes a home for trendy-hip restaurant choice, Essence of India remains understated, homey and authentic. If you're looking for cheap Indian, look elsewhere, at an average $10 to $12, the entrees are a bit on the pricey side, but worth it.

—Keidra Chaney

Fattoush Restaurant (Lebanese Cuisine)

It's as fun to eat as it is to say.

$$$

2652 N. Halsted St., Chicago 60614

(at Diversey Pkwy.,)

www.fattoushrestaurant.com

CATEGORY	Neighborhood eatery.
HOURS	Mon-Thurs: 11 AM-10 PM Fri-Sat: 11 AM-11 PM Sun: 11 AM-9 PM
GETTING THERE	okay street parking
PAYMENT	VISA MasterCard AMERICAN EXPRESS
POPULAR DISH	Lunch special—veggie lentil soup + any sandwich for $6.50. Beef shawarma sandwich, and the hummus is incredible! Fattoush, the dish the restaurant is named after—"The King of Salads"—is lettuce, tomatoes, cucumbers, parsley, mint, green onions, green peppers, radish, garlic, sumac spice, virgin olive oil, and fresh lemon juice topped with toasted pita chips.
UNIQUE DISH	All vegetarian options are great. If you're a strict meat eater, try the kibbeh. (Cracked wheat and meat stuffed with a mixture of ground beef and onions, served with lettuce, tomatoes, cucumbers, pickles, a side of yogurt, and pita bread).
DRINKS	BYOB and Lebanese coffee—like an espresso mixed with cardamom
SEATING	Small and cozy with ten or so tables. This place is for groups of two to four.
AMBIENCE/CLIENTELE	Fattoush epitomizes casual dining. It's the kind of place where if tahini squeezes out of your pita and onto your hand, there's no shame in licking it off. The air smells like garlic, mint, and a complex mixture of other spices you can't quite name. People wear everything – there are businessmen on their lunch break wearing suits at tables next to students with backpacks next to soccer moms on their way home from the gym wearing workout clothes and sneakers.
EXTRAS/NOTES	Fattoush is perfect for two occasions. The first is a night when you and your significant other want to grab a bottle of wine and go out for some flavorful food … but you don't want to change your clothes or do your hair and makeup. You want to have a wide variety of menu options to choose from, but you don't want to play the "see and be seen" game. The other occasion is when you just can't handle another Potbelly's sandwich for lunch. The Fattoush lunch special is there to answer your prayers.

—*Michelle Hempel*

Frances' Restaurant & Deli

"Better than Good"— it even says so on the menu!
Since 1938
$$$
2552 N. Clark St., Chicago 60614
(north of W. Deming Pl.)
Phone (773) 248-4580

CATEGORY	Comfort Food/Deli
HOURS	Mon: 9:30 AM–3 PM
	Tues–Fri: 9 AM–9 PM
	Sat/Sun: 8 AM–9 PM
GETTING THERE	Metered street parking or #22 bus.
PAYMENT	VISA MasterCard AMERICAN EXPRESS
POPULAR DISH	Boneless chicken and roast turkey sandwich
UNIQUE DISH	Breakfast—omelette, pancakes etc.
DRINKS	Beer, soda, juice
SEATING	Around 100 seats, all tables and booths.
AMBIENCE/CLIENTELE	Casual atmosphere. Patrons are mostly young professionals from the neighborhood.

—Beth Kohl

Half Shell

Great seafood in a dive bar ... Chicago's a
strange place.
Since 1968
$$$
676 W. Diversey Pkwy., Chicago 60614
(at N. Clark St.)
Phone (773) 549-1773

CATEGORY	Hole in the wall
HOURS	Mon-Sat: 11:30 AM-11 PM
	Sun: noon-11 PM
GETTING THERE	Hard to find metered parking.
PAYMENT	Cash only
POPULAR DISH	Blue Point oysters, lake perch, and king crab legs
UNIQUE DISH	Frog legs
DRINKS	They have a full bar, but don't order any frou-frou drinks. This is beer country.
SEATING	Cozy is one word for this place. Tiny is another. It's a garden-level bar with a low ceiling and only a dozen tables. There are probably another dozen seats at the bar.
AMBIENCE/CLIENTELE	When you're inside Half Shell, you no longer feel like you're in the city of Chicago. With its basement darkness, year-round multi-colored Christmas lights and the smell of fried fish in the air, you could be in any one of a hundred small-town Midwestern bars. No-frills is the name of the game; the guy behind the bar takes your name and your beer order. When they can seat you—and you will wait if it's a weekend. Chicagoans know a terrific deal on seafood when they see it—the bartender will gesture

at the table that you're assigned. The baskets of fish and fries are crisp and greasy, and a cold Bud Light washes everything down clean.

EXTRAS/NOTES The outdoor seating in the summer is pretty fantastic—the seats are right on busy Diversey, so there is a ton of good people watching. Just order oysters and beer and watch the people go by. Half shell has luncheon specials everyday from 11:30 AM–4:30 PM. Enjoy seven different specials all priced from $5.40-$6.95.

—*Michelle Hempel*

Jaimito's Burritos

A small Mexican joint that produces amazingly fresh and filling fare.

$

1781 N. Clybourn Ave., Chicago 60614
(at Sheffield Ave.)
Phone (312) 397-9009 • Fax (312) 397-9010

CATEGORY	Taquería
HOURS	Sun/Mon: 10 AM–10 PM
	Tues: 10:30 AM–midnight
	Wed/Thurs: 10:30 AM–4 AM
	Fri/Sat: 10:30 AM–5 AM
GETTING THERE	Street parking, Red line, North/Clybourn stop, or #73 bus
PAYMENT	Cash only
POPULAR DISH	Burritos, tacos, etc.
UNIQUE DISH	Anything with Chorizo or Al Pastor
DRINKS	Sodas and great horchata
SEATING	Tables to seat 20-30 people
AMBIENCE/CLIENTELE	This excellent taco joint caters to working-class and late-night denizens.
EXTRAS/NOTES	This late-night slinger of cilantro-spiced steak, chicken, and chorizo satiates the quick bite appetite. While not spacious, the counters make for a great people-watching while scarfing down your food.

—*Richard T. Rainey*

Mayan Palace

Half-priced margarita pitchers. Need we say more?

$$$

2703 N. Halsted St., Chicago 60614-1413
(at Diversey Pkwy.,)
Phone (773) 935-4200 • Fax (773) 935-0664
www.themayanpalace.com

CATEGORY	Neighborhood Mexican
HOURS	Mon-Fri: 11 AM-11 PM
	Sat-Sun: 11 AM-midnight
GETTING THERE	Street parking is OK
PAYMENT	VISA MasterCard AMERICAN EXPRESS DISCOVER
POPULAR DISH	Any enchilada dish—and they have several! steak Fajitas—the meat is always tender, and it's served

with green peppers, red onions, and guacamole. You can have corn or flour tortillas, and your plate comes with enough rice and beans for the whole table.

DRINKS Full bar, but you should skip straight to the margaritas. They have many flavors (strawberry, raspberry, peach, mango, apricot, and tamarind) for you to sample, but if you're feeling basic, the plain margaritas on the rocks with salt are among the best in Chicago.

SEATING Get ready to get cozy! Mayan Palace only has about ten to twelve tables and a few stools at the bar.

AMBIENCE/CLIENTELE Mayan Palace can be a raucous place, probably due to the Tuesday/Thursday night half priced margaritas special, and the groups of 20- and 30-somethings that consume them. The staff rushes continually to and fro, but they never get an order wrong or forget to say "OK sweetie, what are you having tonight?" Walking in, the smells of hamburger, tortillas, and spice makes your mouth immediately water. The chips are warm, and the salsa makes your tongue tingle. The clientele is very diverse. Early in the evening, you can see families with noisy kids taking advantage of the values and big portion sizes. Later, groups of young Lincoln Parkers gather around platters of steaming enchiladas and pitchers of margaritas and chatter away.

EXTRAS/NOTES One more reason Mayan Palace has the best pitchers of margaritas in town … they don't put ice in the pitchers. The only ice is found in the individual glasses, and they are happy to replenish those. This way, the margarita mixture does not get watered down in the pitcher, and your last drink tastes as delicious as your first!

—*Michelle Hempel*

My Pie Pizzeria

A seventies-style pizza place that draws locals and suburbanites alike.

$$

2417 N. Clark St., Chicago 60614
(north of Fullerton Pkwy.)
Phone (773) 929-3380 • Fax (773) 929-0565

CATEGORY Pizza

HOURS Mon–Thurs: 4 PM–10 PM
Fri/Sat: 11 AM–midnight
Sun: noon–10 PM

GETTING THERE Lot at 2515 N. Clark—$3 with validation, Brown, purple, and red lines, Fullerton stop, or #22 and 36 busses

PAYMENT 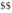 VISA MasterCard AMERICAN EXPRESS DISCOVER

POPULAR DISH Deep dish pizza

UNIQUE DISH Stuffed Spinach Soufflé

DRINKS Beer, wine, some liquor, and sodas

SEATING Tables and booths to seat 173 customers

AMBIENCE/CLIENTELE Warm, cozy, and casual atmosphere with mixed clientele—DePaul students, neighbors, and suburbanites.

EXTRAS/NOTES	My Pie has been in the same location since 1974, and the seventies décor still reigns!
OTHER ONES	• Bucktown: 2010 N. Damen Ave., Chicago 60647, (773) 394-6904

—Beth Kohl

The Original Mitchell's

Old school diner short on frills, long on good, cheap food.
Since 1950
$$
1953 N. Clybourn Ave., Chicago 60614
(south of W. Cortland St.)
Phone (773) 883-1157 • Fax (773) 883-1066

CATEGORY	Diner
HOURS	Daily: 6 AM–midnight
GETTING THERE	Free parking lot or #73 bus.
PAYMENT	
POPULAR DISH	Club sandwiches, Omelets—including the Greek Spinach Pie Omelet—daily Blue Plate Specials.
UNIQUE DISH	Crisper Sandwiches—eight inch long French roll served open-faced and stuffed with onions, green peppers, tomatoes, and choice of cheeses.
DRINKS	Usual suspects of the non-alcoholic variety.
SEATING	30 booths and 10 tables, plus 10 counter spots.
AMBIENCE/CLIENTELE	Typical diner décor and waitresses who seem to have been waiting tables since the 1950s. Weekend hangover crowd and night owls.
EXTRAS/NOTES	Prior to opening the restaurants, the Mitchell family owned the famous Buffalo Ice Cream Parlor at Irving and Pulaski.
OTHER ONES	• Old Town: 101 W. North Ave., Chicago 60610, (312) 642-5246

—Jennifer Chan

The Pasta Bowl

A solid choice for traditional and healthful adaptations of the classics.
$$
2434 N. Clark St., Chicago 60614
(north of Fullerton Pkwy.)
Phone (773) 525-BOWL (2695) • Fax (773) 935-BOWL

CATEGORY	Italian-General
HOURS	Daily: 11 AM–11 PM
GETTING THERE	Street parking, Brown, purple, and red lines, Fullerton stop, or take #22 and 37 busses.
PAYMENT	Cash only
POPULAR DISH	Farfalle Pollo
UNIQUE DISH	Nightly specials, weekend fresh seafood special; plus, all pastas/toppings are swap-able.
DRINKS	Wine and beer, San Pellegrino water, sodas.
SEATING	Tall bar tables, seating 35-40 people.
AMBIENCE/CLIENTELE	No frills, but nice; gets packed with young professionals after work.

EXTRAS/NOTES	Daily lunch special (take-out and delivery only) of selected pasta items, plus soft drink for $5.
OTHER ONES	• Catering trucks around town.

—Beth Kohl

Pequod's Pizza

Pan pizza so good it's like eating dessert!
$$

2207 N. Clybourn Ave., Chicago 60614
(just north of Webster Ave.)
Phone (773) 327-1512 • Fax (773) 327-4294

CATEGORY	Pizza
HOURS	Mon–Fri: 11 AM–2 AM
	Sat: noon–2 AM
	Sun: noon–midnight
GETTING THERE	Street parking if you're lucky otherwise pay lot at Webster Place, or #73 bus
PAYMENT	VISA · MasterCard · American Express · Discover
POPULAR DISH	Pan pizza (caramelized cheese-stuffed)
UNIQUE DISH	No, really, pan pizza (they caramelize the edges with cheese).
DRINKS	Wine, beer, liquor, sodas, juice
SEATING	23 tables, plus bar seating to accommodate a total of 70.
AMBIENCE/CLIENTELE	A neighborhood place with many regulars and a mix of movie patrons (across the street from Webster Place movie theater).
EXTRAS/NOTES	A hockey bar—in other words, they show NHL games. Party room for rent upstairs, holds 60 people. Delivery available.
OTHER ONES	• Morton Grove: 8520 Fernald Ave., Morton Grove 60053, (847) 470-9161

—Beth Kohl

Potbelly Sandwich Works

Chicago bellies can't get enough of these made-to-order sandwiches.
$

1422 W. Webster Ave., Chicago 60614
(just east of Clybourn Ave.)
Phone (773) 755-1234 • Fax (773) 755-4270
www.potbelly.com

CATEGORY	Sub shop
HOURS	Daily: 11 AM–11 PM
GETTING THERE	Free parking lot—access from Janssen Ave. via Belden Ave. or take the #73 bus.
PAYMENT	VISA · MasterCard · American Express · Discover
POPULAR DISH	Hot, made-to-order sandwiches, triple-thick malts, milkshakes, and smoothies
UNIQUE DISH	A Wreck, which is loaded with every type of meat imaginable, Big Jack's PB&J
DRINKS	Sodas and water pulled from a refrigerator before the customer orders

SEATING	Roughly 40 spots inside, and seating for 30 at picnic tables outdoors
AMBIENCE/CLIENTELE	Charming atmosphere; they often feature live music, which can be entertaining while you wait to order.
EXTRAS/NOTES	The original location at 2264 N. Lincoln Ave. was a small antique business. The young couple that ran the store supplemented their income by selling sandwiches on the side. The business took off from there!
OTHER ONES	• Too many to list! Check website.

—Jennifer Chan

P S Bangkok Restaurant

172 different paths to Thai ecstasy.
$$

2521 N. Halsted St., Chicago 60614
(south of Lill Ave.)
Phone (773) 348-0072
www.psbangkok.com

CATEGORY	Thai
HOURS	Sun–Thurs: 10 AM–10 PM Fri/Sat: 10 AM–11:30 PM
GETTING THERE	Metered street parking, Brown and purple lines, Diversey stop, Brown, purple, and red lines, Fullerton stop, or #8 bus
PAYMENT	[VISA] [MasterCard] [AMERICAN EXPRESS] [DISCOVER]
POPULAR DISH	The "Yupi Special" is under seven bucks and uncludes an appetizer Or try one of the sixteen different curries, from Jungle to Panang.
UNIQUE DISH	Banana Blossom Salad, extensive seafood selections, Sala Cream (in red or green) to drink
DRINKS	Thai iced tea and coffee, sodas, coffee, and tea
SEATING	Plenty of seating
AMBIENCE/CLIENTELE	Check out the magical hypnotic art that requires electricity.
OTHER ONES	• Wrigleyville: 3345 N. Clark St., 60657, (773) 871-7777

—Leah Moyers

Roong Petch Thai Restaurant

(see page p. 143)
Thai
1828 W. Montrose, Chicago 60613
Phone (773) 989-0818

Royal Thai

That's what I call a power Thai!!!

$$$

2209 W. Montrose Ave., Chicago 60618
(at Lincoln Ave.)
Phone (773) 509-0007

CATEGORY	Dinner spot
HOURS	Thurs-Tues: 11:30 AM-10 PM
GETTING THERE	Street parking is not difficult.
PAYMENT	VISA
POPULAR DISH	Good Thai choices. The prawns are excellent. Try the Pad Thai.
UNIQUE DISH	Large selection of vegetarian dishes
DRINKS	BYOB
SEATING	Very small/10 tables
AMBIENCE/CLIENTELE	One of my favorite Thai restaurants in Chicago— even though there is not much to it. It is very intimate but the Royal Thai differs from other places in that it takes presentation into consideration. Not only do they do it with their food but this restaurant is very bright and clean, with excellent service. Not your typical hole in the wall Thai joint.

—Brian Diebold

Stanley's Kitchen & Tap

The quintessential Midwestern meal—just like Mom's home cooking.

$$

1970 N. Lincoln Ave., Chicago 60614
(south of Armitage Ave.)
Phone (312) 642-0007 • Fax (312) 642-0008

CATEGORY	Comfort Food
HOURS	Mon/Tues: 5 PM–11 PM Wed–Fri: 11:30 AM–11 PM Sat/Sun: 11 AM–11 PM
GETTING THERE	Limited street parking, or use #11, 22, 36, and 73 busses.
PAYMENT	VISA MasterCard AMERICAN EXPRESS
POPULAR DISH	Chicken Fried Chicken, Jerry's Pot Roast, and the weekday specials
UNIQUE DISH	Catfish and Spaghetti
DRINK	Full bar, including the American Whiskey Bar featuring over 75 different whiskeys.
SEATING	Dining room seats approximately 90 people plus twelve counter seats at the bar.
AMBIENCE/CLIENTELE	A lively crowd in the front room, likely catching a game on one of several televisions. Great jukebox tunes make Stanley's a good choice for happy hour. Quiet, family atmosphere in the dining room, with memorabilia reminiscent of a rumpus room.
EXTRAS/NOTES	The $10.95 All-You-Can-Eat Homestyle Buffet on Monday nights offers ribs, fried chicken, mashed potatoes, and banana pudding. Great home cooking at great prices!

—Carol Michael

Sweet Mandy B's

For the kid in all of us

$

1208 W. Webster Ave., Chicago 60614

(at Racine Ave.)

Phone (773) 244-1174 • Fax (773) 244-1109

CATEGORY	Charming bakery for the kid in all of us
HOURS	Sun-Thurs: 8 AM-10 PM
	Fri-Sat: 8 PM-11 PM
GETTING THERE	Street parking
PAYMENT	VISA MasterCard AMERICAN EXPRESS
POPULAR DISH	Super moist chocolate and vanilla cupcakes, with a butter cream frosting that is mind-boggling. The dense, stick-to-the-roof-of-your-mouth chocolate pudding layered with homemade whipped cream is what dreams are made of. Check out the intensely creamy, cloudlike coconut cream pie.
UNIQUE DISH	Individual cheesecakes (all with fresh berries), and literally the best cheesecake in the city
DRINKS	Lattes, cappuccinos, hot chocolate, and teas
SEATING	35
AMBIENCE/CLIENTELE	Packed with a crossbreed of Lincoln Park mommies and ravenous sweet tooth junkies, this sunny, neighborhood bakery is one of the most popular haunts in the city. The breathtaking aroma is overwhelming and inescapable, so plan on dishing out more dough than you anticipated. The intent is to purchase a simple cookie, but when it's all said and done, a cool twenty is out the door. Oh, the glory in all those cakes, cookies and cupcakes though…who cares about rent! The open kitchen, with all those cute chicks slathering creamy icing on fluffy cakes is a dreamy getaway in the midst of concrete city chaos.

—Misty Tosh

Taquería el Asadero

A gritty taco joint with excellent food.

$

2213 W. Montrose Ave., Chicago 60618

(north of Lincoln Ave.)

Phone (773) 583-5563

CATEGORY	Mexican-Taquería
HOURS	Daily: 10 AM–10 PM
GETTING THERE	Street parking or #11 and #78 busses.
PAYMENT	Cash only
POPULAR FOOD	Chicken burritos
UNIQUE FOOD	Menudo on weekends
DRINKS	Sodas, Jarritos, Sangria o Sidral, horchata
SEATING	Eight tables or so
AMBIENCE/CLIENTELE	Décor and set-up constantly in flux. TV always set to Univision. Bright orange booths are always occupied.

EXTRAS/NOTES	All the food is perfectly greasy, but go stroll around across the street at Welles Park first and you won't feel so bad for gorging yourself on a huge burrito and homemade tortilla chips.

—Sarah Eaton

Toast

Breakfast served all day for the post-Golden Nugget set

$$$

746 W. Webster Ave., Chicago 60614

(at N. Halsted St.)

Phone (773) 935-5600

CATEGORY	All-day breakfast nook for yuppies
HOURS	Mon-Fri: 8 AM-3 PM
	Sat-Sun: 8 AM-4 PM
GETTING THERE	Metered, street parking
PAYMENT	VISA MasterCard AMERICAN EXPRESS DISC●VER
POPULAR DISH	Given that the owners decided to call this place "Toast," some form of heated sliced bread must be the specialty, which brings us to the French Toast Orgy, a monster of a meal in which Mascarpone cheese, pureed strawberries, yogurt, granola, fruit, and honey are the guilty parties.
DRINKS	Coffee, tea, and citrus juices—all the accordant beverages of breakfast
SEATING	A modest amount of tables keeps the atmosphere abuzz but without echoing the cacophony of a kindergarten classroom.
AMBIENCE/CLIENTELE	On bright spring Sunday mornings, the line to enter Toast spills out the door as scores of young professionals mull about, all of them, hell bent on silencing the rumble in their stomachs.
OTHER ONES	• Bucktown: 2046 N. Damen Ave., Chicago 60647, (773) 772-5600)

—Josh Cox

Tomato Head Pizza Kitchen

A neighborhood joint with more than just great, cheap za.

$

1011 W. Webster Ave., Chicago 60614

(at Sheffield Ave.)

Phone (773) 404-8010 • Fax (773) 404-1209

www.tomatoheadpizza.com

CATEGORY	Pizza/Sandwich Shop
HOURS	Mon–Sat: 11 AM–11 PM
	Sun: noon–11 PM
GETTING THERE	Street parking, if you can find it otherwise Brown, red, and purple lines, Fullerton stop, Brown and purple lines, Armitage stop or #37 bus.
PAYMENT	VISA MasterCard AMERICAN EXPRESS
POPULAR DISH	Pizza

UNIQUE DISH	BBQ Chicken pizza or Zorba Za, with feta cheese, tomato, and kalamata olives
DRINKS	Sodas
SEATING	35-40 seats at grab-your-own tables
AMBIENCE/CLIENTELE	Neighborhood place with more than its fair share of De Paul University students.
EXTRAS/NOTES	Was Roma's Restaurant for 40 years, so the space has good karma!

—Beth Kohl

Twisted Lizard

Underground Tex-Mex haven propels tequila induced blur

$$$

1964 N. Sheffield Ave., Chicago 60614

(at Armitage Ave.)

Phone: (312) 929-1414

www.thetwistedlizard.com

CATEGORY	Mexican/Tex-Mex bar/restaurant
HOURS	(summer) Daily: 11:30 AM-10 PM (winter) Mon-Thurs: 4 PM-10 PM Fri-Sun: 11:30 AM-midnight
GETTING THERE	Street parking
PAYMENT	VISA MasterCard AMERICAN EXPRESS
POPULAR DISH	Flame grilled fajitas, with black beans and rice. They have a slightly "healthier" approach to Mexican food and the chips (which are perfect and not too thick) and salsa come out fast and furious. It's quite easy to shove down multiple baskets.
UNIQUE DISH	Baja style fish tacos—Huge hunks of perfectly fried Corona beer-battered cod, covered with crispy purple cabbage (shredded and mixed with just a touch of lettuce), and then all lightly coated in a super-spicy chipolte sour cream/mayonnaise sauce. What better mix is there than that? There was a tiny sprinkle of Anejo white cheese crumbled on top, a stack of limes and the flour tortillas so soft and chewy that when I bit into them I breathed in Mexico at the same time.
DRINKS	Full bar, with twenty different kinds of tequila…somewhat pricey for the margaritas, but half-way through a small pitcher and watch out!
SEATING	70
AMBIENCE/CLIENTELE	Slightly kitschy and definitely hard to find, the atmosphere brings to mind a beer soaked frat boy, but the health-conscious food brands the place as a reputable contender in the city's heavy Mexican restaurant scene. It's way cooler than most of the other Mexican joints, catering to the hip college crowd that populates the hood. I usually drag all my out-of-town visitors here and get them good and liquored on insanely potent margaritas, then let 'em loose on the streets of Chicago. Clean, honest fun, you know?

EXTRAS/NOTES There is nothing finer than wiling away a sunny afternoon in the outdoor cantina. Icy, cold margarita in hand, of course.

—Misty Tosh

Uncle Julio's Hacienda

Fun ambiance, good times, makes you long for a vacation in a Mexican retreat.

$$$

855 W. North Ave., Chicago 60622-2504

(at Clybourn Ave.)

Phone: (312) 266-4222 • Fax: (312)266-0805

CATEGORY	A Tex-Mex restaurant with a fun, casual atmosphere
HOURS	Sun-Thurs: 11:30 AM-10:30 PM Fri-Sat: 11:30 AM-11:30 PM
GETTING THERE:	They have valet parking for $4 (how many times have you seen valet parking that cheap in Chicago???). Street parking is a nightmare, but you can take the red line to the Clybourn stop and it is about a 1/3 block walk away from there. You could also take the 72 North Avenue bus, which stops right in front of the restaurant.
PAYMENT	VISA MasterCard AMERICAN EXPRESS DISCOVER
POPULAR DISH	This is your basic Tex-Mex restaurant, so you see a lot of people ordering tacos, burritos, or the always popular "combo" platter (may include chile relenos, enchiladas, tacos, etc…). Everyone loves their home-made chips and salsa, which they always happily refill.
UNIQUE DISH	They have this dish of grilled jumbo shrimp, stuffed with jalapeno, wrapped in bacon with some cheese melted on top. MMMM They also have the best tortilla soup. Also, don't pass up their homemade flour tortillas which you can see them making from your seat.
DRINKS	They have a full-service bar. Their specialty drink is the frozen swirl. It is a mix between sangria and a margarita. These are very refreshing and cost $7.50.
SEATING	This place is very spacious. Most of the tables are for four, but they are very accommodating to large groups.
AMBIENCE/CLIENTELE	On Friday and Saturday nights, the place fills up with twenty- to thirty-somethings looking for their next date, most of whom are there just for the drinks and chips and salsa.
EXTRAS/NOTES	Location makes it perfect for a Saturday or Sunday afternoon. You can do all of your weekend shopping at Crate and Barrell, Pottery Barn, Old Navy, Victoria's Secret….then walk over to Uncle Julio's for lunch!
OTHER ONES	• Lombard IL, Dallas TX (2 locations), Fort Worth TX, Fairfax VA, Richmond VA, Reston VA, Arlington VA, Atlanta GA, Bethesda MD, Gaithersburg MD.

—Marcy Wrzesinski

The Wiener's Circle

A neighborhood, picnic-style hot dog stand.

$

2622 N. Clark St., Chicago 60614
(north of W. Wrightwood Ave.)
Phone (773) 477-7444

CATEGORY	Hot Dog Stand/Burger Joint
HOURS	Sun–Thurs: 11 AM–4 AM
	Fri: 11 AM–5 AM
	Sat: 11 AM–6 AM
GETTING THERE	Parking lot available or take brown, purple, and red lines, Fullerton stop, #22 and 36 busses
PAYMENT	Cash only
POPULAR DISH	Hot dogs and cheese fries.
UNIQUE DISH	Chicago-style dogs—pickles, onions, peppers, and mustard
DRINKS	Sodas
SEATING	Limited counter space indoors plus four picnic tables outside
AMBIENCE/CLIENTELE	The spectrum ranges from young urban professionals to the salt of the earth.
EXTRAS/NOTES	Bring a strong ego—the fare here is served with all the mustard and superciliousness you can stomach!

—*Richard T. Rainey*

Zig Zag Kitchen
Zig through the menu, Zag out the door!

$$$

2436 N. Lincoln Ave., Chicago 60614
(at Fullerton Pkwy.)
Phone (773) 472-2222 • Fax (773) 472-7607

CATEGORY	Great take-out
HOURS:	Mon-Fri: 9 AM-11 PM
	Sat: 10 AM-11 PM
	Sun: 11 AM-11 PM
GETTING THERE:	Street parking is OK
PAYMENT	VISA MasterCard
POPULAR DISH	"Zag" veggie sandwich—hummus, provolone, cucumber, tomato and lettuce on multigrain bread. Tri-color tortellini with chicken, spinach, and pine nuts in a basil crème sauce
UNIQUE DISH	Spice basil chicken fettuccini—grilled chicken, green beans, tri-colored peppers, onions, and carrots in a spicy ginger and basil garlic sauce. Is it Thai or Italian?
DRINKS	BYOB. Sodas, iced tea, bottled water—reasonably priced.
SEATING	About fifteen tables. But this is a better place for take-out than dining in.
AMBIENCE/CLIENTELE	Zig Zag is efficient, fast, and friendly. The dining room is spacious and casual, but it's almost never full. At times it feels like an afterthought to the thriving delivery and catering business. The room's

dominant smell is of pizza and all that implies. The waiters and clientele both wear t-shirts.

EXTRAS/NOTES Zig Zag is perfect for grabbing sandwiches or pizza on the way home for lunch or dinner. It's also great for delivery when you have numerous or picky houseguests. There's something for everyone on the enormous menu. Burgers, pizza, pasta, fish, vegetarian options … if a person can't find something to order on this menu, they don't eat.

—*Michelle Hempel*

OLD TOWN

Nookie's

Comfort food for breakfast anytime.

$$

1746 N. Wells St., Chicago 60614

(north of North Ave. at St. Paul Ave.)

Phone (312) 337-2454 • Fax (773) 248-7028

CATEGORY	Heinz 57
HOURS	Mon–Sat: 6:30 AM–10 PM
	Sun: 6:30 AM–9 PM
GETTING THERE	Limited street parking; #72 bus
PAYMENT	Cash only
POPULAR FOOD	Brunch: omelettes, pancakes, waffles, crepes, and egg dishes
UNIQUE FOOD	Artichoke frittata and Jalisco breakfast wrap
DRINKS	Coffee, tea, hot chocolate, soft drinks, and fresh lemonade in the summertime
SEATING	Thirty tables, and roughly 10 counter spots
AMBIENCE/CLIENTELE	Minimal décor, but the food and service make up for it; locals, and the weekend late-morning hangover crowd
EXTRAS/NOTES	Dining on the weekend between 11:30 AM and 1:30 PM usually guarantees a wait of at least fifteen minutes to half an hour.
OTHER ONES	• Lincoln Park: 2114 N. Halsted St., Chicago 60614, (773) 327-1400 (open 24 hours Fri/Sat)
	• Boys' Town: 3334 N. Halsted St., Chicago 60657, (773) 248-9888 (open 24 hours Fri/Sat)

—*Jennifer Chan*

Old Jerusalem

Have a falafil! Have two!! Incredible Middle Eastern cuisine.

$$

1411 N. Wells St., Chicago 60610

(at W. Schiller St.)

Phone (312) 944-0459 • Fax (312) 944-3304

CATEGORY	Middle Eastern/Lebanese
HOURS	Daily: 11 AM–11 PM
GETTING THERE	Metered street parking; Red line, Division stop; #22,

	36, 70, and 156 busses will get you close enough to walk
PAYMENT	VISA · MasterCard · AMERICAN EXPRESS · DISCOVER
POPULAR FOOD	Falafel
UNIQUE FOOD	Musaheb—broiled, boneless breast of chicken marinated in olive oil, garlic, and vinegar, served with Jerusalem Salad, hummus, rice pilaf, and Lebanese bread for under $10
DRINKS	Arabic coffee, fresh carrot and apple juices, Liquid Yogurt, tea, sodas, and lemonade
SEATING	Room for 48
AMBIENCE/CLIENTELE	Cozy, comfortable, very casual ambience. The crowd changes daily
EXTRAS/NOTES	The staff is warm and friendly, and service is outstanding!

—Michelle Burton

Topo Gigio

Where a puppet is king, the food better be fantastic!

$$

1516 N. Wells St., Chicago 60610

(at North Ave.)

Phone (312)266-9355 • Fax 312-266-8531

CATEGORY	Historic, where the Italian boys go eat, lounge attached
HOURS	Mon-Sat: 11:30 AM to 11 PM Sun: 4 PM-10 PM
GETTING THERE	Valet, $8, street parking on meters difficult
PAYMENT	VISA · MasterCard · AMERICAN EXPRESS · DISCOVER
POPULAR DISH	Topo Gigio is known for their eggplant. Something about it is so good, that every dish that has eggplant in it, is highly recommended and always delicious, especially the eggplant parmesan.
UNIQUE DISH	The restaurant was named after a little mouse puppet named "Topo Gigio" who used to appear on the Ed Sullivan Show, back in the day. Unknown as to why it was named after the puppet, perhaps a childhood memory for the owner.
DRINKS	Full bar, red wines are suggested for different meals
SEATING	100 inside, 40–100 private party room upstairs, 95 seats out in garden, when open…Small, cozy, but loud and lively
AMBIENCE/CLIENTELE	Welcome to Topo Gigio, where the restaurant is famed for its friendly mouse puppet whose portrait sits atop a brick fireplace, smiling at you while you eat, and also giving the joint a famous name. Families, Saturday night dates, and groups of long-time friends; mostly older cigar-smoking men, make up the mix of clientele. Beyond the traditional Italian décor, and Italian feel of a dimly lit, cozy and romantic restaurant, there's something else that lingers in the atmosphere at Topo Gigio that equals an eclectic experience. Perhaps it's the outstanding food, which includes hearty pasta dishes, infused with eggplant (the best!), chicken and seafood.

Maybe it's the sweet and attentive waiters, who all look like Italian models, but are as nice as a Mama's boy. But I think it's the underlying sense of happiness that is contagious from table to table through smiles, strolling musicians, and the objective of all guests: to have a great time. This isn't a restaurant to rush in and out of within the hour. Everyone comes to Topo Gigio with at least two hours to spare in order to feel like a guest at an Italian family celebration.

EXTRAS/NOTES	T-shirts, sweatshirts and cigars for sale.
OTHER ONES	• Used to be located across the street, but the new location features the lovely outdoor garden seating.

—*Mindy Golub*

LAKEVIEW

Ann Sather Restaurant

Chicago's true Swedish legacy.
Since 1945
$$$

929 W. Belmont Ave., Chicago 60657
(east of Sheffield Ave.)
Phone (773) 348-2378 • Fax (773) 348-1731
www.annsather.com

CATEGORY	Swedish
HOURS	Daily: 7 AM–9 PM
GETTING THERE	Adjacent lot; Brown, purple, and red lines, Belmont stop, #8, 22, and 77 busses.
PAYMENT	VISA MasterCard AMERICAN EXPRESS
POPULAR DISH	Breakfast: Swedish pancakes, eggs benedict, omelets; Lunch: hot, open-face sandwiches; Dinner: Swedish Sampler (duck, meatball, potato sausage, sauerkraut, brown beans), Lake Superior whitefish.
UNIQUE DISH	Roast duckling, pan-fried calf's liver, potato pancakes
DRINKS	Sodas, juices, coffee, tea, beer and wine, cocktails; Swedish glogg
SEATING	Booths and tables to seat 200.
AMBIENCE/CLIENTELE	Family-oriented, gay friendly, open holidays, including Christmas day
EXTRAS/NOTES	Scrumptious bakery items (including their signature cinnamon and pecan rolls), Swedish breakfast kits (with pancake mix, lingonberry sauce, and coffee), and cookbooks (featuring recipes from the original Ann Sather herself) all available for sale. There is a private room available for parties on the second floor; and they do carry-out, delivery, and catering, too. If you miss Ann Sather, you miss an amazing part of Chicago's food history!
OTHER ONES	• Lakeview: 3416 N. Southport Ave., Chicago 60657, (773) 404-4475 • Lakeview: 3411 N. Broadway St., Chicago 60657, (773) 305-0024

• Andersonville: 5207 N. Clark St., Chicago 60640, (773) 271-6677
• Wicker Park: 1448 N. Milwaukee Ave., Chicago 60622, (773) 394-1812

—*Victoria Cunha*

Ann Sather Restaurant

(see page p. 53)
Swedish
3416 N. Southport Ave., Chicago 60657
Phone (773) 404-4475

3411 N. Broadway, Chicago 60657
Phone (773) 305-0024

A Marriage of Opposites: Chicago's Saga Launder Bar & Café

Sometimes the marriage of opposites works miracles in the culinary world. While pickles and ice cream might give anyone but pregnant woman heartburn, a restaurant serving grilled halibut with mango chutney creates an unexpected delight. The Saga Launder Bar & Café does not offer exotic dishes like fish with fruit or pickles and ice cream—instead it serves up beer and laundry detergent!

Known by locals simply as the "Launder Bar," this non-traditional establishment caters to those who don't have access to a washing machine at home and like to eat and drink inexpensively. In a working city like Chicago, where time is money and few enjoy a schedule that allows enough of it for leisure and the monotonous routines of life, the Launder Bar makes it possible to have both. Yes, the Saga is a Laundromat with an adjacent bar and café—you can wash your dirty clothes and still go out for dinner and drinks with friends. Never again will you have to choose between having clean underwear and going out for a wild night on the town!

The Launder Bar's food is decent, but with specials of $2–3 beers every night of the week, you can easily end up spending more on your laundry than you do in the bar. The menu ranges from sandwiches and salads to pasta and pizzas, with an average price of around six dollars and nothing over ten or twelve. The Wings from Hell and The Newport Burger are favorites—and go nicely with a $2 beer.

At the Saga Launder Bar & Café the pleasure of food and drink are cunningly connected to the dreaded task of doing laundry. It's quite a brilliant combination.

Lakeview: *3435 N. Southport Ave. (on the regal "Southport strip" in Lakeview) Chicago 60657, (773) 929-9274.*

—*Ondy Sweetman*

"Sex is good, but not as good as fresh sweet corn."
—*Garrison Keillor*

Bamboo Garden

Not your typical Chinese take-out!
$$$
3203 N. Clark St., Chicago 60657
(at Belmont Ave.)
Phone (773) 525-7600

CATEGORY	Chinese
HOURS	Daily: 11 AM-11 PM
GETTING THERE	Street parking
PAYMENT	VISA MasterCard AMERICAN EXPRESS DISCOVER
POPULAR DISH	Bamboo Garden Kung Pao Chicken, Pad Thai noodles, dumplings
UNIQUE DISH	Bamboo Garden serves "fine Chinese" food. This means the menu is sprinkled with the usual fare like egg rolls, fried rice, and sweet & sour chicken, as well as hors d'oeuvres and shrimp with lobster sauce
DRINKS	BYOB
SEATING	Small and cozy, seats about 25
AMBIENCE/CLIENTELE	Don't judge a book by its cover! Bamboo Garden isn't the kind of place that it resembles from the outside. Simple signage and menu taped to the window. Walk inside and feel an instant sense of calm wash over you with the beautiful bamboo screens, light wood tables, and a fresh flower on each table. The atmosphere matches the food, which the restaurant calls fine Chinese cuisine. The mood is romantic and intimate but casual. Bamboo Garden sits on the corner of a very busy intersection, so be sure to grab a table by the large window if you are a people watcher. And you are sure to see some characters on Belmont Avenue!

—Carrie Asato

Bamee Noodle Shop

We know noodles
$$
3120-3122 N. Broadway St., Chicago 60657
(at Briar Pl.)
Phone (773) 281-2641 • Fax (773) 248-8209

CATEGORY	Thai Noodle House
HOURS	Sun-Thurs: 11 AM-10 PM Fri/Sat: 11 AM-11 PM
GETTING THERE	Lot and street parking
PAYMENT	VISA MasterCard AMERICAN EXPRESS
POPULAR DISH	Satay, crab Rangoon, Pad Bamee. All kinds of noodle dishes: They offer them every way you could want them—on a plate, in a bowl, spicy, stir-fried, with seafood, and more!
DRINKS	Hot jasmine tea, coffee, soda, iced tea, Thai iced tea and coffee
SEATING	Spacious and outdoor seating available too, which is very popular and crowded in the summer.

AMBIENCE/CLIENTELE	The vibe is very casual and laid back, which even the wait staff embodies. Bamee is known for more than their noodles. Their food is classic Thai but with a fresh taste. Some dishes are spicier than advertised so be sure to ask their friendly waitstaff for advice. Outdoor seating is available in the summer months, and someone in the hoards of people that walk down Broadway St. is sure to entertain you.

—Carrie Asato

Clark St. Dog

The best damned greasy pit in town! Open late!!
$
3040 N. Clark St., Chicago 60657
(between Wellington and Barry Aves.)
Phone (773) 281-6690

CATEGORY	Hot Dogs
HOURS	Sun–Thurs: 9 AM–3 AM Fri/Sat: 9 AM–4 AM
GETTING THERE	Small lot, metered street parking, Brown line, Wellington stop, Brown and Red lines, Belmont stop, #8, 22, 36, 76, and 77 busses
PAYMENT	Cash only
POPULAR DISH	Chicago's BEST Philly Steak sandwich—onions, green peppers, mushrooms, and Swiss cheese on Clark Dogs' special Italian rolls
UNIQUE DISH	Gyros served with tsatziki sauce, tomatoes, and onions on a pita; chili tamale—mmm…mmm…good!!
DRINKS	Awesome shakes and malts—Oh, and a FULL BAR
SEATING	Room enough for 28
AMBIENCE/CLIENTELE	Definitely a late night, greasy joint. Perfect after a night of clubbing. Gay/straight, every nationality you can imagine. Very cool vibe here.
EXTRAS/NOTES	You won't find a friendlier late night crowd anywhere! Everyone's so happy after a long night of drinking and dancing…

—Michelle Burton

Duke of Perth

Show me the way to the next Whiskey bar!
$$$
2913 N. Clark St., Chicago 60657
(at Surf St.)
Phone (773) 477-1741

CATEGORY	Restaurant/Bar/Neighborhood Pub
HOURS	Mon: 5 PM-2 AM Tues-Fri: 11:30 AM-2 AM Sat: 11:30 AM-3 AM Sun: noon-2 AM
GETTING THERE	Difficult street parking
PAYMENT	

POPULAR DISH	Every Wednesday and Friday the joint is packed for the all you can eat fish and chips.
UNIQUE DISH	Don't forget to try the 1 lb. "Sean Connery" burger.
DRINKS	Full bar with 90 kinds of single malt whiskey.
SEATING	Good sized spot with many tables.
AMBIENCE/CLIENTELE	Is it a bar? Is it a restaurant? Who knows? What is known is that the Duke of Perth is as close to an authentic Scottish Pub as you will find in Chicago. With 90 different types of single-malt whiskey, even the seasoned Scotsman remembers little else after walking out of this cozy neighborhood pub. Casual and laid back, the Duke of Perth is an excellent place to hang out with family or friends.

—*Brian Diebold*

Matsu Yama

Scrumptious sushi, friendly folks, BYOB ... oh my!

$$$$

1059 W. Belmont Ave., Chicago 60657

(at N. Seminary Ave.)

Phone (773) 327-8838

CATEGORY	Friendliest sushi joint in Chicago.
HOURS:	Mon-Fri: 11 AM-2:30 PM
	Sun-Thurs: 5 PM-10 PM
	Fri-Sat: 5 PM-1 AM
GETTING THERE	Free valet
PAYMENT	VISA MasterCard
POPULAR DISH	Everything is good! But the Summer Roll, Firecracker Roll, and the Red Dragon Roll are real winners. Their salmon sushi pieces melt in your mouth.
DRINKS	Currently BYOB
SEATING	It's spacious. Table seating for about 50 people, plus ten spots at the sushi bar.
AMBIENCE/CLIENTELE	Matsu Yama has serene, light blue walls and upbeat techno music at just the right volume. The music keeps the room moving and lively, but you can speak to someone across the table without raising your voice. The staff is ridiculously friendly, and if you become a regular visitor, they'll remember what you like. The clientele used to be mainly neighborhood couples who discovered this diamond in the rough. But then Chicago magazine named it one of the best sushi places in town, so on weekends it's become a destination for sushi-lovers all over the city. On weeknights, feel free to wear your tank top and flip flops, but on weekends, wear your trendy jeans and a cute shirt—you'll feel more appropriately attired.
EXTRAS/NOTES	Matsu Yama is perfect for date night, girls night, and groups of all sizes. It's rare to leave a sushi restaurant with both your stomach and wallet full, but you can do it here. Warning – going to Matsu Yama once may be addictive. Weekly cravings for the Summer Roll and Firecracker Roll are common. Don't say I didn't warn you.

—*Michelle Hempel*

Maxwell Street Bus Stop

*Serious Polish sausages and hearty hot dogs—this stop is
truly Chicago.*

$

2805 N. Damen Ave., Chicago 60618
(at intersection of Damen, Diversey, and Clybourn Aves.)
Phone (773) 935-1256

CATEGORY	Hot Dogs/Stand
HOURS	24/7
GETTING THERE	Street parking, small lot or #50 and 76 busses
PAYMENT	Cash only
POPULAR DISH	The world famous Maxwell Street-style Polish sausage—one of Chicago's best signature sandwiches
UNIQUE DISH	Juicy pork chop sandwich—lip smackin' good
DRINKS	Soda
SEATING	No seating
AMBIENCE/CLIENTELE	Right smack in the middle of the Haves and the Have-Nots; suits on line next to baggy jeans, waiting for a taste of the best Polish Chicago has to offer
EXTRAS/NOTES	The cool thing about this place is its location. It sits in the parking lot of a convenience store in one of the most diverse neighborhoods of the city.

—*Michelle Burton*

Moti Mahal Restaurant

Classic Indian food—best in Chicago.

$$

1035 W. Belmont Ave., Chicago 60657
(west of Sheffield Ave.)
Phone (773) 348-4392 • Fax (773) 348-5241

CATEGORY	Indian
HOURS	Sun–Thurs: noon–9:30 PM Fri/Sat: noon–10:30 PM
GETTING THERE	Street parking, if you're lucky otherwise Brown, purple, and red lines, Belmont stop; #77 bus
PAYMENT	
POPULAR DISH	Samosas—delicious potato and pea filled pastry.
UNIQUE DISH	Tandoori Chicken, Bengan Bhartha—baked eggplant with tomatoes, onions, and coriander.
DRINKS	Sodas, juices, lassi, BYOB
SEATING	Dining room accommodates approximately 100.
AMBIENCE/CLIENTELE	No frills; shop for Indian groceries before or after you eat.
EXTRAS/NOTES	Call for great take-out or delivery. Moti Mahal will also cater your private events—up to 1,000 people!

—*Jen Lawrence*

"After a good dinner one can forgive anybody, even
one's own relatives."

—*Oscar Wilde*

Orange Breakfast

Fruit-infused brunch joint that'll absolutely knock yer friggin' socks off.

$$$

3231 N. Clark St., Chicago 60657
(north of Belmont Ave.)
Phone (773) 549-4400 • Fax (773) 549-4413

CATEGORY	Brunch
HOURS	Tues–Sun: 8 AM–3 PM
GETTING THERE	Metered street parking, if you're lucky otherwise Brown, purple, and red lines, Belmont stop, #22 and 77 busses
PAYMENT	VISA AMERICAN EXPRESS DISCOVER
POPULAR DISH	Puff pastry and custom juice blends.
UNIQUE DISH	Frushi—fruit sushi, a.k.a. fruit, delicately carved and elegantly served.
DRINKS	Fresh juices, sodas, organic coffee and tea.
SEATING	Accommodates around 50.
AMBIENCE/CLIENTELE	Expect young breakfast-loving go getters. The air is orange-infused(it smells good!) and the exposed brick and huge window set a perfect mood.
EXTRAS/NOTES	While Orange has loads of interesting dishes to discover, they also serve more traditional omelets and sandwiches, including what has to be among the finest examples of a grilled cheese anywhere. Starting with great, thick, toasted whole wheat bread, you get a healthily unhealthy dollop of melted sharp cheddar cheese (and the sharp cheddar makes all the difference in the world), topped with a spectacular veggie mixture. So awesome, my friends, that your toes will curl up with pleasure. Expect to wait a long time to be seated on weekends—fortunately, there's plenty of window-shopping to be done in the area!

—*Colin Lohse*

Panes Bread Café

It ain't just bread, but the bread sure ain't bad.

$

3002 N. Sheffield Ave., Chicago 60657
(at Wellington Ave.)
Phone (773) 665-0972

CATEGORY	Café
HOURS	Mon–Sat: 10 AM–10 PM Sun: 10 AM–9 PM
GETTING THERE	Street parking, if you're lucky, otherwise Brown line, Wellington stop, Red and Purple lines, Belmont stop, or #22, 76, and 77 busses
PAYMENT	Cash only
POPULAR DISH	Portobello mushroom and mozzarella with pesto on tomato bread or anything with marinated pork
UNIQUE DISH	Daily soup specials, especially squash 'n' bean in tomato—two words: Awe Some
DRINKS	Great coffee drinks

SEATING	Room for maybe 25 or so
AMBIENCE/CLIENTELE	Cozy and sunny, with a nice, family-run feel
EXTRAS/NOTES	There's a Mexican slant on many of the sandwiches here, so chipotle mayonnaise is a popular ingredient, along with caramelized onions, roasted peppers, pepper jack cheese...you get the idea. They sell the same breads that you get your sandwiches on, and there's a great display of the day's options behind the counter. Panes always has that fresh bread smell, so even if you aren't hungry when you walk in the door, you will be by the time you get to ordering.

—Colin Lohse

Pat's Pizzeria & Ristorante

Chicago's best thin-crust pizza and superb Italian cuisine.
Since 1950
$$$
3114 N. Sheffield Ave., Chicago 60657
(south of Belmont Ave.)
Phone (773) 248-0168

CATEGORY	Pizza/Italian-General
HOURS	Mon–Thurs: 5 PM–10 PM
	Fri: 5 PM–11 PM
	Sat: 1 PM–11 PM
	Sun: 1 PM–10 PM
GETTING THERE	Free parking; Brown, purple, and red lines, Belmont stop; #77 bus.
PAYMENT	VISA MasterCard AMERICAN EXPRESS
POPULAR DISH	Terrific fried calamari, perfect Italian beef sandwich—get it with the hot peppers!
UNIQUE DISH	Thin crust pizza—cracker-thin crust, tangy tomato sauce, and just the right amount of cheese
DRINKS	Sodas, beer, and wine
SEATING	Accommodates 60, give or take
AMBIENCE/CLIENTELE	Comfortable yet elegant with a good mix of tourists and regulars.
EXTRAS/NOTES	Pat's was founded in 1950 and has been owned and operated by the same family ever since. They were one of the first to offer pizza delivery in Chicago—speaking of which, even after the dining room closes, Pat's will deliver until 1:30 a.m. Sun-Thurs, and 2:30 a.m. Friday and Saturday! Stick with sandwiches and pizza to keep the tab low...

—Heather Augustyn

Penny's Noodle Shop

(see page p. 129)
Thai
3400 N. Sheffield Ave., Chicago 60657
Phone (773) 281-8222

Philly's Best

The most authentic Philly Cheese Steaks and pizza in Chicagoland.

$$

907 W. Belmont Ave., Chicago 60657
(west of Clark St.)
Phone (773) 525-7900
www.phillysbest.com

CATEGORY	Sandwich shop/Pizza
HOURS	Mon–Thurs: 11 AM–midnight
	Fri/Sat: 11 AM–2 AM
	Sun: 11:30 AM –9 PM
GETTING THERE	Metered street parking if you're really lucky otherwise Brown, purple, and red lines, Belmont stop or #22 and 77 busses.
PAYMENT	VISA MasterCard
POPULAR DISH	Philly Steaks, pizza, and grinders
UNIQUE DISH	Tasty Cakes (packaged sweets from the East Coast)
DRINKS	Sodas and water
SEATING	Twelve tables, accommodating up to 30 people
AMBIENCE/CLIENTELE	It's about the food, not the ambience; early 80s fast food décor, complete with local newscasters' and Cubs/Sox players' signed headshots on the wall; mixed clientele.
OTHER ONES	• Evanston: 815 Emerson St., Evanston 60201, (847) 733-9000

—Hunter Arnold

Pompei Bakery

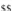

The pasta is really dessert just masquerading as dinner.
Since 1909

$$

2955 N. Sheffield Ave., Chicago 60657
(south of Wellington Ave.)
Phone (773) 325-1900 • Fax (773) 325-1942
www.pompeipizza.com

CATEGORY	Pizza/Italian-General
HOURS	Mon–Sat: 11 AM–10 PM
	Sun: 11 AM–9 PM
GETTING THERE	Limited street parking, or Brown, purple, and red lines, Belmont stop, Brown and purple lines, Wellington stop, or #151, 152 busses.
PAYMENT	VISA MasterCard AMERICAN EXPRESS DISCOVER
POPULAR DISH	Handmade pastas (made fresh daily), pizzas, salads, mouthwatering desserts
UNIQUE DISH	Check out the daily ravioli special (maybe you'll get lucky with pumpkin and walnut or spinach and goat cheese), Mela Verde salad with apple slices, dried cherries, bleu cheese, and walnuts
DRINKS	Sodas, iced tea, homemade lemonade, bottled beer, and wine by the glass
SEATING	Large seating area fits 138 indoors; outdoor patio seats 28, weather permitting.
AMBIENCE/CLIENTELE	Homey, family attitude. Successful combination of

cafeteria hustle-bustle and comfortable dining
experience. Lookout for DePaul students and
neighborhood yuppies smiling and moaning about
how the pasta melts in their mouths.

EXTRAS/NOTES Pompei's unassuming corner location belies its
family-owned heritage dating back to 1909.
Originally famed for the variety and quality of the
pizza, Pompei is now loved by its faithful for the
wonderfully simple pasta dishes and fresh salads.
And the quick service cafeteria style—you place an
order at the counter and pay, then have your dish
brought out to you—lets you enjoy the food at your
own pace, without the prospect of a surprisingly
high bill at the end of the affair. A word to the wise:
save some of that thick, yeasty bread until the end so
none of the luscious sauce goes to waste. Limited
space available for private parties.

OTHER ONES • South Loop: 1531 W. Taylor St., Chicago 60607,
(312) 421-5179 (Original location; banquet facilities
available)
• Oakbrook Terrace: 17 W. 744 22nd St., Oakbrook
Terrace 60181, (630) 620-0600 (Banquet facilities
available)

—*Paul Breloff*

Schuba's Tavern and the Harmony Grill

Rock and rolls...Dinner that is.
$$$
3159 N. Southport Ave., Chicago 60657
(at W. Belmont Ave.)
Phone (773) 525-2508 • Fax (773) 525-2508
www.schubas.com

CATEGORY Trendy/live entertainment/restaurant bar
HOURS Mon-Fri: 11 AM-11 PM
Sat: 9 AM-11 PM
Sun: 9 AM-10 PM
GETTING THERE Small lot next door on Southport. Street parking is a
nightmare on weekend nights.
PAYMENT VISA MasterCard AMERICAN EXPRESS
POPULAR DISH The Harmony Grill specializes in comfort foods.
Clam chowder Fridays are popular, along with a
southern style Po' Boy. Try the meatloaf. Just like
Mom used to make.
UNIQUE DISH Seven types of mac and cheese. Need I say more? I
swear I thought I had died and woke up in
Wisconsin!
DRINKS Full bar
SEATING A smaller place, this is an add on to Schuba's (see
below).
AMBIENCE/CLIENTELE The Harmony Grill is an addition (1996) to a
Chicago music legend, Schuba's. The atmosphere
and clientele reek of Rock & Roll. In fact, no two
nights here are ever the same—unless of course, a
band is playing a two-night stint. Specializing in
comfort foods like pot roast and meatloaf, it almost
feels, or tastes, like you've walked into Mama's

kitchen. The smells are delectable but be sure and wear your earplugs and don't plan on an intimate conversation during a gig.

EXTRAS/NOTES Light on merchandise, heavy on music, any band looking to make it wants to play Schuba's.

—*Brian Diebold*

Sinbad's

Unbeatable falafel at unbeatable prices, with JUICE!

$

921 W. Belmont Ave., Chicago 60657
(east of Sheffield Ave.)
Phone (773) 477-6020 • Fax (773) 477-6068

CATEGORY	Middle Eastern
HOURS	Mon–Sat: 11 AM–10 PM Sun: 11 AM–9:30 PM
GETTING THERE	Street parking, Brown, purple, and red lines, Belmont stop, #77 bus.
PAYMENT	VISA MasterCard AMERICAN EXPRESS DISCOVER
POPULAR DISH	Falafel and hummus sandwich, shawarma, meat platter, gyros, baklava
UNIQUE DISH	The juice bar—'nuf said; low-fat oatmeal raisin cookies and brownies.
DRINKS	Fresh fruit juices, custom blended, sodas, tap water (which occasionally costs a quarter, though no one seems very eager to enforce that policy).
SEATING	Ample table seating, good counter for people-watching.
AMBIENCE/CLIENTELE	Maple paneling, and the hodge-podge of protein jars, swords, and dormant hookahs make this one hard to place.
EXTRAS/NOTES	Chicago has no shortage of cheap Mediterranean holes-in-the-wall, but Sinbad's eclectic combination of plate-lickable hummus, moist falafel, smoothies, and healthy desserts makes it special. The meals are budget (a sandwich costs about $3, with platters straying up to $6), but the quality is not. Just don't ask the owner to make change, as smaller bills from the register seem to be a hot commodity—he smiles much wider if you pay with singles.

—*Paul Breloff*

Standard India Restaurant

Tasty, hot, homemade Indian food—a fresh buffet all day.

$$

917 W. Belmont Ave., Chicago 60657
(east of Sheffield Ave.)
Phone (773) 929-1123 • Fax (773) 929-1876
www.sirchicago.com

CATEGORY	Indian
HOURS	Sun–Thurs: noon–3 PM; 5 PM–10 PM Fri/Sat: noon–3 PM; 5 PM–11 PM
GETTING THERE	Metered street parking if you're lucky otherwise

	Brown, purple, and red lines, Belmont stop, #22 and 77 busses.
PAYMENT	VISA MasterCard
POPULAR DISH	Chicken Tikka Masala—marinated and roasted chicken pieces cooked with mild gravy and herbs.
UNIQUE DISH	Chicken Tandoori—chicken marinated in yogurt, lemon juice, ginger, garlic, and herbs, cooked over charcoal in a clay over…Mmm, good!
DRINKS	Sodas, Lassi—homemade yogurt drink, sweet or salted, mango shake, coffee, tea
SEATING	Dining room accommodates 46.
AMBIENCE/CLIENTELE	A feast for all; crowd is a mix of young and old, gay and straight, artsy and not-so-artsy, slacker and professional.
EXTRAS/NOTES	This is one of the best Indian buffets in town. All You Can Eat Lunch Buffet for $6.95, Dinner just $7.95.

—*Michelle Burton*

Coffee Culture

It seems that all across America the hipster looking for non-corporate coffee is hopeless. The nation has become awash in Starbucks green. But, thankfully, we in Chi-town have kept our heads above the water (or water-like coffee, as the case may be). Here are a few of our favorite places to grab a cup of Joe. Bring a good book and enjoy sticking it to the man from the comfort of a plush couch. Who knows, you might even run into Scott Lucas from another Illinois homebrew, Local H.

Filter
Large windows and plentiful couches make this the perfect place to watch the Wicker Park hipsters stroll by. Be sure to try a quiche or a salad with your latte. *(1585 N. Wilwaukee Ave., (773) 227-4850)*

Perfect Cup
Just what the name says, you can grab an amazing cup of coffee here all in the comfort of a shop that might remind you of your best friend's living room. *(4700 N. Damen Ave, (773) 989-4177)*

Su Van's
The creation of friends Susan and Vanessa (Su Van's, get it?), this cozy home-style café has over thirty sandwiches that might be mistaken for art. There's so much food here you just might forget about the coffee. *(3351 N. Lincoln Ave. (773) 281-0120)*

Jinx
The red, black, and yellow paint gives this funk coffee shop the feeling of a hip Berlin café. While you're there grab a free 'zine. If you're not in the mood for coffee, try the Peanut Butter Milk shake. *(1928 W. Division, (773) 645-3667)*

Atomix
This space age coffee shop always serves up something fresh to the Ukrainian Village crowd. Forget what your mama told you about bad boys and bad girls. The arm-inked cuties here bake some of the best zucchini bread. *(1957 W. Chicago Ave, (312) 666-2649)*

Stella's Diner

A small-town feel in a not-so-small city

$$

3042 N Broadway St., Chicago 60657

(at Barry Ave.)

Phone (773) 472-9040

CATEGORY	Diner
HOURS	Daily: 6 AM-10 PM
GETTING THERE	street parking, nightmare
PAYMENT	VISA MasterCard AMERICAN EXPRESS Discover
POPULAR DISH	Any of the 50+ breakfast dishes. This popular diner offers everything you could imagine, including breakfast (available 'round the clock), salads, comfort food like meatloaf, pasta, a large selection of chicken sandwiches and entrees, and burgers. Sandwiches come simple (grilled cheese, egg salad) or sensational (Chicken Salad Croissant, Eggplant Parmesan). And you won't want to leave without trying one of their delicious and yummy-looking desserts. Just try to resist one after looking at the large selection of cakes throughout your entire meal, thanks to the perfectly placed display case at the front of the restaurant.
DRINKS	Juices, shakes, sodas, coffee, tea, herbal tea, iced tea, milk
SEATING	Indoor seating, plus large outdoor area
AMBIENCE/CLIENTELE	Stella's Diner is unique because of the people, not necessarily the food. The family-owned diner has a tremendous loyal following. Many Lakeview residents have been coming to Stella's for years, including older couples who come in for their morning cup of coffee, working professionals who stop in for breakfast before work, or groups of friends on the weekend. And with hundreds of offerings on their menu, even the most loyal customer is sure to find something new on the menu! The large fist on the front of Stella's diner clutches a knife and fork. You better have your eating utensils ready too! Don't go into Stella's when you're in a hurry—it is best to sit back, relax, and give the huge menu the time it deserves (and takes to absorb it all). The large fist is also very representative of the in-your-face and sassy style of the owners. The menu even spells out the rules ("Smile" "Have Fun"). Stella's Diner offers much more than just diner food, it is an experience that you're sure to enjoy and come back for time and time again!

—Carrie Asato

Thai Classic

Reliable Thai fare

$$$

3332 N. Clark St., Chicago 60657

(at W. Buckingham Pl.)

Phone (773) 404-2000 • Fax (773) 404-2715

www.thaiclassicrestaurant.com

CATEGORY	Neighborhood restaurant, vegetarian friendly
HOURS	Mon–Sat: noon-10:30 PM Sun: 11:45 AM-9:30 PM
GETTING THERE	Minimal street parking
PAYMENT	*VISA* (MasterCard) (AMERICAN EXPRESS)
POPULAR DISH	Pad Thai, although the $10.95 buffet is the main attraction.
DRINKS	BYOB
SEATING	Spacious seating—the optional Thai style seating with pillows in front are a treat.
AMBIENCE/CLIENTELE	Ornate Thai statues, rugs and artwork line the walls, but the clientele is casual and unpretentious.
EXTRAS/NOTES	Long a favorite of neighborhood regulars and frugal students, Thai Classic's menu features standards like Pad Thai, spring rolls and Red and Green Curry. If you're hungry and looking to eat heartily for fairly cheap, it's hard to beat the$10.95 buffet(available on Saturdays from 11:30 AM to 4:00 PM and Sundays from 11:30 AM-9 PM), where you can sample beef, chicken and/or squid salad, a variety of noodle and rice dishes and dessert with breaking the budget. If you're normally turned off by buffet-style dining, don't fear, the atmosphere is clean and inviting and the food is fresh and well prepared, and the entrees are a tasty, filling option.

—Keidra Chaney

A cackle-berry wreck*:
(Or: deciphering the new
short-order lingo)

Short order cooks started barking orders in code to wait staff over the sizzling bacon. Some of this lingo became part of the vernacular, such as: BLT, sunnyside up, eggs over easy, mayo, OJ, Coney, stack (as in pancakes), and java.

Here's a selection of terms that haven't quite caught on:

Whiskey down: rye toast

Burn the British: toasted English muffin

Merry Christmas: tuna on toast with lettuce and tomato

Put out the lights and cry: liver and onions

Breath: onions

B and B: side of bread and butter

On wings: to go

scrambled eggs

Tibet Café
*A little piece of the Himalayas right
beneath the El.*
$$
3913 N. Sheridan Rd., Chicago 60613
(south of Irving Park Rd.)
Phone (773) 281-6666

CATEGORY	Tibetan
HOURS	Mon: 1 PM-6 PM
	Tues–Fri: 9 PM–9 PM
	Sat: 9 PM–6 PM
	Sun: 1 PM-6 PM
GETTING THERE	Street parking; Red line, Sheridan stop; #80 bus.
PAYMENT	VISA MasterCard AMERICAN EXPRESS DISCOVER
POPULAR DISH	Curries, momo—steamed or fried dumplings.
UNIQUE DISH	Shokog Khatsa—spicy potato dish served cold on a lettuce leaf, accompanied by warm bread, yummy desserts.
DRINKS	Sodas, juice, tea, Boe Cha—traditional churned tea with light salt, butter, and milk; Thara—homemade yogurt shake; BYOB.
SEATING	Eleven tables, accommodating around 30 people.
AMBIENCE/CLIENTELE	Tibetan butter sculptures (traditionally made by monks out of yak butter to honor the Tibetan New Year's festival); golden wood-paneled walls; photos of the Dalai Lama.
EXTRAS/NOTES	Despite its unlikely location, Tibet Café is one of the true gems of Chicago's north side. Family owned and operated, the proprietors will make you feel like a welcome friend. Don't be surprised if you see their adorable daughter running around, coloring with crayons, or disappearing into her own private "clubhouse" (no boys allowed) across from the restroom.

—*Courtney Arnold*

Tie Me Up Noodles

Real authentic Thai food in Chicago

$$$

434 W. Diversey Pkwy., Chicago 60657
(at Sheridan Rd.)
Phone (773) 404-1145 • Fax (773) 404-1145

CATEGORY	Thai and Asian
HOURS	Sun-Thurs: 11 AM-10 PM
	Fri-Sat: 11 AM-11 PM
GETTING THERE	Difficult street parking
PAYMENT	VISA MasterCard AMERICAN EXPRESS DISCOVER
POPULAR DISH	Curries, spring rolls, Tie Me Up Pad Thai, Lime Chicken
UNIQUE DISH	The extensive menu, which includes more than 90 items, contains non-typical Thai dishes. Several of their "new" dishes like Drunken Noodles and Orange Chicken make up the bulk of the menu at other Thai restaurants. Customers and critics alike rave about Tie Me Up Noodles for offering authentic Thai food. For that reason, the restaurant is a neighborhood favorite.
DRINKS	BYOB
SEATING	Spacious, seating for more than 60

AMBIENCE/CLIENTELE	The mood is very casual and the crowd mostly consists of loyal neighborhood customers. From the outside, Tie Me Up Noodles looks like the average hole-in-the-wall place offering greasy Thai food. The inside looks like a tavern, with wood paneling and mirrored walls. But if you pass this place by based on appearance, you'll miss out on some great Thai food!

—*Carrie Asato*

Tombo Kitchen
Karaoke spewing sushi fiends pack the house
$$$
3244 N. Lincoln Ave., Chicago 60657
(at Melrose Ave.)
Phone (773) 244-9885 • Fax (773) 244-9886

CATEGORY	Hip and comfy sushi eatery
HOURS	Mon-Thurs: 5 PM-midnight
	Fri-Sat: 5 PM-2 AM
	Sun: 5 PM-10 PM
GETTING THERE	Metered parking is somewhat difficult to find
GETTING THERE	VISA MasterCard AMERICAN EXPRESS DISCOVER
POPULAR DISH	All of the sushi is incredible (especially the sweetly flavored unagi) and the Dragontail roll is the most popular. I adore the delicious Shrimp Tempura roll and the go mae is fresh and invigorating.
UNIQUE DISH	They have an unique Green Dragon Shrimp Tempura roll with kiwi, massago, cucumber and wasabi sauce peppered throughout.
DRINKS	They have wine, sake and beer, but also operate under a BYOB policy, which many of the regulars take advantage of. There is a $3 corking fee for BYOB'ers. They have specialty drinks like unfiltered sake and a rice wine with fruit and rose spices called "sen sa chun"—the ladies love it.
SEATING	Seating for around 90
AMBIENCE/CLIENTELE	A serene and calming oasis in the middle of a bustling stretch of Lincoln Avenue, this neighborhood sushi house is a popular den for cool, in-the-know neighborhood creative-types. The later the night creeps on, the swankier the crowd becomes. Watch out for the sake sippin', sushi shoving, karaoke loving madmen; they come in ballsy droves.
EXTRAS/NOTES	Karaoke is popular on the weekend, when everyone is just drunk enough to think they're the next "Idol." The eager wait-staff is so right-on with all recommendations and suggestions, it takes the intimidation out of sushi, especially for first timers.

—*Misty Tosh*

"If you are what you eat, then I'm fast, cheap and easy."
—*Anon*

Tortas U.S.A.

Inexpensive and tasty, with great service.

$

3057 N. Ashland Ave., Chicago 60657
(south of Barry Ave.)
Phone (773) 871-8999 • Fax (773) 871-8998

CATEGORY	Mexican
HOURS	Daily: 7 AM–midnight
GETTING THERE	Free lot or #9 bus.
PAYMENT	Cash only
POPULAR DISH	Build-your-own burrito, tortas and tacos.
UNIQUE DISH	Fruit and health shakes, lunch specials with unusual ingredients.
DRINKS	Sodas, juices, horchata
SEATING	Eight or ten tables, seating about 35
AMBIENCE/CLIENTELE	Torta U.S.A., aka Dona Torta, is a sit-down restaurant with a hodge-podge of houseplants and Mexican decorations. You walk through an ivy-draped arch to reach the dining area where you'll hear blaring Mexican music that, somehow, does not detract from the experience.
EXTRAS/NOTES	Cilantro lime rice and black beans make for a good appetizer, and their soft shell tacos are an outstanding follow-up. The really great thing about this place is the amount-of-food-to-dollars ratio. It's a fast food hit to your wallet, without having to endure the fast food flavor. For carry-out, simply order and pay at the counter and be on your way in a couple of minutes.

—*Sarah Eaton*

Twisted Spoke

(see page p. 28)
Sunday Brunch
3369 N. Clark St., Chicago 60613
Phone(773) 525-5300

The Union Tavern

The archetypical Lakeview sports bar, plus great food!

$$

2858 N. Halsted St., Chicago 60657
(north of Diversey Pkwy.)
Phone (773) 755-9870

CATEGORY	Bar & Grill
HOURS	Mon–Fri: 5 PM–2 AM
	Sat: 11 AM–3 AM
	Sun: 11 AM–1 AM
GETTING THERE	Street parking or Brown line, Wellington and

	Diversey stops or #8 and 76 busses
PAYMENT	VISA MasterCard AMERICAN EXPRESS DISCOVER
POPULAR DISH	Sandwiches, burgers, wings
UNIQUE DISH	$1 burgers on Mondays
DRINKS	Large beer selection, wine by the glass, sodas
SEATING	Bar and tables indoors to seat around 80 plus large beer garden outside.
AMBIENCE/CLIENTELE	Expect a crowd of mostly lake view and Lincoln Park locals in this very friendly and casual spot with exposed brick walls.
EXTRAS/NOTES	After walking through the dark wood interior, the layout funnels back toward a large outside deck equipped with trees, satellite TV, and a cocktail bar. It's a great place for Big Ten fans to grab a bite after a softball game.

—*Richard T. Rainey*

Wishbone Restaurant

Down-home comfort food.

$$

3300 N. Lincoln Ave., Chicago 60657
(corner of School St.)
Phone (773) 549-BONE (2663) • Fax (773) 549-4154
www.wishbonechicago.com

CATEGORY	Southern American
HOURS	Mon: 7 AM–3 PM
	Tues–Fri: 7 AM–10 PM
	Sat: 8 AM-10 PM
	Sun: 8 AM-9 PM
GETTING THERE	Metered street parking, Brown line, Paulina stop, and #11 and 77 busses. Lot across the street for $5 (It's free after 7 PM. That is, if there's if no attendant).
PAYMENT	VISA AMERICAN EXPRESS DISCOVER
POPULAR DISH	Weekend brunch
UNIQUE DISH	Corn cakes, chicken sausage, crunchy French toast (courtesy of cornflake batter)
DRINKS	Full bar; Bloody Marys and Mimosas for brunch; house special: Mr. Funky (champagne and cranberry juice)
SEATING	Booths and tables to seat around 150; outdoor seating for 60, weather permitting
AMBIENCE/CLIENTELE	There are paintings done by the owner's wife—check out that religesque triptych featuring a chicken with, yep, breasts. Expect young people, old people, families, couples, and everyone enjoys food like Mom used to make
EXTRAS/NOTES	Now wouldn't a nice Wishbone t-shirt, complete with rabid-looking poodle photo be the perfect addition to your wardrobe? Children's menu available.
OTHER ONES	• Loop: 1001 W. Washington Blvd., 60607, (312) 850-BONE (2663) (Rumored to be the lunch spot of Oprah staffers from nearby Harpo Studios.

—*Kelly Svoboda*

Think You Can't Eat Healthy-Cheap? Think Again!

Nearly half of all Americans eat out on typical day. Forty percent of those are trying to eat more healthfully, and chefs are taking notice. Restaurants are responding with healthier menu items, making it easier for diners to make smart food choices.

To trim calories from your plate without sacrificing taste or feeling deprived, try the following quick fixes and start dining out the healthy way.

One of the nicest things you can do for your heart is this: forget fried and order grilled. Frying generally doubles the calories and saturated fat in a given food. Don't worry, most menus offer grilled, broiled and even baked alternatives to fried dishes— and they taste better too!

Have you noticed that restaurant plates have gotten bigger and bigger over the years? Entrees have grown to be gargantuan, doubling, and sometimes tripling, a normal serving. If you don't want to eat yourself silly, try ordering an appetizer as your main course. The average appetizer is actually closer to a normal serving size than most entrees are.

If you must order an entree, skip the pre-dinner bread and butter. This tiny adjustment can shave hundreds of calories from your meal. When the bread arrives, a simple "no, thanks" will suffice.

If you are going to have an entrée, there's no need to order an appetizer; and take a pass on the high calorie soft drinks and juices. The entrée will be more than enough to fill you up. Most people become full once they've consumed a normal serving size, but continue to eat because the food is "there" or because they want to get their money's worth. Whatever the case, you should always stop when you feel comfortable, not stuffed. Don't have enough willpower? Have the plate removed, or request a doggie bag when you're done. Another way to stop stuffing is to make your plate as unappealing as possible. Drown it in salt, cover it with napkins, or pour ketchup over it. Do what you have to do.

It's okay to play with your food. Dab the extra oil off your pizza or trim the fat off meat if you have to— this could save you 100 calories or more! Try ordering sauces and dressings on the side and dip instead. If you're among friends, split an entrée and have an extra salad. You can also fill up on fat-free fare such as vegetables and fruit or split a desert rather than eat a whole one. Remember, most deserts contain 400-1000 calories per portion!

Dining defensively isn't as bad as it sounds. Not only can it amount to huge calorie savings, but it can save you money too. Think about it. Appetizers cost considerably less than entrées, and ordering an entrée alone is considerably less expensive than ordering appetizers, an entrée, and dessert! Fit fare menu items and salads can cost slightly less than regular entrees. Small is cheaper than large, á la cart is cheaper than deluxe, and sharing is cheaper than not sharing. Get the picture?

Since you're in Chicago, why not check out the following healthy alternatives:

Chicago Diner for vegetarian and vegan meals. (see page 76) Lakeview-Boystown: 3411 N. Halsted St., Chicago 60657, (773) 935-6696

Emerald City Restaurant for a great salad bar, hot bar, no fried foods, fruit smoothies, and fresh vegetable drinks. Lakeview: 2852 N. Clark St., Chicago 60657, (773) 477-0555

Heartland Cafe for vegetarian friendly and healthy dishes. (see page 118) Rogers Park: 7000 N. Glenwood Ave, Chicago 60626, (773) 465-8005

—*Michelle Burton*

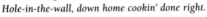

BOYSTOWN

Arnold's Restaurant & Hickory Smoke House

Hole-in-the-wall, down home cookin' done right.
$$
4001 N. Broadway St., Chicago 60613
(at Irving Park Rd.)
Phone (773) 929-3338

CATEGORY	Diner/Southern American
HOURS	Mon–Fri: 5:30 AM–7:30 PM
	Sat/Sun: 5:30 AM–5:30 PM
GETTING THERE	Street parking, Red line, Sheridan stop, #36 and 80 busses
PAYMENT	Cash only
POPULAR DISH	Early morning breakfast specials, burgers, BBQ
UNIQUE DISH	Memphis Rib Tips (wet or dry), Crispers, Hoppin' John/Jack, catfish
DRINKS	Sodas, juices, coffee, tea, Sanka, hot chocolate
SEATING	Ten booths, 18 counter seats.
AMBIENCE/CLIENTELE	Green vinyl, creeping vines, fantastic mirror-tiled wall (complete with painted pheasant) that is, unfortunately, being slowly covered with snapshots make this spot a favorite for Boystown, blue collar, and random other crowds.
EXTRAS/NOTES	Vegetarians will be pleasantly surprised by the number of options available! If you're up early enough, check out the super-cheap breakfast specials (not necessarily listed on the menu). There are plenty of diner-type restaurants in the area, but Arnold's beats the big chain competitors (ah-hem, IHOP) any day.

—*Courtney Arnold*

Brewpub Hoppin'—For What Ales You

So you chase those greasy, spicy, savory foods down with a cold one. But forget drinking something that's been hauled across country, or continent. In Chicago, fresh and delicious beer is often brewed right down the street or, at the very least, across town.

Beer was probably accidentally discovered as much as 15,000 years ago when jars of grain got wet and spontaneously fermented, creating an intoxicating porridge. Time passed before hops were first used—roughly 1100 years ago. Then around 1859, we have Louis Pasteur to thank for his role in identifying the part that yeast played in brewing. But Prohibition destroyed the American brewing industry, closing over 1,500 breweries in 1920 alone. Even after the booze ban ended in 1933, it would be another half-century before anything other than fizzy yellow brew became widely available.

While we may have been kings of bootlegging seventy years ago, today we make some of the finest microbrews. So step out for a bite to eat at some of my favorite brewpubs around town and bring home a six-pack to go with the doggy bag.

Goose Island

With over 50 different small brews on tap, this might be the prefect place to watch the Cubs and try something new. Be sure to take a brewery tour and tasting, led by the brew master himself (3 PM every Sunday)! *(1800 N. Clybourn Ave. (312) 915-0071)*

Rock Bottom Brewery

In the summer the third floor rooftop deck here is the perfect place to sit back and watch the city skyline. Five beers on tap on the deck and tap and tons more down below. *(1 West Grand St. (312) 755-9339)*

Piece

Winner of awards at both the World Beer Cup and the Great American Beer Festival, Piece is a sure bet for a great hand crafted beer. While you're there grab some equally impressive hand crafted pizza. *(1927 W. North Ave., (773) 772-4422)*

The Bagel Restaurant & Deli

Family-run Jewish deli—kishkes, blintzes, and matzo, oh my!

Since 1950

$$

3107 N. Broadway St., Chicago 60657

(south of Belmont Ave.)

Phone (773) 477-0300 • Fax (773) 477-9895

www.bagelrestaurant.com

CATEGORY	Jewish/Deli
HOURS	Daily: 8 AM–10 PM
GETTING THERE	Free lot or take the #36 bus.

PAYMENT	VISA · MasterCard · AMERICAN EXPRESS
POPULAR DISH	Matzo ball soup.
UNIQUE DISH	Red, white, and blue blintzes—cherry, cheese, and blueberry, respectively
DRINKS	Dr. Brown's soda, Chocolate Phosphate, milk, chocolate milk; freshly squeezed orange juice; coffee, tea, hot chocolate
SEATING	Room for around 100 people
AMBIENCE/CLIENTELE	Attracts a great mix of old folks and young professionals from this very diverse neighborhood. Walls are plastered with posters from Broadway shows, old and new.
EXTRAS/NOTES	The Bagel has both delivery and dine-in options, but the best way to do it is find a beautiful day, get a pastrami on rye from the counter up front, and head out to the shore of Lake Michigan, which is only two blocks away.
OTHER ONES	• Skokie: 50 Old Orchard Center; Skokie 60077, (847) 677-0100

—Colin Lohse

Café at Hearty Boys

Funky café/catering company —a new brunch favorite in Lakeview.

$$$

3404 N. Halsted St., Chicago 60657

(at Roscoe St.)

Phone (773) 661-0229

www.heartyboys.com

CATEGORY	Brunch spot/trendy joint
HOURS	Tues-Sat: 9 AM-10 PM Sun: 9 AM-8 PM Sat-Sun brunch: 9 AM-3 PM
GETTING THERE	Little to no street parking. In walking distance of Red Line Belmont stop.
PAYMENT	VISA · MasterCard · AMERICAN EXPRESS · DISCOVER
POPULAR DISH	Crab Cake Eggs Benedict have earned raves from most regulars.
UNIQUE DISH	Hearty Boys is one of the few places to find authentic beignets in Chicago. The "eggs in a basket," brunch specials are best described as breakfast equivalent of pot pie, with eggs and fillings (included andouille sausage, crawfish or spinach and brie) in a flaky crust.
DRINKS	BYOB
SEATING	Seating for about twenty, smaller tables for couples and small groups.
AMBIENCE/CLIENTELE	Located in the heart of Boystown, Hearty Boys' LGBT-friendly sensibility is apparent right now to the cheeky wall photographs of attractive same sex couples dusted in flour. While a favorite of brunching couples both gay and straight, the cozy coffeehouse atmosphere also makes it a welcoming place for solo diners seeking to nurse a cup or two of coffee.

EXTRAS/NOTES The restaurant extension of the trendy Hearty Boys catering company, this casual storefront café offers grilled panini's sandwiches, small pizzas, and a number of Cajun-influenced items for breakfast, lunch, brunch and dinner. While the atmosphere says "leisurely brunch spot, the music choice of loud, pulsing club remixes may make it a distracting experience for some. Meal portions are satisfying, but not heavy, though strict vegetarians may find their options limited – the menu is heavy on meat, egg and dairy.

—*Keidra Chaney*

Canton Express

Abused by the overworked, this tiny, takeout is an on-the-fly haven!

$$

3205 N. Halsted St., Chicago 60657

(at Belmont Ave.)

Phone (773) 528-7331

CATEGORY	Take-out Chinese
HOURS	Mon-Thurs: 11 AM-10:30 PM
	Fri/Sat: 11 AM-11 PM
	Sun: 11 AM-10 PM
GETTING THERE	Metered parking somewhat hard to find, especially on weekends
PAYMENT	
POPULAR DISH	Garlic chicken and garlic beef are the house favorites. The veggie-packed vegetable rice (with loads of little fried egg bits) is delicious, as well.
SEATING	Takeout only, with a tiny bit of counter seating, for those with nowhere to go.
AMBIENCE/CLIENTELE	Exhausted students, poor artists and busy neighborhood families abuse this Chinese takeout hole-in-the-wall on a regular basis. The standard menu features Chinese food that is above average and comes flying out of the tiny kitchen almost as quick as you can order it. It brings to mind what it would be like if you were living in NYC and wanted to hang out on your fire escape, digging into the perfect Chinese takeout cartons, full of flash-fried noodles and perfectly fried rice. Tiny and authentic, this is the place to help you fulfill that romantic vision.

—*Misty Tosh*

Casbah Cafe

Rocked at the Casbah.

$$$

3151 N. Broadway St., Chicago 60657

(at Briar Pl.)

CATEGORY	Trendy/ Upscale Dinner
HOURS	Mon: 5 PM-11 PM
	Tues-Sun: noon-11 PM

GETTING THERE	Difficult street parking
PAYMENT	VISA MasterCard
POPULAR DISH	Flavorful combination dinners are a popular choice—they typically include falafel, hummus, and dolmeh
UNIQUE DISH	Unlike many Mediterranean places, this one has many pasta dishes
DRINKS	BYOB
SEATING	Small and cozy
AMBIENCE/CLIENTELE	A bit more upscale than you would think.

—*Brian Diebold*

The Chicago Diner

Boystown vegan diner loaded with boys, sans the meat

$$

3411 N. Halsted St., Chicago 60657
(at Roscoe St.)
Phone (773) 935-6696 • Fax (773) 935-8349
www.veggiediner.com

CATEGORY	Totally vegetarian neighborhood haven
HOURS	Mon-Thurs: 11 AM-10 PM Fri: 10 AM-11 PM Sat: 10 AM-10 PM
GETTING THERE	Metered parking is easy to find at lunch and more difficult in the evening
PAYMENT	VISA MasterCard AMERICAN EXPRESS DISCOVER
POPULAR DISH	Philly steak sandwich made with tender seitan and smothered in melted cheese. Soy cheese is available and the most popular way to go. Santa Fe Salad, packed with veggies, faux taco meat, and tossed (very important) with a delicious, house made lime cilantro vinaigrette. The chunk of cornbread served on the side is slathered in creamy butter and addictively haunting.
UNIQUE DISH	Seitan fajitas that taste so much like real thing, they could fool a meat addict.
DRINKS	All natural margaritas, organic beers, and organic, vegan wines. The prices are average, but the taste difference between organic and non-organic is mind blowing.
SEATING	Seating for 50
AMBIENCE/CLIENTELE	From the serious, hard-core vegan to the trendy, newly baptized veg-head, the cheery, earth friendly atmosphere packs in the "granola" brand of diner. This is the perfect place to head when you really want to feel good about yourself; with clean food, cozy booths and a perky wait-staff, what's not to love about this smoke-free veggie landmark.

—*Misty Tosh*

"Food is the most primitive form of comfort."
—*Sheila Graham*

Chili Mac's 5-Way Chili

Chili! Try it 5 Ways

$$

3152 N. Broadway St., Chicago 60657

(at Briar Pl.)

Phone (773) 404-2898

CATEGORY	Where the "boys" go to eat
HOURS	Sun-Thurs: 11 AM-10 PM
	Fri/Sat: 11 AM-11 PM
GETTING THERE	Very difficult street parking
PAYMENT	VISA MasterCard
POPULAR DISH	May as well go for the gusto! Get the 5-way chili. Chili, spaghetti, cheddar cheese, beans and onions. Not for the faint of heart.
UNIQUE DISH	This is definitely a unique place for Chicago. For those who don't know, one-way chili is just chili. Two -way is chili and spaghetti. Three way: chili, spaghetti and cheddar cheese, four-way, add beans and the five-way, add the onions.
DRINKS	Full bar. Frozen Margaritas and Texas Martinis are recommended.
SEATING	Small and cozy
AMBIENCE/CLIENTELE	Not a great place to take a date but wonderful for "pull my finger" and other flatulence-related jokes. Hang there with the boys if you know what I mean. Very casual with a light, cheery mood, Chili Mac's is a great place for lunch and cheap enough for that dinner out with your unemployed friends. Any fan of chili really needs to check this place out. It's different from your typical Texan style chili. I think the northern reply to their challenge is a real taste treat. Highly recommended!

—*Brian Diebold*

Eat a Pita

A Unique Restaurant Serving Good Food Fast

$$

3155 N. Halsted St., Chicago 60657

(at Belmont Ave.)

Phone (773) 929-6727

www.eatapitachicago.com

CATEGORY	American-style neighborhood eatery
HOURS	Daily: 11 AM-9:45 PM
GETTING THERE	Street parking's a nightmare, lucky there's a garage nearby
PAYMENT	VISA MasterCard
POPULAR DISH	Toasted crispers are Eat a Pita's claim to fame. They are sandwiches, ranging from melts to corned beef reubens, served on thick toast, which is grilled to a "greaseless, waffle-like texture." The restaurant also serves pitas, of course! But that's not all: The place is a one-stop shop, offering stir-fry pitas, cold pocket pitas, burgers, hot dogs, pasta, seafood, mac & cheese, salads, soup, and even Ben & Jerry's ice cream. Everything on the menu is cooked fresh to order.

DRINKS	Fountain soda, hot chocolate, coffee, tea, juices, and nine flavors of shakes.
SEATING	Smallish, can seat about 30 to 40. Outdoor seating is available as well and is popular in the summer.
AMBIENCE/CLIENTELE	As soon as you walk through the door, you may think you're in college again. The place is reminiscent of a late-night college spot, from the burgers and hot dogs on the menu to the bulletin board with neighborhood announcements. TVs blast in the background and the tables, which would be perfect for studying, are filled with people reading or casually waiting for their food. Although there isn't a university nearby, it is in a pretty busy area with a popular theater and shopping mall down the street. While there is a lot of comfort-type food on the menu, health nuts will be just as happy. The restaurant offers several vegetarian dishes, salads, and healthy pitas.

—*Carrie Asato*

Jitlada Thai House

Authentic Thai on the North Side—and it's cheap!
$$
3715 N. Halsted St., Chicago 60613
(north of Waveland)
Phone (773) 388-9988

CATEGORY	Thai
HOURS	Daily: 11:30 AM–midnight
GETTING THERE	Free parking in Lakeshore Plaza lot behind restaurant, metered street parking, Red line, Addison stop, #154 bus
PAYMENT	VISA MasterCard AMERICAN EXPRESS
POPULAR DISH	Pad Thai, fried rice, pot stickers
UNIQUE DISH	Try one of the spicy curry dishes
DRINKS	BYOB, Thai iced coffee and tea, sodas
SEATING	About eight tables
AMBIENCE/CLIENTELE	Very casual. Small place where there's a game always on the TV. Unless you're a Cubs fan, takeout is your best bet.
EXTRAS/NOTES	Check the takeout menu for coupons for free appetizers.

—*Kelly Svoboda*

Joy's Noodles & Rice

Quick and easy Thai food.
$$
3257 N. Broadway St., Chicago 60657
(at Melrose St.)
Phone (773) 327-8330 • Fax (773) 327-6339
www.joysnoodlesandrice.com

CATEGORY	Thai, Asian
HOURS	Sun-Thurs: 11 AM-10 PM
	Fri/Sat: 11 AM-11 PM

GETTING THERE	Nightmare street parking
PAYMENT	
POPULAR DISH	Pad Thai, Drunken Noodles, Chicken Coconut Curry, Lard Na
UNIQUE DISH	Curry dishes, Tofu soup, seafood dishes.
DRINKS	BYOB, jasmine tea, sodas, iced tea and coffee
SEATING	Spacious, popular outdoor seating
AMBIENCE/CLIENTELE	Joy's is a popular neighborhood eatery. Therefore, it can get very crowded, very quickly. But the staff is efficient at getting people in and out. The dining room is casual and inviting, with a warm brick wall that gives the place a homey feel (maybe that's why people tend to linger for hours). Food is classic Thai, with the curry dishes, Lard Na, and Cashew Chicken among the favorites.

—Carrie Asato

Las Mañanitas

Huge portions, fun and festive atmosphere, and great margaritas.

$$$$

3523 N. Halsted St., Chicago 60657

(south of Addison St.)

Phone (773) 528-2109 • Fax (773) 528-2697

CATEGORY	Mexican
HOURS	Sun–Thurs: 11 AM–11 PM
	Fri/Sat: 11 AM–midnight
GETTING THERE	Street parking or Red line, Addison stop or #8 bus
PAYMENT	
POPULAR DISH	Fajitas
UNIQUE DISH	Creative daily specials and desserts, and breakfast anytime
DRINKS	Margaritas!! but they also have sodas, juices, iced tea, iced coffee drinks, and beer.
SEATING	Large dining room and outdoor patio, weather permitting
AMBIENCE/CLIENTELE	A good mix of neighborhood folks of all ages and backgrounds.
EXTRAS/NOTES	Save money by sticking with the basics—you're here for the margaritas, anyhow!

—Kelly Hutchison

Mamacitas

Fresh, healthy Mexican for a steal!

$$

3324 N. Broadway St., Chicago 60657

(at W. Buckingham Pl.)

Phone (773) 868-6262

www.mamacitarestaurant.com

CATEGORY	Neighborhood spot
HOURS	Mon-Thurs: 10 AM-9 PM
	Fri/Sat: 10 AM-10 PM
	Sun: 9 AM-9 PM

GETTING THERE	Some metered parking, street parking is virtually nil. Close to Red and Brown lines.
PAYMENT	VISA MasterCard AMERICAN EXPRESS DISCOVER
POPULAR DISH	Fajita platter (chicken and steak or shrimp/duck for an extra $1.50) are a favorite of most regulars.
UNIQUE DISH	The Mexican style brunch include huevos rancheros, mango pancakes and turkey bacon and sausage. Mexican pizzas are primarily veggie-friendly options.
DRINKS	BYOB
SEATING	Size is comfortable for couples, small groups as well as larger gatherings.
AMBIENCE/CLIENTELE	Located in a hot spot of Lakeview, Mamacita's can attract its fair share of young hipsters, but the inexpensive meal options and homey, friendly atmosphere make it a great spot to meet friends or to break the ice with a blind date.
EXTRAS/NOTES	There's any number of Mexican greasy spoons located on the North side of Chicago, but this colorful neighborhood spot serves up inexpensive, hearty meals with a funky flair. There are plenty of no-meat options (including lard-free beans) on the menu, so vegetarians can partake. There's plenty of outdoor seating in summer for people watchers and those who want to be seen.
OTHER LOCATIONS	• Lincoln Park: 2439 N. Clark St., Chicago 60614

—Keidra Chaney

Melrose Restaurant
Truck stop diner—Chicago style!
$$$
3233 N. Broadway St., Chicago 60657
(at W. Belmont Ave.)
Phone (773) 327-2060

CATEGORY	Diner
HOURS	24/7
GETTING THERE	Street
PAYMENT	VISA MasterCard
POPULAR DISH	The food is common diner offerings—sandwiches, eggs, French toast, burgers. It's a bit unusual to find a truck-stop diner in the middle of the city but in this neighborhood, it works. The restaurant is open 24/7 and is usually quite busy. The locals have embraced Melrose and it is a fave no matter if it's weekend brunch, a late-night coffee break, or a quick burger at lunchtime.
DRINKS	Customers are looking for typical diner fare—coffee and juices are most popular.
SEATING	Large diner feel, can seat more than 100.
AMBIENCE/CLIENTELE	The atmosphere is like any that you would expect to find in a diner—casual, laidback, and busy. The décor is true to diner policies—big booths, tacky colors, and funky artwork. Melrose Restaurant is a great place to people-watch, especially in the summertime when you can take advantage of the great outdoor seating. The crowd can vary a lot and often includes students, gay couples, older adults,

punk kids, and drunken partiers. You are always in
for an adventure! If people-watching isn't for you,
the quirky wait staff will be happy to entertain you.
The food can be quite good, but is usually
overshadowed by the clientele.

—*Carrie Asato*

Murphy's

A glorified hot dog stand.

$

1211 W. Belmont Ave., Chicago 60657

(west of Racine Ave.)

Phone (773) 935-2882

CATEGORY	Hot Dogs
HOURS	Mon: 11 AM– 8 PM
	Tues–Fri: 11 AM–8:30 PM
	Sat: 11 AM– 8 PM
	Sun: 11 AM–5 PM
GETTING THERE	Metered street parking, Brown, purple, and red lines, Belmont stop, #77 bus.
PAYMENT	Cash only
POPULAR DISH	Red Hots, burgers, Italian Beef sandwiches Brats.
UNIQUE DISH	The finest Red Hot franks available.
DRINKS	Sodas, iced tea, triple-thick milkshakes
SEATING	Five small tables inside; outdoor deck in warm weather.
AMBIENCE/CLIENTELE	Loud when busy; any hot dog eater is welcome (especially the Irish variety!)
EXTRAS/NOTES	"Enjoy Life…Eat Out More Often" beams the large sign hanging on the wall. Hey, why not? Especially at a place where the menu states that the mission is to be "Top Dog in a Dog Eat Dog World". Boasting the greatest Red Hot around, Murphy's is a little shack of a place with some quick 'n' greasy eats. The dogs are sliced up so that all the fixin's rest snugly inside, the service is fast food-esque, and involves some friendly yelling ("Hey! You want hot peppers on that?"). The space is cramped, so unless the weather is in your favor and you can eat outside, best to grab your dog and hit the road.

—*Trisha L. Falb*

Nohana Restaurant

*Straightforward sushi that is always fresh and
dependable.*

$$

3136 N. Broadway St., Chicago 60657

(south of Briar Pl.)

Phone (773) 528-1902

CATEGORY	Japanese-Sushi
HOURS	Mon–Thurs: noon–2:30 PM; 5 PM–10 PM
	Fri/Sat: noon–2:30 PM; 5 PM–10:30 PM
GETTING THERE	Limited street parking, lot nearby, #36 bus.

PAYMENT	VISA · MasterCard · AMERICAN EXPRESS · DISCOVER
POPULAR DISH	Extremely fresh sushi and Bento Boxes
UNIQUE DISH	Special rolls of the day, including dragon rolls also entrees like Katsu, Teriyaki, and Tempura.
DRINKS	Sodas, Asian beers, limited wine menu.
SEATING	Accommodates 30
AMBIENCE/CLIENTELE	Family-friendly atmosphere with the most hospitable waitstaff around
EXTRAS/NOTES	The dinner menu is quite pricey, but lunch is yummy and affordable. Takeout and delivery available.

—Jennifer Chan

Nookie's

(see page p. 51)
Heinz 57
3334 N. Halsted St., Chicago 60657
Phone (773) 248-9888

Ping Pong

Unbelievably flavorful Pan-Asian cuisine that's a step above the rest.
$$$
3322 N. Broadway St., Chicago 60657
(north of Aldine Ave.)
Phone (773) 281-7575 • Fax (773) 281-0137

CATEGORY	Pan-Asian
HOURS	Daily: 4 PM–midnight
GETTING THERE	Metered street parking; Brown, purple, and red lines, Belmont stop, #36 and 77 busses
PAYMENT	VISA · MasterCard · AMERICAN EXPRESS
POPULAR DISH	Sesame Chicken—crunchy and sesame-coated in sweet glaze with broccoli, the best you'll ever have.
UNIQUE DISH	Teriyaki Box—grilled teriyaki chicken breast over a bed of rice.
DRINKS	Sodas, San Pellegrino, Pure Fruit Smoothies made to order, large selection of teas.
SEATING	Twenty inside—four counter seats, seven tables; outdoor seating for fifteen in warm weather
AMBIENCE/CLIENTELE	Youngish, multicultural mix of gay and straight. Green and orange mod décor.
EXTRAS/NOTES	This tiny space serves up House beats, Techno, and Trance, accompanied by a flat screen TV playing images and videos.

—Michelle Burton

"I never worry about diets. The only carrots that interest me are the number you get in a diamond."

—Mae West

The Soup Box

Simple, hearty soups and frozen Italian ices bring instantaneous comfort

$$

2943 N. Broadway St., Chicago 60657
(at W. Wellington Ave.)

Phone (773) 935-9800

www.thesoupbox.com

CATEGORY	Takeout soup joint
HOURS	Daily: 11 AM-10 PM (winter)
	Daily: 11 AM-11 PM (summer)
GETTING THERE	Metered parking is difficult to find
PAYMENT	Cash Only
POPULAR DISH	The chicken & wild rice soup is creamy and addictive, while the Lobster Bisque brings to mind a cold New England day. All of the soups can be served piping hot in a sour dough bread bowl for just a bit extra (trust me, the soup-soaked bread bowl is an incredible treat at the very end of the meal.) You'd never be able to tell, but all of the soups are soy-based, which makes them even healthier.
UNIQUE DISH	In the wintertime, the eatery is a Soup Box, meaning that they have twelve different kinds of homemade soup rotating on a daily basis. In the summertime, they scale back the soup (offering only nine) and bring out twenty different kinds of Italian ice, all made fresh in the store every day. The name effectively changes to Ice Box and they definitely have a great thing going.
DRINKS	Juices, waters, and soda
SEATING	Twenty seats inside, plus little benches outside for the warm-weather days
AMBIENCE/CLIENTELE	This Lakeview storefront is just a small, friendly place serving nothing but fresh, hot soups, but is such a brilliant idea, it's amazing that more folks haven't stolen the concept and created their own hot soup paradise. Usually packed with neighborhood regulars, it's the perfect place to stop by on your way home from work, when you're starving and just don't want to drop another twenty bucks. The huge black cauldrons of freshly made soup always fog up the windows and you can smell the various herbs and spices they use all the way down the block. In the summertime, the Italian ices reign queen (the most popular flavors are cantaloupe, strawberry and lemon) and you'll never have to drop more than six bucks just to fill your belly.

—*Misty Tosh*

Yoshi's

Fancy food, delectable desserts, and Yoshi himself.

$$$$

3257 N. Halsted St., Chicago 60657
(at School St.)

Phone (773) 248-6160

CATEGORY	Japanese fusion
HOURS	Tues-Thurs: 5 PM-10:30 PM
	Fri/Sat: 5 PM-11 PM
	Sun: 11 AM-2:30 PM; 5 PM-9:30 PM
GETTING THERE	Valet, street parking
PAYMENT	VISA MasterCard AMERICAN EXPRESS Discover
POPULAR DISH	All dishes are unique because they have Japanese, American, Italian, and French influences—all mixed together. Pecan breaded pork tenderloin with Asian noodle with sweet and tangy tonkatsu sauce and julienne vegetable, red pepper oil with sesame apricot sauce. Sometimes they have a halibut special – the grilled halibut rests on a delicious crab cake, and they both sit in a shrimp bisque
DRINKS	Full bar, extensive wine list
SEATING	Many tables. Can seat about 90 people.
AMBIENCE/CLIENTELE	Yoshi's is unusual in that it serves impeccable food in a café-like surrounding. So, while the food is a gift to your taste buds and the presentation a gift to your eyes, the dining room is rather modest and comfortable. The wait staff makes excellent recommendations and attends to your every need. While it is more casual than a lot of upscale restaurants, don't dress in jeans and a sweatshirt—you will feel out of place. The clientele here is delightfully mixed. You can see residents of Boystown out for neighborhood treat, but since it is also a destination restaurant, there are couples and groups of all ages sitting at tables, waiting to be dazzled by Chef Yoshi Katsumura's latest creations. Yoshi himself often swings by the tables after you've finished your entrée to make sure you loved it. Personal touches like these keep customers coming back again and again. Whatever you do, save room for dessert. The dessert tray will be presented to you … don't send it away! Order the "Mille"—creamy chocolate mousse and berries nestled between two crispy wafers and topped with pecan ice cream.
EXTRAS/NOTES	Go on Wednesdays! They feature. 1/2 price bottles of wine! To keep costs down, split an appetizer, entrée, and dessert. That way you get all the taste and half the bill.

—*Michelle Hempel*

Andalous Moroccan Restaurant

Authentic food from all regions of Morocco.
$$$
3307 N. Clark St., Chicago 60657
(north of Belmont Ave.)
Phone (773) 281-6885
www.andalous.com

CATEGORY	Moroccan

HOURS	Sun–Thurs: 2 PM–10 PM Fri/Sat: 2 PM–11:30 PM
GETTING THERE	Metered street parking, Brown, purple, and red lines, Belmont stop, #22 and 77 busses
PAYMENT	VISA MasterCard
POPULAR DISH	Kebabs, marinated and served over a bed of couscous and vegetables
UNIQUE DISH	Tagine—traditional Moroccan-style cooking at a high degree in a cone-shaped, clay pot
DRINKS	Sodas, iced tea, orange juice, Green Mint Tea—mint leaves steeped with tea and heavily sugared-- as good as dessert.
SEATING	Accommodates 65 inside and patio outside seats another 65
AMBIENCE/CLIENTELE	Decorated with Moroccan artifacts, such as pottery, musical instruments, and textiles, you'll also hear music from various regions of Morocco.
EXTRAS/NOTES	Owned and operated by a family from Northeastern Morocco. They can also accommodate parties and gatherings.

—Heather Augustyn

El Burrito Mexicano

Mexican, Mexican.
$
936 W. Addison St., Chicago 60613
(east of Clark St.)
Phone (773) 327-6991

CATEGORY	Mexican
HOURS	Sun–Thurs: 10 AM–2 AM Fri/Sat: 10 AM–4:30 AM
GETTING THERE	Metered street parking, if you're lucky. Otherwise red line, Addison stop, or #22 and 152 busses
PAYMENT	Cash only
POPULAR DISH	Burritos and guacamole top the list. Also try the tacos, tamales, tostadas, quesadillas, and breakfast selections served with rice, beans, and tortillas.
UNIQUE DISH	Beef tongue tacos
DRINKS	Horchata, limonada
SEATING	Six tables/booths
AMBIENCE/CLIENTELE	Fluorescent lighting, plywood and linoleum; clientele can get sloppy after a Cubs game or midnight
EXTRAS/NOTES	"For here" orders are served with chips and four types of salsa.

—Robyn Porter

El Jardin Restaurant

Wrigleyville cantina smacks of Mexico, margaritas and mayhem
$$
3335 N. Clark St., Chicago 60657
(at W. Buckingham Pl.)
Phone (773) 528-6775 • Fax (773) 528-0857

CATEGORY	Mexican lunch/dinner joint
HOURS	Mon-Thurs: 11 AM-10:30 PM
	Fri/Sat: 11:30 AM-midnight
	Sun: 11 AM-10:30 PM
GETTING THERE	Street parking and metered parking are somewhat hard to find, especially on the weekends
PAYMENT	VISA MasterCard AMERICAN EXPRESS DISCOVER
POPULAR DISH	Carne asada: Buttery flank steak grilled to perfection
UNIQUE DISH	In a city full of Mexican eateries, this Wrigleyville mainstay serves up the best chunky, made-to-order guacamole on the Northside.
DRINKS	Margaritas and full bar
SEATING	Seats 150
AMBIENCE/CLIENTELE	Replete with rabid Cubs fans, unruly children and neighborhood Northsiders, the hungry hordes keep this backroom barrio packed to the gills. The standard is to kick back, chill and guzzle a blended margarita, an icy-cold Corona or a silky smooth shot of tequila, while downing basket-after-basket of freshly fried chips and homemade salsa.

—*Misty Tosh*

Heaven on Seven

(see page p. 8)
Cajun
3478 N. Clark St., Chicago 60657 (773) 477-7818
(Live music every Sunday from noon until 2 PM)

Leona's

(see page p. 21)
Italian
3215 N. Sheffield, Chicago 60657
Phone (773) 327-8861

Messner's Wrigleyville

Killer Deli—short 'n' sweet.
$$
3553 N. Southport Ave., Chicago 60657
(south of Addison St.)
Phone (773) 325-0123

CATEGORY	Pub grub and sandwiches
HOURS	Mon–Fri: 11 AM–8 PM
	Sat/Sun: 11 AM–6 PM
GETTING THERE	Metered street parking, Brown line, Southport stop, #152 bus
PAYMENT	VISA MasterCard AMERICAN EXPRESS DISCOVER
POPULAR DISH	Reuben's and spicy turkey sandwiches
UNIQUE DISH	Low fat/fat free options

DRINKS	Full bar
SEATING	Plenty of booths and tables
AMBIENCE/CLIENTELE	Typically a young, Lakeview crowd
EXTRAS/NOTES	This Wrigleyville pub is a no-frills, darned good place to grab a bite. As a sandwich aficionado, I'd venture to say that their honey ham with havarti is close to the best sandwich that had graced my lips. They make 'em cold, they make 'em hot, plus they offer a variety of salads, soups, and pub grub to tempt the palate.

—*Trisha L. Falb*

Pick Me Up

Funky low-key hangout
nourishes neighborhood night owl's
$$

3408 N. Clark St., Chicago 60618
(at Roscoe St.)
Phone (773) 248-6613 • Fax (773) 248-6722

CATEGORY	Low-key coffee bar/restaurant
HOURS	24/7
GETTING THERE	Metered parking, easy except for Cubs games nights
PAYMENT	VISA MasterCard AMERICAN EXPRESS DISCOVER
POPULAR DISH	The black bean vegetarian chili cheese fries are smothered in real cheddar cheese and loaded with huge dollops of sour cream. Out of this world and trust me, you will not want to share. The menu is half for meat eaters and half for vegetarians (heavy on the vegan side), and all with a very heart-healthy twist.
UNIQUE DISH	The brownie ice cream sundae is outrageous and unforgettable. Served in a deep white bowl, the bottom is first covered with chunks of soft, dark brownie, then layered with three huge scoops of vanilla ice cream and topped off with swirls of warm chocolate sauce. The capper is about a cup of vanilla whipped cream, little sugar sprinkles and a perfectly unblemished maraschino cherry. I know it all sounds simple, but when you dig into the dish and hit rock bottom with the long teaspoon, the brownie bits have beautifully caramelized from the cold of the ice cream and have become chewy and hard, all at the same time. Every single bite unleashes a new face from everyone I've convinced to share one with me; really, just a parade of clown faces are unveiled, it's that brand of rapture. Beware though, sometimes, it can get ugly.
DRINKS	No Liquor or BYOB. Loads of coffees, teas, and sodas. Caffeine is king here.
SEATING	Seating for 90
AMBIENCE/CLIENTELE	A diverse crowd of exhausted college students, budding artists, and lazy musicians treat this offbeat hangout as a home away from home. The menu reeks of comfort, with a socially conscious spin, and the always-kickin' background music makes you feel like your actually getting something accomplished. Always consistent, the kids in the kitchen never let

you down, and the backyard, art-house feel of the place is perfect for chillin' all day, gettin' high off the super-strong java and coming up with your next brilliant idea.

EXTRAS/NOTES The vegan milkshakes, made with soy ice cream, are extremely popular.

—*Misty Tosh*

P S Bangkok Restaurant

(see page p. 44)
Thai
3345 N. Clark St., Chicago 60657
Phone (773) 871-7777

Salt & Pepper Diner

50s style diner that is timelessly cool.
$$
3537 N. Clark St., Chicago 60657
(south of Addison St.)
Phone (773) 883-9800

CATEGORY	Diner (American Retro)
HOURS	Mon–Thurs: 7 AM–10 PM Fri/Sat: 7 AM–midnight Sun: 7 AM–4 PM
GETTING THERE	Metered street parking, Red line, Addison stop, #22 and 152 busses
PAYMENT	Cash only
POPULAR DISH	Great breakfast items: omelets, pancakes, and eggs; hash browns are the best in the city—perfectly crisp and greasy.
UNIQUE DISH	Banana Nut French Toast; meatloaf sandwich served on French bread; grilled salmon with veggies and potatoes.
DRINKS	Sodas, shakes, malts, root beer floats, Brown Cow, and beer
SEATING	Tables, booths, and counter to seat 85
AMBIENCE/CLIENTELE	Chrome-rimmed tables and booths surround a long counter, which faces the sizzling grill. Waitresses are an updated version as the ones from Mel's Diner.
EXTRAS/NOTES	60 oz. pitchers of Rolling Rock and Miller Lite for just six bucks!
OTHER ONES	• Lincoln Park: 2575 N. Lincoln Ave., Chicago 60614, (773) 525-9575

—*Leanne Sharoff*

"There is no sincerer love than the love of food."
—*George Bernard Shaw*

ROSCOE VILLAGE

Always Thai

Thai food that goes way beyond the norm.
$$

1825 W. Irving Park Rd., Chicago 60613
(east of Wolcott Ave.)
Phone (773) 929-0100 • Fax (773) 929-5726

CATEGORY	Thai
HOURS	Mon–Thurs: 11 AM–9:30 PM
	Fri/Sat: 11 AM–10 PM
GETTING THERE	Street parking, Brown line, Irving Park stop, #80 bus
PAYMENT	VISA MasterCard AMERICAN EXPRESS DISCOVER
POPULAR FOOD	Chicken satay, pad thai, spring rolls, vegetarian curries, ginger beef
UNIQUE FOOD	Chive Dumplings with dark soy sauce, Asparagus Soup, Ho-Moke Salmon—spicy, curried fish with coconut milk and Thai herbs, Taro Custard
DRINKS	Sodas, juices, Thai iced coffee and tea, coffee, tea
SEATING	About fifteen tables
AMBIENCE/CLIENTELE	Pleasant, windowed storefront that's busy for the $4.99 lunch specials; mostly area residents, businesspeople, and students during the day, plus commuters and artistes at night, great service.
EXTRAS/NOTES	The chef here trained at Chicago's preeminent Thai restaurant, Arun's, so you know the food is phenomenal.

—*Victoria Cunha*

Costello Sandwich & Sides

*Superb sandwiches and slammin' sides are
a tough act to follow!*
$$

2015 W. Roscoe St., Chicago 60618
(west of Damen Ave.)
Phone (773) 929-2323 • Fax (773) 929-2372
www.sandwichme.com

CATEGORY	Sandwich Shop
HOURS	Mon–Sat: 11 AM–9 PM
	Sun: 11 AM–7 PM
GETTING THERE	Metered street parking, Brown line, Addison and Paulina stops, #50, #77, and #152 busses
PAYMENT	VISA MasterCard AMERICAN EXPRESS DISCOVER
POPULAR FOOD	Smokin' Turk—delicious, smoked turkey breast and cheddar cheese baked on an Italian sub, topped with lettuce, tomato, onion, sweet pepper rings, and mayo
UNIQUE FOOD	The Mess—beef, pastrami, Genoa salami, provolone cheese, French fries (yes, on the sandwich), coleslaw, and tomato, all sandwiched on Costello's great Italian bread and oven-baked…tasting is believing!
DRINKS	Sodas, juice, coffee, tea
SEATING	A tight squeeze, but well worth it; 12-16 counter seats along the wall and 24 seats outdoors, weather permitting.

AMBIENCE/CLIENTELE	Very casual, low key crowd, mostly Roscoe Villagers, though this is a place for all
EXTRAS/NOTES	You won't find better sides anywhere! Mouthwatering garlic red skin mashed potatoes and Grandma Costello's Mostaccioli Marinara will have you begging for mercy. Check out the red pepper hummus, served with tomato-basil tortillas—yeow!!
OTHER ONES	• Lincoln Square: 4647 N. Lincoln Ave., 60625, (773) 989-7788

—*Michelle Burton*

El Tinajon
Sunny Guatemalan storefront whips up authentic fare for the adventurous palate
$$

2054 W. Roscoe St., Chicago 60618
(at Hoyne Ave.)
Phone (773) 525-8455 • Fax (773) 525-8664

CATEGORY	A neighborhood Guatemalan joint that's very popular at lunch and dinner with the margarita-slurping locals.
HOURS	Mon-Thurs: 11 AM-10 PM Fri: 11 AM-11 PM Sat: 9 AM-11 PM Sun: 9 AM-9 PM
GETTING THERE	Free street parking and metered parking are easy to find.
PAYMENT	VISA · MasterCard · American Express · Discover
POPULAR FOOD	Callo de Pollo: Gigantic bowl of chicken stew, loaded with corn-cobs, chunky potatoes, green beans and hearty homemade chicken broth. Served with rice and homemade corn tortillas, it's the quintessential winter soup. The deliciously fried yucca appetizer is peppered with loads of fresh garlic and butter, and yet somehow it maintains the sweet flavor of fresh yucca.
UNIQUE FOOD	The refried black beans are awesome and the veggie burrito is truly one of the best in the city. It's chock full of beans, yellow rice, chopped lettuce, diced tomato, melting white cheese, and chunks of avocado. Served smothered in red sauce and cheese, be prepared to split the feast.
DRINKS	A full bar offering lethal margaritas, sangrias, and specialty beers. Guatemalan coffee, espresso and horchata are also served.
SEATING	Seats 40
AMBIENCE/CLIENTELE	This cheery Roscoe Village hideaway is a kid-friendly, loaded-with-natives type of place. The sunny walls make you feel like you've hit the jackpot, bolted from the city and gotten off the plane on the beaches of Guatemala. Tasty, authentically inspired platters of food come out of the kitchen slow and steady, as if the cooks had not a care in the world. The happy servers, who are moseying about filling your chip baskets and replenishing your salsa, make the wait worthwhile. Oh, and maybe that pitcher of potent 'ritas has a little to do with the happy-go-lucky attitude you've suddenly adopted.

—*Misty Tosh*

Hot Doug's: The Sausage Superstore

Dogs with a twist—it doesn't get any better than this!

$

2314 W. Roscoe St., Chicago 60618
(west of Damen Ave.)
Phone (773) 348-0326 • Fax (773) 348-0488
www.hotdougs.com

CATEGORY	Hot Dogs
HOURS	Mon–Sat: 10:30 AM–4 PM
GETTING THERE	Metered street parking, Brown line, Addison and Paulina stops, #49, #50, #77, and #152 busses
PAYMENT	Cash only
POPULAR FOOD	The Dog—"nuff said"
UNIQUE FOOD	The Raquel Welch—hot, HOT Andouille sausage cooked the way you like it; the best veggie dog this city has to offer
DRINKS	Soda, bottled water, iced teas
SEATING	Space for approximately 28
AMBIENCE/CLIENTELE	Walls covered with Elvis memorabilia and anything Madonna. Very cool crowd, laid back, lil' bit of this, lil' bit of that.
EXTRAS/NOTES	The owner will always greet you with a smile, and you'll be best friends before you leave. Every Friday and Saturday, stop in for fresh-cut potatoes cooked in duck fat! Say what??

—*Michelle Burton*

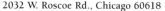

Kaze

Sleek, neophyte Japanese sushi bar

$$$$

2032 W. Roscoe Rd., Chicago 60618
(at Seeley Ave.)
Phone (773) 327-4860 • Fax (773) 327-4870
www.kazesushi.com

CATEGORY	Upscale Japanese/Sushi restaurant that is extremely neighborhood friendly
HOURS	Daily: 5 PM-11 PM
GETTING THERE	Some metered, some street parking, and valet service
PAYMENT	VISA MasterCard AMERICAN EXPRESS DISCOVER
POPULAR FOOD	Delicate whitefish tempura, wrapped around shrimp and layered on a bed of creamy parsley butter sauce. This appetizer is so unique stone-cold addictive, I've been know to order three in one meal.
UNIQUE FOOD	While it's a little high on the Hungry? range, the Chef's Tasting Menu is a great deal. For $50 flat per person, the chef will prepare dish after dish of tempting house specialties. In the end, it works to be the best deal because the food is so delicious, you cannot stop ordering. Just put it all in his hands and make life easier, that's the best scenario, plus you cap the cost, to boot.
DRINKS	Full bar, with specialty drinks appearing every season
SEATING	Small and appealingly cozy, Kaze seats 35 to 40 people, with about nine people at the sushi bar

AMBIENCE/CLIENTELE	Elegant, black-clad sushi connoisseurs flock to this new Roscoe Village hot spot. Reservations are mandatory, especially on the weekends, when the wait could be hours. The vibe is super clean, natural and sleek, and the chefs are artisans of display and create the most tantalizing array of Japanese cuisine on the Northside. Good for a date, an anniversary, or an important meeting meant to impress, Kaze has raised the bar for sushi restaurants across the city. The crowd is good looking, upscale, and credit card heavy; you definitely need it for a place like this. Not because the prices are so outlandish, it's just that you can't stop ordering.
EXTRAS/NOTES	Chicago magazine named Kaze one of the best new restaurants in town and the "pretty boy" chef team has worked at some of the best sushi houses in the city (Mirai, Heat, and Sushi Samba Rio) and their skill with the knife is awesome to watch. Thankfully, it's easy to do, with an open sushi bar dominating the room.

—Misty Tosh

Kitsch'n on Roscoe
*Like food? Like kitsch? Then you'll
like Kitsch'n.*
$$
2005 W. Roscoe St., Chicago 60618
(just west of Damen Ave.)
Phone (773) 248-7372
www.kitschn.com

CATEGORY	Comfort Food
HOURS	Tues–Sat: 9 AM–10 PM Sun: 9 AM–3 PM
GETTING THERE	Metered street parking; #50 bus
PAYMENT	VISA MasterCard AMERICAN EXPRESS
POPULAR FOOD	Southern Fried Chicken Dinner—so good it goes straight to your thighs!
UNIQUE FOOD	Jonny's Lunch Box—served in a real, retro-lunchbox! Also includes your choice of a Twinkie or Ding Dong.
DRINKS	Sodas (including Tab and Fresca); Tang; orange juice, lemonade; smoothies; coffee, hot cocoa; all kinds of alcoholic drinks that come with umbrellas and little swords stuck in fruit wedges.
SEATING	About 50, indoors and out
AMBIENCE/CLIENTELE	Á la 1974; essentially an upscale diner, if there can be such a thing; tons of fun stuff to look at—all of which would be a little too cute if it weren't tongue-in-cheek; play Chutes and Ladders or doodle on an Etch-a-Sketch while you wait for your food.
EXTRAS/NOTES	Kitsch'n is a fun place to get a decent bite to eat. Actually, the food hardly matters because you'll be too transfixed, bedazzled, and generally mystified by the hypnotic movements of the dancing Elvis clock to taste much of the grub you've shoveled into your stomach. Eating here will bring home the fact that, somewhere in your DNA, you're encoded to recognize that playing with Mr. Potato Head is a perfectly worthy method of spending time.

—Colin Lohse

Robey Pizza Company

Pizzas and oven-baked sandwiches, too!

$$

1954 W. Roscoe St., Chicago 60657

(east of Damen Ave.)

Phone (773) 248-7800

CATEGORY	Pizza/Sandwich Shop
HOURS	Mon–Sat: 11 PM–11 PM
	Sun: 11 AM–10 PM
GETTING THERE	Street parking; Brown line, Paulina and Addison stops; #11, 50, and 77 busses
PAYMENT	VISA MasterCard AMERICAN EXPRESS DISCOVER
POPULAR FOOD	Personal pizzas, topped with Asiago cheese, mozzarella, onions, and spicy sausage
UNIQUE FOOD	Oven-baked chicken pesto on a French roll—to die for!
DRINKS	Sodas, lemonade, iced tea, Powerade
SEATING	Accommodates 35
AMBIENCE/CLIENTELE	Very casual; rustic, old-Italian theme
EXTRAS/NOTES	This is a great place to grab a pizza and have a drink at the adjoining Riverview Tavern.

—*Michelle Burton*

Su Van's Café & Bakeshop

Bright and cheery gem of a restaurant with a small-town feel.

$$

3351 N. Lincoln Ave., Chicago 60657

(south of Roscoe St.)

Phone (773) 281-0120

CATEGORY	Café
HOURS	Mon–Fri: 10 AM–7 PM
	Sat: 9 AM–6 PM
	Sun: 9 AM–3 PM
GETTING THERE	Metered street parking, Brown line, Paulina stop #11 bus.
PAYMENT	Cash only
POPULAR DISH	Excellent Panini sandwiches, a different specialty soup every day. Try the split pea.
UNIQUE DISH	Homemade sweets and breads
DRINKS	Sodas, juices, coffee, and tea
SEATING	Ten tables.
AMBIENCE/CLIENTELE	Friendly, cheery, and welcoming A Bridges of Madison County kind of feel.
EXTRAS/NOTES	Sandwiched between a Hallmark card shop and a massive thrift store, I was thrilled to find a quaint, friendly little café/bakery with some of the best panini sandwiches around. This open and airy restaurant has large floor-to-ceiling windows, bright yellow walls, and a case chock full of enticing scones, breads, cookies, cakes, and brownies. The ambience is low-key and the menu is inventive, with cleverly named items and descriptions. Most enjoyable? The Lean-Mean Turkey Supreme.

—*Trisha L. Falb*

Thai "Linda" Café

Tasty Thai cuisine—the secret's in the curry!

$$$

2022 W. Roscoe St., Chicago 60618

(west of Damen Ave.)

Phone (773) 868-0075, 868-0163 • Fax (773) 868-1020

www.thailinda.com

CATEGORY	Thai
HOURS	Sun–Thurs: 11 AM–9 PM Fri/Sat: 11 AM–10 PM
GETTING THERE	Metered street parking, Brown line, Paulina and Addison stops, #11, 50, 77 busses
PAYMENT	VISA MasterCard AMERICAN EXPRESS
POPULAR FOOD	Angel Wings appetizer—boneless chicken wings stuffed with crab meat, minced chicken, and Asian noodles, Thai custard—bean cake baked with coconut milk, eggs, and palm sugar
UNIQUE FOOD	Deep fried catfish with your choice of basil, red curry, or hot sweet and sour sauces
DRINKS	BYOB, fruit smoothies, teas, juices, and soda
SEATING	Accommodates 45-50
AMBIENCE/CLIENTELE	Very cozy and quiet spot that's also open and airy. Expect soft music, a laid-back crowd, and friendly staff and patrons
EXTRAS/NOTES	This a great place to go during the summer, as the outdoor seating looks out onto Roscoe St., the neighborhood strip.

—Michelle Burton

Turquoise Café

Sexy supper club demands refined palate

$$

2147 W. Roscoe Rd., Chicago 60618

(at N. Leavitt St.)

Phone (773) 549-3583 • Fax (773) 549-3748

www.turquoisedining.com

CATEGORY	Ethnic neighborhood restaurant
HOURS	Mon-Thurs: 1 AM-11 PM Fri/Sat: 11 AM-1 AM Sun: 11 AM-10 PM
GETTING THERE	Street parking and metered parking are very easy to find
PAYMENT	VISA MasterCard AMERICAN EXPRESS
POPULAR FOOD	Salt crusted sea bass, served whole, straight out of the oven and sealed with a flame tableside. People go nuts over the kabobs, especially the tender lamb and though not on the menu, the potato soufflé is the creamiest melt-in-your-mouth potato concoction you'll ever taste. They will bring out a slab for anyone who asks.
UNIQUE FOOD	Manti—served liked it was just a big fat bowl of pasta alfredo, the presentation was a bit deceiving, but after rooting around through the sauce and discovering noodle after fluffy noodle full of a

slightly spicy ground meat and swishing hunks of warm bread through the extremely creamy (but somehow super light) garlic yogurt sauce, I realized I'd never tasted anything quite like it. The top of the dish was coated with a heavenly marinara sauce, full of fresh tomatoes, chunks of garlic and loads of chili oil. Of course I had to dissect a few noodles to inspect the meat: I was stunned after opening the pasta pockets because the meat, which tasted so dense and intense, was barely more than a pinky thumbnail of nutmeg-scented ground beef. Those crazy Turkish cooks, so clever.

DRINKS	Full bar, with Turkish wines being very popular
SEATING	Seating for 70
AMBIENCE/CLIENTELE	You know it's authentic when even the natives pack the house. Not only have they embraced this as the premiere Turkish restaurant in the city, even the neighborhood foodies have quickly adopted this sleek eatery as a local favorite. It's a comfortable place to hang out any time of the day, due to the warm atmosphere and it feels like you're visiting a long lost relative. The smoldering gazes from the suave clientele is always flattering and the unforgettable food keeps you coming back for more. (It's not those gazes, I swear).
EXTRAS/NOTES	The owner Zengo is a perfect host, always so happy to see everyone and a real foodie; he just stared importing his homelands premier Turkish olive oil, which he serves at every table with warm, homemade sesame bread (always alongside a small dish of addictive hummus or maybe a creamy carrot, yogurt dip, too). I especially adore ZiZi, the ever-present old-school waiter because of A) His lack of English and incessant accent-heavy ramblings coupled with wild, frenzied giggles and B) The way he'll create a meal for you that isn't on the menu, using the what could be terrifying phrase "Trust me." I always do, though, and he is always right on the money.

—Misty Tosh

Victory's Banner

Come in with an appetite, leave a little closer to enlightenment.

$$

2100 W. Roscoe St., Chicago 60618
(at Hoyne Ave.)
Phone (773) 665-0227

CATEGORY	Vegetarian
HOURS	Wed–Mon: 8 AM–3 PM
GETTING THERE	Metered street parking, #50 bus.
PAYMENT	VISA MasterCard AMERICAN EXPRESS Discover
POPULAR FOOD	Victory's Banner Award-Winning French Toast or Peace-Love-Bliss Burger
UNIQUE FOOD	Uppama—"India's answer to cream of wheat", Spring Chicken Salad (with grilled soy chicken)
DRINKS	Chai—hot or iced, Mango Lassi, Green Tea Cooler, coffee, teas, Italian hot chocolate, sodas, juices,

	mineral water
SEATING	Seats 32 indoors plus six tables or so outdoors in nice weather
AMBIENCE/CLIENTELE	This peaceful and bright spot where the waitresses wear saris is owned, operated, and staffed by devotees of Sri Chinmoy, whose paintings adorn the walls. Look for the photo of the guru lifting massive weights on the back wall. The clientele is a mix of Roscoe Villagers and the spiritually minded
EXTRAS/NOTES	In the evenings, classes are offered (for free!) in meditation, music, and Sri Chinmoy's teachings. Cards, incense, books, and music are available for sale at the front of the restaurant. Don't forget to sign up for the Meal and Chai Club cards—get a stamp each time you purchase, and the 11th one is half off!

—*Courtney Arnold*

My Kind of Town*: The Chicago Culinary Cheat Sheet

Only in the Windy City for a few days? You've shopped till you dropped on Michigan Avenue, cried into your drink at the Blues clubs, and snuggled up to your honey on the Ferris Wheel at Navy Pier—but no visit would be complete without sampling a few of our local culinary specialties.

Chicago-Style Hot Dogs: Don't even think of dubbing your dog a Chicago-Style without the requisite toppings—yellow mustard, sweet relish, freshly chopped onions, one kosher dill pickle spear, sliced tomatoes, hot peppers, and, last but not least, a dash of celery salt. Perfection! Check out: *Gold Coast Dogs 159 N. Wabash Ave., (312) 917-1677, Clark Street Dog, see page 56, or Murphy's see page 80.*

Italian Beef: Roll up your sleeves and dive into this classic sandwich, made with thinly sliced, melt-in-your-mouth roast beef served up on an Italian roll with grilled peppers, hot giardinara, and a gravy seasoned just so. If you only have one in your whole life, get it from Mr. Beef on Orleans St. (see page 22).

Pizza: This ain't your East Coast, thin crust, floppy, folded pie. Chicagoans know how to do it up deep dish with a thick, bready crust, lots of sauce, and cheese, cheese, cheese. See page 27 for a list of hometown favorites.

Maxwell Street Polish Sausages: Nothing will warm you up on a brisk day like a juicy, sweet Polish on a toasted bun, complete with spicy grilled onions and brown mustard. While the Maxwell Street district itself has changed face over time, this favorite lives on. See page 58 for the complete history.

Garrett's Popcorn: Walk a few blocks in the Loop and you're bound to run across one of their four locations. Hint: follow your nose and look for the line that goes out the door and around the corner! Have patience, and you will be rewarded. Try a combo bag of Caramel Crisp and Cheese Corn—just make sure to grab

plenty of napkins. Check ouy locations at *670 N. Michigan, 26 East Randolph, 4 East Madison, and 2 West Jackson.*

The Original Rainbow Cone: A Chicago tradition since 1926. Even the best imagination can't do justice to this creamy combination of five flavors—chocolate, strawberry, palmer house cherry, and pistachio ice creams, topped with orange sherbet, all on one cone. You've got to taste it to believe it. *(9233 S. Western, (773) 238-7075)*

Soul Food: Remember that scene in *The Blues Brothers* when Aretha Franklin sheds her apron and gets down in the dining room of her Soul Food restaurant? We can't guarantee musical accompaniment, but head to the South Side and you're sure to find some down home cookin' worth singing about. For starters, check out *Soul Vegetarian East,* see page p.166.

Note: the following are not just food items, they are Chicago Institutions!

UPTOWN

New Saigon Restaurant

Flavorful and authentic? Yes, and the owner will also be your new best friend.
$$

5000 N. Broadway St., Chicago 60640
(north of Argyle St.)
Phone (773) 334-3322

CATEGORY	Thai
HOURS	Daily: 10 AM–10 PM
GETTING THERE	Feed thy meter as thou feedest thyself and #36 bus
PAYMENT	Cash only
POPULAR FOOD	Juicy, marinated pork chop with rice, Lemongrass chicken with rice (so good that regulars write songs about it)
UNIQUE FOOD	Bún Chả Giò—steamed rice noodles with egg rolls, lettuce, cucumbers, bean sprouts, and mixed fish sauce; battered frog legs fried in butter
DRINKS	Soybean milk, Thai iced coffee, guanabana shake sodas, lemonade coffee, tea
SEATING	Seats 40 plus in nondescript tables.
AMBIENCE/CLIENTELE	Lots of regulars and soon-to-be regulars here. Low-key décor.
EXTRAS/NOTES	Truthfully, the only reason you'll notice your surroundings is if Anthony, the owner, isn't chatting with you or you haven't yet begun burying your face in the food. If you do notice the décor, then you will agree that there's nothing much to write about. Anthony, on the other hand, could fill a couple of chapters. Also, try ordering in French—the man has more than one talent.

—Justin Goh

Siam Noodle & Rice

Tucked away and tasty—a cozy favorite of the Thai community.

$$

4654 N. Sheridan Rd., Chicago 60640

(north of Wilson Ave.)

Phone (773) 769-6694

CATEGORY	Thai
HOURS	Tues–Fri: 11 AM–4 PM; 5 PM–9 PM
	Sat: 11:30 AM–4 PM; 5 pm–9:30 PM
	Sun: 11:30 AM–4 PM; 5 PM–8 PM
GETTING THERE	Street parking, Red line, Wilson stop, #151 bus
PAYMENT	VISA MasterCard (minimum $12)
POPULAR FOOD	Homemade Thai pork sausage, sticky rice
UNIQUE FOOD	Eight kinds of soup, papaya salad, roast duck
DRINKS	Thai iced coffee and tea; sodas
SEATING	Room for 40
AMBIENCE/CLIENTELE	Simple surroundings; happy, hungry customers busy enjoying themselves; on the dark side, but not in the seedy sense—sets the mood for a romantic night out.
EXTRAS/NOTES	Strange but true, Siam Noodle & Rice serves only one shrimp dish! Also, if you can read Thai, the menu is bilingual for your practicing convenience.

—*Justin Goh*

Places in Chicago to Break Out a Party (Without Breaking the Bank)

Hosting a group event can be expensive; but if you're in the know, your friends can have food to nosh on, libations to drink, and a great time to remember without putting a strain on your bank account. Here are some of the best places around Chicago that will host your group in a private, or semi-private, setting and accommodate your food and drink needs for a decent price:

The following prices do not include tax or gratuity

Govnor's Pub

There are two sections of this active downtown bar that can be sectioned off for your group. The semi-private setup in this traditional pub setting can accommodate groups from 20-150 people. Event planners will provide any food off of their menu, such as mini Italian beef sandwiches, buffalo chicken fingers, and tacos, starting at $2.95 per person, per hour for a two-hour minimum. Add a beer and wine package for just $4.50 per person, per hour. (*The Loop: 207 N. State St., Chicago, 60601, (312) 236-3696, www.govnors.com*)

Lou Malnati's Pizzeria

Lou Malnati's is known for its Chicago-style deep-dish pizzas and terrific pastas. Now your group of twenty or more can dine in this River North location's private rooms without paying a room fee. A two-hour party with unlimited pizza and soda will start at only $7.75 per person, and set up can be either sit down or cocktail

reception style. For $12.50 per person, the same party can include a beer and wine package! Additional options, such as desserts, pastas, and salads, can help you to customize the event according to your needs. The hardwood floors and exposed-brick walls make this Italian restaurant the perfect, comfortable location for mingling. *(The Loop: 439 N. Wells St., Chicago, 60610, (312) 828-9800, www.loumalnatis.com)*

Café Suron

Your group of 10-50 will enjoy Persian cuisine in the restored lobby of an old Rogers Park hotel. Ordering off of the menu in one of two private rooms, you can expect to pay about $10 per person for entrees and between $3-$8 for appetizers, with no room rental fee. Entrees such as marinated chicken kebabs or salmon with sun-dried tomatoes, garlic, red peppers, and black olives or appetizers of hummus, fattoush, or dolmas are definite crowd pleasers, and a change of pace from the usual party-fare. This location has no liquor license, but feel free to bring your own wine—if you don't mind paying a corking fee of $7 per bottle. *(Rogers Park, 1146 W. Pratt Blvd., Chicago, 60629, (773) 465-6500, www.cafesuron.com)*

John Barleycorn

This popular Lincoln Park bar caters to DePaul University students, neighborhood locals, and tourists alike. John Dillinger even frequented this bar back in the 1920s, when it was a speakeasy. A private back room will accommodate large groups of over 100, and requires no room rental fee. A beer, wine, and well liquor package starts at $15 per person for three hours, and you can add flautas, egg rolls, a veggie tray, chicken wings, and tasty cheese quesadillas for $6 more per person. The room has a hardwood floor, contains its own bar and private bartender, a projection screen television that can play your own videos, and plenty of sitting or standing room. *(Lincoln Park: 658 W. Belden Ave., Chicago, 60614, (773) 348-8899, www.johnbarleycorn.com)*

Cousin's

Your guests will enjoy a private room that can accommodate up to 80 people. There is no minimum number of guests, but there is a minimum amount of $400 that must be spent by your party. Ordering off of the menu, your group will enjoy traditional Middle Eastern dishes such as Turkish delight or delicious beef or lamb kebobs. Vegetarians in your group will especially enjoy the ample selections, including vegetable moussaka. Cousin's also has a liquor license. *(Lakeview: 2833 N. Broadway Ave., Chicago, 60657, (773) 880-0063)*

Four Moon Tavern

Enjoy the couches, wood paneling, and knickknacks in this cozy, home-like setting. Private events take place in the back room, which can accommodate 20-40 people comfortably. Bar packages of beer and wine start at $15 per person for three-and-a-half hours, and appetizers start at $6 per person for the same amount of time. Appetizers, including mini crab cakes, hot wings, chicken and pork satay, and perogies, are exceptional. *(Roscoe Village: 1847 W. Roscoe St., Chicago, 60657, (773) 929-6666)*

—Heather Augustyn

RAVENSWOOD/LINCOLN SQUARE

Café Selmarie

Classic American food satiates quirky crowd of regulars

$$

4729 N. Lincoln Ave., Chicago 60625

(at Lawrence Ave.)

Phone (773) 989-5595 • Fax (773) 989-9837

www.cafeselmarie.com

CATEGORY	Classic neighborhood eatery/bakery
HOURS:	Mon: 11 AM-3 PM Tues-Thurs: 8 AM-10 PM Fri-Sat: 8 AM-11 PM Sun: 10 AM-3 PM; 3 PM-10 PM
GETTING THERE	Metered and parking and street parking are relatively easy to find
PAYMENT	VISA MasterCard
POPULAR FOOD	Vegetarian Chili: Impossible to finish, the too-hot-to-touch bone-white bowl comes filled to the brim with hearty chunks of tomato, slivers of green and red peppers, diced celery and (what I'm thinking is the secret ingredient) rattlesnake beans. With the clever disguise of a black bean and the shockingly familiar consistency of a pinto, it's a rather unexpected final complement; not a single other type of bean is needed. The other secret weapon that Selmarie implements is white cheddar cheese; the entire bowl is smothered with it, perfectly melted and just sharp enough to cause a stir. Two fat wedges of honey-tinged cornbread stand beside the bowl, with a couple packets of creamy Grassland's unsalted butter making a friendly appearance. Thankfully, they're just soft enough (taken out of the fridge hours beforehand), ready to be slathered on, piece by marvelous piece.
UNIQUE FOOD	The Chef dishes up Asian-inspired seafood dishes every couple of days and it makes for a nice twist to the classically American menu. For the veggie lovers, the menu is extremely vegetarian friendly.
DRINKS	Wine, specialty drinks: Bloody Mary's, Mimosa's
SEATING	40 seats inside, 35 outside
AMBIENCE/CLIENTELE	Moms with strollers, first-time home buyers and whimsical Lincoln Square artists claim this bakery and neighborhood haunt as their kitchen away from home. The front bakery bustles with folks buying baguettes, sugar cookies and entire cakes to take home for dinner. All of the incredible desserts are made-from-scratch in house and the mixed fruit custard tarts are pretty enough to swoon over. Back in the dining area, the small tables are tucked nicely between lovely wall art when you find yourself sandwiched between a bakery and a kitchen that makes every dish to order, watch out…ordering can get a little difficult.
EXTRAS/NOTES	They offer a fall wine tasting class and Wed. night, there are half-price bottles of wine. The house specials change every day.

—*Misty Tosh*

Caro Mio

Rustic Italian cucina caters to relaxed neighborhood BYOB'ers

$$$$

1825 W. Wilson Ave., Chicago 60613

(at Ravenswood Ave.)

Phone (773) 275-5000 • Fax: (773) 275-3659

www.caromiochicago.com

CATEGORY	Neighborhood eatery
HOURS	Mon-Thurs: 11 AM-10 PM
	Fri: 11 AM-11 PM
	Sat: 3 PM-11 PM
	Sun: 3 PM-9 PM
GETTING THERE	Free street parking and metered abound
PAYMENT	VISA MasterCard AMERICAN EXPRESS DISCOVER
POPULAR FOOD	Pollo Biomontese, a Chicken breast with a porcini mushroom sauce served with delicate, homemade portabella raviolis and the Tortelloni di Pollo, delicious little chicken stuffed tortelloni, sauteed with julienne sliced chicken breast, white wine, eggplant, parmesan cheese and fresh tomato sauce
DRINKS	BYOB…but only on the inside. If you want to sit at the outdoor patio, you can't bring your drinks with you.
SEATING	Combined indoor and outdoor seating for 67
AMBIENCE/CLIENTELE	The charming, old-world atmosphere brings to life an Italian cucina in the hills of Tuscany. The mixed crowd of regulars sits elbow-to-elbow at the cozy tables and the candlelit vibe makes for an intimate, but comfortable conversation. The owner, who is also the DJ on the weekends, mixes up great compilation disks to complement the beautiful dinner.

—Misty Tosh

Diner Grill

Intimate, 24-hour atmosphere brings dining with strangers to a new level

$$

1635 W. Irving Park Rd., Chicago 60613

(at Marshfield Ave.)

Phone (773) 248-2039

CATEGORY	Counter-style 24 hr. diner
HOURS	24/7
GETTING THERE	Street parking easy to find
PAYMENT	Cash only (ATM inside)
POPULAR FOOD	The slinger: Imagine a huge platter of crispy fried hash browns, topped with two juicy cheeseburgers (loaded with onions), two eggs (any way you take 'em) and a huge ladle of homemade chili on top of all of that. With the bread and butter served on the side, be prepared for a full food coma aftermath.
DRINKS	No alcohol, just coffee, coffee, and more coffee
SEATING	Fourteen at the bar

AMBIENCE/CLIENTELE	This tiny, hole-in-the-wall has exactly what you crave after a long night out of drinking and debauchery: grease, butter, cheeseburgers and platters of eggs, bacon and toast, preferably all at once. The shoulder-to-shoulder bar seats about 14 folks, and look out, there are some doozies that roll through the front door of this one. Peppered with a mix of revelers, cheapo's, and city workers, the most lauded chef's in Chicago's premiere restaurants treat this as their end-of-the-shift treat and are happy to share space with the shady (but friendly) characters that populate the counter. A one-man-shop, the chef manages to treat everyone the same, tune the TV, whip up dish-after-dish of perfectly cooked diner food, and run the register with the skill of a master. I guess it takes one to know one.

—*Misty Tosh*

Garcia's Mexican Restaurant

A burrito stand with class.

$$

1758 W. Lawrence Ave., Chicago 60640

(east of Ravenswood Ave.)

Phone (773) 784-1212

CATEGORY	Mexican-General
HOURS	Daily: 11 AM–10 PM
GETTING THERE	Street parking, #81 bus.
PAYMENT	VISA MasterCard
POPULAR FOOD	Fresh burritos
UNIQUE FOOD	Everything from desayunos (breakfast) to a nice mole sauce
DRINKS	Horchata, liquados, sodas, lemonade, iced tea, coffee, and tea
SEATING	Dining room seats 30
AMBIENCE/CLIENTELE	Chicago police officers—they know where good Mexican food can be found; prominently-displayed TV showing telenovelas and soccer games.

—*Jen Lawrence*

Horseshoe

Redneck Chic on the North Side

$

4115 N. Lincoln Ave., Chicago 60618-3027

(at Belle Plaine St.)

Phone (773) 549-9292

CATEGORY	If "Redneck Chic" is not yet a term, it should be. Texas-style BBQ kitchen is open until midnight, even on nights when bands are playing.
HOURS	Sun-Fri: 6 PM-2 AM
	Sat: 6 PM-3 AM
GETTING THERE	Street parking gets tougher the later it gets, but it's never impossible. You can always take a cab or a bus, but that wouldn't be very "cowboy" of you, now would it?

PAYMENT	
POPULAR FOOD	The Texas BBQ beef brisket is tops. This is a real man's meal. And don't forget the side of mac and cheese.
UNIQUE FOOD	This is the North Side's first cultivated hillbilly bar and grill. Special care was taken to make sure the setting, the food, the beer and the music are even better than authentic.
DRINKS	Buddy, if you're not drinkin' PBR out of a can in this joint, you need to get with the program!
SEATING	The ten tables are spaced widely to encourage dancing. Four leather-backed booths are in the rear.
AMBIENCE/CLIENTELE	This place is casual, but people do tend to sport the cowboy boots and belt buckles here. It's all part of the fun. My standard business casual clothes did not attract unwanted attention—this is not a bar with real rednecks (until some of the bands show up), but hip people who know how to slum it with style.
EXTRAS/NOTES	John Litz, the owner of Horseshoe, has brought together highbrow hipness with low-brow twang. He may not have invented the concept, but he dang-well may have perfected it!

—*Mark Vickery*

La Amistad Restaurant

Quite possibly the city's best chips and salsa!
$
1914 W. Montrose Ave., Chicago 60613
(between Wolcott and Winchester Aves.)
Phone (773) 878-5800

CATEGORY	Mexican-General/American
HOURS	Daily: 9 AM–10 PM
GETTING THERE	Metered street parking, Brown line, Montrose stop, #78 bus
PAYMENT	
POPULAR FOOD	Warm, crispy chips with fresh, spicy salsa, cheap and filling combo platters, veggie tacos
UNIQUE FOOD	American breakfasts, burgers, hot dogs
DRINKS	Sodas, Mexican drinks like Jarritos, Sidral, etc., horchata, liquados, coffee, hot chocolate
SEATING	Six modest booths and a few counter seats
AMBIENCE/CLIENTELE	Super clean and rarely crowded. this spot's popular with Spanish and English speaking locals. The "artwork" here is the kind you would win at a carnival
EXTRAS/NOTES	La Amistad, or "friendship" in English, lives up to its name with consistently gracious service. A few of the combo platters can be a bit pricey, but the rest of the menu is a steal. Also—I've used the bathroom here several times. Spotless! Always a good sign. Delivery available.

—*Sean O'Connor*

Pauline's Breakfast

"A neighborhood place since…as long as anyone can remember."

$$

1754 W. Balmoral Ave., Chicago 60640

(east of Ravenswood Ave.)

Phone (773) 561-8573

CATEGORY	Breakfast
HOURS	Daily: 7 AM–3 PM
GETTING THERE	Street parking
PAYMENT	Cash only
POPULAR FOOD	The extremely inexpensive French Toast, huge omelets, Fresh Fruit Trifecta—a pancake extravaganza
UNIQUE FOOD	Country Time omelet—stuffed with corned beef hash and cheddar cheese; English Cinnamon Crumb ice cream waffle with strawberries and whipped cream.
DRINKS	Bottomless coffee, fresh-squeezed orange juice, milkshakes, sodas
SEATING	Counter, booths, and tables to seat at least a couple of softball teams, plus the neighbors.
AMBIENCE/CLIENTELE	Amazingly friendly and upbeat, but not annoyingly so; mural on the back wall; fish motif in the bathroom.
EXTRAS/NOTES	This is a breakfast and lunch place, and they seem to have realized that their clientele just may be a little bit groggy. If you have to wait, Pauline's will provide orange juice until they can find you a table.

—*Emily B. Hunt*

Pizza D.O.C.

Tuscan-inspired pizza joint for the upscale pie lover

$$

2251 W. Lawrence Ave., Chicago 60625

(at Oakley Ave.)

Phone (773) 784-8777 • Fax (773) 743-2147

www.pizza-doc.com

CATEGORY	Rustic neighborhood eatery and pizzeria
HOURS	Mon-Fri: 5 PM-11 PM Sat-Sun: noon-11 PM
GETTING THERE	Metered parking easy to find
PAYMENT	VISA MasterCard AMERICAN EXPRESS DISCOVER
POPULAR FOOD	All of the wood-fired, uncut (just like in Italy) pizzas are delicious and the most popular is the Pizza Margarita, with fresh basil, homemade tomato sauce with San Marzano tomatoes, and little blobs of mozzarella cheese. All of the pizza dough is fresh and made in-house every day and then fired up in the huge wood-burning brick oven. Another favorite is the Pizza Patate and Rosmarino with fresh mozzarella, thin-sliced potatoes, extra virgin olive oil and fresh rosemary all bundled up into a delicious

platter of heaven.

DRINKS	Full bar and the wine list is extensive.
SEATING	100
AMBIENCE/CLIENTELE	On a lonely stretch of Lawrence Ave., beams the brightly lit exterior of one of the best pizza joints in the city. Though they strive to not "reinvent the wheel," compared to most of the pizza offerings in Chicago, this traditional Italian eatery has legions of devotees clamoring for their pizza, pasta, and salads. The crowd, which is more on the upscale young couple and dinner date-ish side of things, takes full advantage of the help yourself (and you'll be charged accordingly) antipasto bar. The delicious 12" thin-cut pizzas are kept simple and mostly cheeseless, and for the heartier appetite, try any one of the fish specials. Simple food, reasonable prices, friendly wait staff, what's not to love?
EXTRAS/NOTES	They always feature various, fish, steak and veal specials, as well as a rotating risotto dish.

—*Verloren Perdido*

Rockwell's Neighborhood Grill

Neighborhood nice and homeowner hip
$$
4632 N. Rockwell St., Chicago 60625
(at Eastwood Ave.)
Phone (773) 509-1871

CATEGORY	A clean and friendly bar and grill that doubles effectively as a weekend brunch place.
HOURS	Tues-Thurs 11:30 AM–10 PM Sat: 10 AM-2 PM Sun: 9 AM-2 PM
GETTING THERE	Metered parking on Rockwell, but free parking on Wilson St. (one block south). Also a quarter-block from the El train.
PAYMENT	
POPULAR FOOD	You can't go wrong with a Black Angus burger, which comes with a nice selection of side dishes such as pasta or black bean salad.
DRINKS	Rockwell's has a full bar, but apparently does more wine and specialty drink ("Cosmotini," et. al.) business than simple bottles of Budweiser.
SEATING	Roughly a dozen cherry-stained wood tables fill the space before and at the decent-sized bar. Three small tables with bar stools line up near the back door.
AMBIENCE/CLIENTELE	Next to the lovely brick bungalows of the Ravenswood Manor neighborhood where the El trains rolls in at street level (just like in the olden days), Rockwell's Neighborhood Grill welcomes its neighbors with a tasteful setting, tasty menu choices, and a down-to-earth sense of humor. A bowl of Dum-Dum lollipops sit on a stand other venues would place the maitre d'. Rockwell's provides locals with a worthy meet-up spot for weekend brunch, an

after-work drink and dinner, or a night cap before heading home to walk the dogs.

EXTRAS/NOTES Though open a mere ten months, Rockwell's celebrates Chicago's rich history with an entire wall dedicated to black and white photos of skyscrapers being built and old-time streetcars making their way through the Loop. Its unpretentious attitude and quality American fare fits perfectly in the pleasant, pretty neighborhood.

—*Mark Vickery*

Rosded Restaurant

Amazingly authentic Thai food—even the Thai government agrees!

$$

2308 W. Leland Ave., Chicago 60625

(west of Lincoln Ave.)

Phone (773) 334-9055

CATEGORY	Thai
HOURS	Tues–Sat: 11:30 AM–9 PM
	Sun: noon–8:30 PM
GETTING THERE	Street parking, Brown line, Western stop, #11 bus
PAYMENT	VISA MasterCard
POPULAR FOOD	Tom Yum Koong and Tom Kha Kai soups, Panang Beef, Pad Thai
UNIQUE FOOD	Fantastic sticky rice or Fried Whole Fish
DRINKS	Sodas, Thai iced coffee and tea, and Longan juice
SEATING	Small tables to seat 28
AMBIENCE/CLIENTELE	Homey, authentic atmosphere; nice mix of clientele—some Thai, some not.
EXTRAS/NOTES	This is one of my absolute favorite restaurants in Chicago. If that isn't a strong enough recommendation, check out the certificate from the Thai government on the back wall. Around since 1973, which is unusual for Asian restaurants in this city.

—*Emily B. Hunt*

Smokin' Woody's

The Mesquite That Can't Be Beat

$$

4160 N. Lincoln Ave., Chicago 60618

(at Berteau St.)

Phone (773) 880-1100

CATEGORY	This is your prototypical neighborhood BBQ joint.
HOURS	Mon-Fri: 11:30 AM-9 PM
	Sat/Sun: 11:30 AM-11 PM
GETTING THERE	Street parking is decent; if you're doing take-out, you might get to scam a space in the Osco parking lot across the street.
PAYMENT	VISA MasterCard AMERICAN EXPRESS DISCOVER
POPULAR FOOD	Anything—as long as it starts with Bar-Be-Cue! They do have other things on the menu, but really— what's the point?

DRINKS	Woody's serves soft drinks mostly, but does have a modest selection of bottled beers one might expect (Bud, Heineken, etc.).
SEATING	Ten tables line the walkway inside, and a few tables are set up outside in the summer, but folks in-the-know mostly do take-out.
AMBIENCE/CLIENTELE	The smell of burning wood chips when you walk in the front door makes your mouth water instantly. Pictures of vintage hot-rods adorn the walls but this place is all about the food. The pleasant 19-year-old who served me knew nothing about what style or region of barbecue Smokin' Woody's prepared, but the tangy sauce was everything I hoped it would be: thick, red, spicy, sweet and not too hot.
EXTRAS/NOTES	Smokin' Woody's has been a success in the neighborhood since before the area became gentrified. I'm still mystified by what style of BBQ puts breaded onion pieces on top of its pulled pork dish, but I couldn't get enough of that sauce! White t-shirts go for $7, black t-shirts for $10.

—*Mark Vickery*

Zephyr Café

Retro sweet tooth haven slings colossal burgers and frozen treats

$$$

1777 W. Wilson Ave., Chicago 60641
(at Ravenswood Ave.)
Phone (773) 728-6070 • Fax (773) 784-0384
www.zephyricecream.com

CATEGORY	1940s style diner/restaurant
HOURS	Sun-Thurs: 8 AM-midnight Fri/Sat: 8 AM-1 AM
GETTING THERE	Tons of free street parking
PAYMENT	VISA MasterCard AMERICAN EXPRESS DISCOVER
POPULAR FOOD	Fully loaded cheeseburger and crispy french fries…you can never go wrong with that! The entire dessert menu is phenomenal, with the ten-scoop War of the Worlds being the final icing on the cake. In the summer, their fresh strawberry shortcake with homemade whipped cream is one of the best in the city.
DRINKS	Mudslides, malts, and Milkshakes
SEATING	300—great for parties. They have separate rooms for party space and big large groups of folks always take over the back room.
AMBIENCE/CLIENTELE	A nostalgic throwback to a much simpler time, this legendary ice-cream parlor sports seasoned regulars, young couples and feisty bambinos. The never-ending menu is chock full of home-style, comfort food with juicy burgers, grilled chicken, and tossed salads being the core of the offerings (as well as everything that you could imagine being fried). Endless seating allows plenty of space for the hungry masses that populate this neighborhood joint nightly, and beware: they come in droves for the monstrous ice cream concoctions, especially the bathtub sized sundaes.

—*Misty Tosh*

ANDERSONVILLE

Andies

Large portions of quality Mediterranean food.
$$
5253 N. Clark St., Chicago 60640
(north of Foster Ave.)
Phone (773) 784-8616
www.andiesres.com

CATEGORY	Mediterranean
HOURS	Mon-Thurs: 11 AM-11 PM
	Fri: 11 AM-midnight
	Sat: 10:30 AM-midnight
	Sun: 10:30 AM-11 PM
GETTING THERE	Street parking, Red line, Berwyn stop, #22 and #92 busses
PAYMENT	VISA MasterCard AMERICAN EXPRESS DISCOVER
POPULAR FOOD	Combination platters
UNIQUE FOOD	Potato chops—mashed potatoes stuffed with vegetables
DRINKS	Full bar, sodas, coffee and tea
SEATING	Large dining room accommodates 130-140
AMBIENCE/CLIENTELE	In this well-lit spot with white tablecloths and photos of Middle Eastern sights, you can expect a mixed crowd which represents the diversity of the neighborhood.
EXTRAS/NOTES	Most of Andies' entrees run just under $10, with cheaper meals for lunch, but portions are so large that the combos are ideal for splitting. Ten kabob and four vegetarian combinations allow for sampling of different dishes, and all come with warm, fresh pita and a plentiful side of rice. For cheap dining, Andies offers a number of sandwiches, including the popular and tasty falafel. Check out the live jazz during Sunday brunch hours.
OTHER ONES	• Ravenswood: 1467 W. Montrose Ave., Chicago 60613, (773) 348-0654 (closed on Mondays)

—Jeff Fleischer

Augie's Restaurant

Everything a diner should be!
Since 1954
$$
5347 N. Clark St., Chicago 60640
(south of Balmoral Ave.)
Phone (773) 271-7868

CATEGORY	Greek Diner
HOURS	Mon–Sat: 6 AM–8 PM
	Sun: 7 AM–7 PM
GETTING THERE	Sizeable, free parking lot or #22 bus
PAYMENT	Cash only
POPULAR FOOD	Excellent breakfasts all day, spinach pie, sandwiches, and Cream of Chicken and Rice Soup on Sundays

UNIQUE FOOD	Low-fat frozen yogurt
DRINKS	Sodas, lemonade, coffee, tea, hot chocolate, milkshakes
SEATING	Long counter, two dining rooms
AMBIENCE/CLIENTELE	Looks like it hasn't been remodeled since the '70s— hope it never is. Clientele reflects the harmonious diversity of the neighborhood -- little old ladies lunching, twenty-somethings nursing hangovers, everything in between
EXTRAS/NOTES	Mr. and Mrs. Augie Georgopulous have run this diner since the day it opened back in 1954. The joy of being a regular keeps me coming back again and again. A few things you can count on: great food, great service, and a friendly comment about the weather from Augie, himself.

—Sean O'Connor

Calo Ristorante

A little Italy here in Chicago
$$$$
5343 N. Clark St., Chicago 60640
(at Summerdale Ave.)
Phone (773) 271-7725

CATEGORY	Family Dinner Spot
HOURS	Mon-Thurs: 11 AM–12:30 AM
	Fri-Sat: 11 AM–1:30 AM
	Sun: 2 PM–1:30 PM
GETTING THERE	Street parking. Free lot across the street.
PAYMENT	VISA MasterCard AMERICAN EXPRESS DISCOVER
POPULAR FOOD	Typical Italian dishes like Chicken Vesuvio and Lasagna Bolognese. I'd give their Prime Rib a try. Done to perfection.
UNIQUE FOOD	You can also slum it with pizza or BBQ baby back ribs.
DRINKS	Full bar
SEATING	Spacious spot for family style dinning.
AMBIENCE/CLIENTELE	In 2004, Calo's underwent some changes to fit in more with the times. The red and black striped throwback look of the '70s is gone and the feel is more contemporary. Okay, as contemporary as old Italians can get. The exposed brick, soft lighting and windows overlooking Clark Street make Calo a comfortable family style dinning spot.

—Brian Diebold

Kopi a Traveler's Café

No time for travel? Head to Kopi for the next-best thing.
5317 N. Clark St., Chicago 60640
(between Summerdale and Berwyn Aves.)
Phone (773) 989-5674

CATEGORY	Café

HOURS	Mon–Thurs: 8 AM–11 PM Fri: 8 AM–midnight Sat: 9 AM–midnight Sun: 10 AM – 11 PM
GETTING THERE	Metered street parking or #22 bus.
PAYMENT	VISA MasterCard DISCOVER
POPULAR FOOD	Libido Burrito, Deluxe Nachos, veggie burger, and yummy desserts
UNIQUE FOOD	Chevre Chaud—warmed goat cheese on sliced French baguette, served over mixed organic greens, Hummus Plate, Tuna Pesto Melt
DRINKS	Natural and Italian sodas fruit spritzers, juices wide assortment of coffee drinks and teas NY Egg Creams, Chai Shake etc.
SEATING	Seats 50 inside with five outdoor tables in warm weather
AMBIENCE/CLIENTELE	Laid-back atmosphere with a mixed clientele. Clocks on the wall can tell you the time in Jakarta, Kuala Lumpur, Madrid, and even some places you probably haven't heard of. Wide range of music, from world beats to local artists.
EXTRAS/NOTES	Travel books for sale, but don't bring them to the table before you've paid! Also, there's a nice little boutique in the back with jewelry, clothing, crafts, etc. from around the world. If you like the coffee, why not buy it in bulk? Or take home one of the delicious desserts (the carrot cake is guaranteed to please). The staff at kopi is friendly, and not averse to customers lingering with a book or laptop computer. If you want to smoke, though, you'll have to go outside.

—*Mary Lou Mangan*

Noodle Zone

Thai restaurant specializing in food "zones."
$$

5427 N. Clark St., Chicago 60640
(corner of Rascher Ave.)
Phone (773) 293-1089 • Fax (773) 293-1088

CATEGORY	Thai
HOURS	Sun–Thurs: 11:30 AM–9:30 PM Fri/Sat: 11:30 AM –10 PM
GETTING THERE	Metered street parking or #22 bus
PAYMENT	VISA MasterCard
POPULAR FOOD	Curries and Pad Thai
UNIQUE FOOD	Deep Sea Curry Pineapple, Golden Triangle dumplings.
DRINKS	Sodas, Thai iced coffee and tea, bubble tea lattes, or BYOB
SEATING	Accommodates 48 inside plus outdoor seating in warm weather.
AMBIENCE/CLIENTELE	Charming space, exposed brick with golden Thai Buddha, trickling fountain complete with fog and pleasant, efficient service.

EXTRAS/NOTES	The "zone" gimmick may go a bit too far with menu items such as Drunken Noodles, described as "zone of fresh basil and the sensation of hot pepper..." Get past that, though, and the food is quite good. The Red Communist Curry, and Sweet Banana dessert are to die for. For those with a taste for spice, they make their own delicious hot sauce.

—*Mary Lou Mangan*

Restaurant Svea

A cozy Swedish breakfast nook.
$$

5236 N. Clark St., Chicago 60640
(north of Foster Ave.)
Phone (773) 275-7738

CATEGORY	Swedish
HOURS	Mon–Fri: 7 AM–3 PM Sat/Sun: 7 AM–4 PM
GETTING THERE	Street parking or #22 and #92 busses.
PAYMENT	Cash only
POPULAR FOOD	Swedish pancakes, omelets, Swedish meatballs; Swedish-style fried potatoes
UNIQUE FOOD	Wheat Limpa toast, imported lingonberries, Swedish Falukorv sausage
DRINKS	Sodas, juices, consistently delicious coffee, tea, and hot chocolate
SEATING	Ten intimate tables and a few counter seats, too
AMBIENCE/CLIENTELE	Though located on bustling Clark St., feels like it should be in a rural Nordic village-- old-school Swedish flair blue painted wooden walls, checkerboard tablecloths, hundred-year-old working cash register. Warm, welcoming, the epitome of "quaint".
EXTRAS/NOTES	Svea is one of the few remaining authentic Swedish businesses in the historically Swedish Andersonville neighborhood. The overall homey vibe is well complimented by the attentive waitstaff. Visit more than a couple of times, and they'll start to call you by name.

—*Sean O'Connor*

Reza's Restaurant

A variety of Persian dishes, ideal for lunchtime and sharing.
$$

5255 N. Clark St., Chicago 60640
(north of Foster Ave.)
Phone (773) 561-1898 • Fax (773) 561-9896
www.rezasrestaurant.com

CATEGORY	Persian
HOURS	Daily: 11 AM–midnight
GETTING THERE	Free lot (with validation), street parking, Red line, Berwyn stop, #22 and #92 busses

PAYMENT	VISA · MasterCard · AMERICAN EXPRESS · DISCOVER
POPULAR FOOD	Lamb, beef, seafood, poultry, and vegetarian dishes, combination platters
UNIQUE FOOD	Amazingly good dill rice with lima beans
DRINKS	Full bar, sodas, Persian tea, coffee
SEATING	Two large dining rooms, accommodate around 200
AMBIENCE/CLIENTELE	Exposed brick, marble tile floors; tables are spaced well apart; dark, relaxing feel; large windows; local clientele, as well as a large number of Middle Eastern commuters.
EXTRAS/NOTES	The best ordering options here are the samplers, which include sizable portions of several dishes, and can easily be shared. Or build a sampler by combining the excellent appetizers, most notably the grilled mushrooms in lemon-pomegranate sauce. Reza's also features an extensive and reasonably priced lunch menu.
OTHER ONES	• River North: 432 W. Ontario St., 60610, (312) 664-4500 (free valet parking)

—Jeff Fleischer

EDGEWATER

Deluxe Diner

Gigantic plates of food—even at 4 AM.
$$
6349 N. Clark St., Chicago 60660
(south of Devon Ave.)
Phone (773) 743-8244 • Fax (773) 743-0227

CATEGORY	Diner
HOURS	24/7
GETTING THERE	Free lot or #22 and #155 busses
PAYMENT	VISA · MasterCard · AMERICAN EXPRESS · DISCOVER
POPULAR FOOD	Banana split that's worth the effort, grilled cheese sandwich with ham, and huge breakfast burrito.
UNIQUE FOOD	Pie "squares" are oddly enticing also, the pizza.
DRINKS	Sodas, juice, shakes, coffee, tea
SEATING	Ten counter spots, 80 tables and booths
AMBIENCE/CLIENTELE	Very clean, oddly shiny spot. Customers of all sorts.
EXTRAS/NOTES	Deluxe is brought to you by the Leona's folks, though you wouldn't necessarily know it. If you're lucky you'll get to sing along with Air Supply, Supertramp, or even Michael Jackson as you eat. Delivery is available, though they use the name Maria's Pizzeria and Kitchen for that part of the operation. Who knows…

—Emily B. Hunt

"The devil has put a penalty on all things we enjoy in life. Either we suffer in health or we suffer in soul or we get fat."
—Albert Einstein

Ethiopian Diamond Restaurant and Lounge

Wonder what Ethiopian food tastes like? Spicy, fresh, and delicious.
$$$

6120 N. Broadway St., Chicago 60660
(south of Hood Ave.)
Phone (773) 338-6100 • Fax (773) 338-6293

CATEGORY	Ethiopian
HOURS	Sun–Thurs: noon–10 PM Fri/Sat: noon–10:30 PM
GETTING THERE	Street parking, Red line, Granville stop, or #36 bus
PAYMENT	VISA MasterCard AMERICAN EXPRESS DISCOVER
POPULAR FOOD	Taste of Ethiopia platter
UNIQUE FOOD	Injera—traditional Ethiopian bread, spongy and pancake-like, served with every meal
DRINKS	African beer, Ethiopian wine, Ethiopian coffee (in a clay pot) and tea, sodas, and mixed drinks.
SEATING	Large dining room accommodates 170.
AMBIENCE/CLIENTELE	Large, but cozy spot with clientele as diverse as the neighborhood itself.
EXTRAS/NOTES	Live music every Friday from 7-10:30 PM Winner of Best African, Vegetarian, and Ethnic Restaurant awards from the Edgewater Chamber of Commerce.

—*Jelene Britten*

Moody's Pub

Burgers with an attitude!
Since 1959
$$

5910 N. Broadway St., Chicago 60660
(south of Thorndale Ave.)
Phone (773) 275-2696
www.moodyspub.com

CATEGORY	Burger Joint
HOURS	Mon–Fri: 11:30 AM–1:30 AM Sat: 11:30 AM–2 AM Sun: noon–1 AM
GETTING THERE	Free lot, Red line, Thorndale stop, #36 bus
PAYMENT	Cash only
POPULAR FOOD	Half-pound burgers—served on crisped buns that create a perfect relationship between bread and meat (maybe cheese, if you're feeling kinky)
UNIQUE FOOD	The Moody Bleu Burger
DRINKS	Sodas, lemonade, juices, and full bar
SEATING	Room for an army (150) inside plus beer garden outside that seats 50 or so
AMBIENCE/CLIENTELE	Moody's is like a wooden cabin in the midst of concrete and steel. It's nearly pitch black inside after sundown, adding to the woodsy feel—keep friends, family, and belongings close at hand.
EXTRAS/NOTES	Moody's has been turning out burgers since 1959 for politicians, cops, and anyone else looking for a hearty meal. Also, they have salads big enough for

sharing, a very succulent Sloppy Joe, and a Breaded
Perch Sandwich if burgers aren't your thing. Words
of wisdom: if it's a warm day, dress light or head for
the outdoor seating because you may begin to feel
like a hamburger as it heats up to near sweltering
levels inside.

—*Benjamin Trecroci*

Ras Dashen Ethiopian Restaurant

"Comfort food from the mountains of Ethiopia."
$$$
5846 N. Broadway St., Chicago 60660
(south of Rosedale Ave.)
Phone (773) 506-9601 • Fax (773) 506-9685

CATEGORY	Ethiopian
HOURS	Wed-Mon: noon–11 PM
GETTING THERE	Street parking, Red line, Thorndale stop, and #336 bus.
PAYMENT	VISA MasterCard AMERICAN EXPRESS
POPULAR FOOD	Vegetarian combination, Doro Wat—chicken and egg cooked in a spicy sauce
UNIQUE FOOD	Ras Dashen's version of bread pudding, made with inerja, raisins, nuts, and toasted flax seeds
DRINKS	Ethio Chai (hot), Qezqaza Chai (iced), traditional Ethiopian coffee, wine, beer, sodas, and juices.
SEATING	Some traditional Ethiopian tables, but mostly the standard, Western version—seats 86 total.
AMBIENCE/CLIENTELE	Lots of couples, some college students, mostly older patrons
EXTRAS/NOTES	Each night the staff roasts the coffee and brings a pan of the beans through the restaurant. The effect is enchanting. Make sure to take a look at the artwork. While it largely reflects the Christian tradition, the artist's interpretation of the subject matter make for interesting dinner conversation.

—*Emily B. Hunt*

Secret Garden Café

*Outdoor café by the lake serving mouthwatering
sandwiches and salads*
$$
6219 N. Sheridan Rd., Chicago 60660
(north of Granville Ave., inside Berger Park)
Phone (773) 381-5623 • Fax (773) 764-4968

CATEGORY	Café
HOURS	Open seasonally: weekends only in April, May-October Daily: 11 AM–dusk
GETTING THERE	Street parking, Red line to Granville, and #147 and #151 busses
PAYMENT	Cash only
POPULAR FOOD	Cobb Salad, Turkey Reuben sandwich, Tomato Caprese sandwich
UNIQUE FOOD	Specials, including salmon, grilled lamb. and rib eye

steak sandwich.

DRINKS	Sodas, coffee, tea, beer, and wine
SEATING	Accommodates 99, mostly outdoor seating
AMBIENCE/CLIENTELE	On the edge of Lake Michigan; beautiful views and cool breezes
EXTRAS/NOTES	Chef Lisa Jordan offers new specials daily, made with fresh ingredients. Gift certificates and T-shirts for sale. Located in a landmark building.

—*Jelene Britten*

Standee's Snack'n Dine Restaurant

24 hour food, by the book
$$

1133 W. Granville Ave., Chicago 60660
(east of Broadway St.)
Phone (773) 743-5013

CATEGORY	Coffee Shop
HOURS	24/7
GETTING THERE	Small lot in back, street parking, Red line, Granville stop, or #36 bus
PAYMENT	VISA MasterCard AMERICAN EXPRESS
POPULAR FOOD	Grilled cheese sandwich, omelettes
UNIQUE FOOD	Low-cal dinners
DRINKS	Coffee, black, very black, sodas, lemonade, tea, hot chocolate
SEATING	Ten counter seats, seven booths, seating 28
AMBIENCE/CLIENTELE	Loyola students and up-all-night locals
EXTRAS/NOTES	The owner, Pedro, can actually be found cooking in back.

—*Emily B. Hunt*

Susupuato Restaurant & Taquería

Eat here just once and you'll be hooked on authentic Mexican food.
$$$

6161 N. Broadway St., Chicago 60660
(south of Granville Ave.)
Phone (773) 743-0895 or (773) 743-4710

CATEGORY	Mexican
HOURS	Daily: 10 AM–midnight
GETTING THERE	Street parking, Red line, Granville stop, and #36 bus.
PAYMENT	VISA MasterCard AMERICAN EXPRESS
POPULAR FOOD	Burritos, chimichangas, fajitas, and tamales
UNIQUE FOOD	Traditional items such as Huaraches, Gorditas, and Sopes
DRINKS	Horchata, Mexican sodas, milkshakes, juice, iced tea, and fountain sodas
SEATING	Accommodates 48
AMBIENCE/CLIENTELE	Clean, airy restaurant with a friendly waitstaff
EXTRAS/NOTES	Carry-out and delivery are available.

—*Jelene Britten*

The Thai Grill & Noodle Bar

Nice selection of yummy cuisine, with my favorite beef salad in Chicago.

$$

1040 W. Granville Ave., Chicago 60660
(between Winthrop and Kenmore Aves.)
Phone (773) 274-7510 • Fax (773) 274-7590

CATEGORY	Thai
HOURS	Tues–Sun: 11:30 AM–10 PM
GETTING THERE	Parking lot across the street, #36 and #151 busses.
PAYMENT	VISA MasterCard AMERICAN EXPRESS DISCOVER
POPULAR FOOD	Pad Woonsen Jay (vegetarian)—wider noodles than usual, stir-fried with tofu, broccoli, carrots, mushrooms, and egg in a dark sauce
UNIQUE FOOD	Interesting soups and salad appetizers, noodles made to order
DRINKS	Thai iced coffee and tea, bubble drinks, sodas
SEATING	Tables and booths to seat 60
AMBIENCE/CLIENTELE	Expect mostly people from the neighborhood. Booth-style seating with simple, well kept settings
EXTRAS/NOTES	Thai Grill is located inside Sovereign apartment building, a former hotel that maintains some of its glamour and charm. Try the special combination, your choice of entrée or stir-fried noodle dish with egg roll, potstickers, and rice—just $6.75!

—*Justin Goh*

ROGERS PARK/WEST RIDGE

Caribbean American Baking Co.

A little taste of the islands that is not to be missed.

$

1539 W. Howard St., Chicago 60626
(east of Ashland Ave.)
Phone (773) 761-0700 • Fax (773) 761-0764
www.carribeanamericanbakery.com

CATEGORY	Caribbean/Bakery
HOURS	Mon–Thur: 8 AM–9 PM
	Fri: 8 AM–9:30 PM
	Sat: 8 AM–9 PM
	Sun: 10 AM–5 PM
GETTING THERE	Street parking #215 bus
PAYMENT	Cash only
POPULAR FOOD	Beef, pork, and vegetable patties
UNIQUE FOOD	Amazing sweets and plantain tart
DRINKS	Imported sodas and fruit nectars
SEATING	None—take-out only
AMBIENCE/CLIENTELE	Blink and you might miss it—but wouldn't that be tragic?!
EXTRAS/NOTES	All items are available in bulk, for your entertaining (or hoarding) needs.

—*Heather Augustyn*

Carmen's Chicago Pizza

One of Chicago's best-kept Italian secrets.

$$

6568 N. Sheridan Rd., Chicago 60626
(north of Loyola Ave.)
Phone (773) 465-1700 • Fax (773) 465-5258

CATEGORY	Italian
HOURS	Sun-Thur: 11 AM–11 PM
	Fri/Sat: 11 AM–midnight
GETTING THERE	Street parking; Red line, Loyola stop
PAYMENT	VISA MasterCard AMERICAN EXPRESS DISCOVER
POPULAR FOOD	Stuffed spinach pizza
UNIQUE FOOD	Pasta made fresh in-house
DRINKS	Sodas, beer, and wine
SEATING	Room for 110
AMBIENCE/CLIENTELE	Pizzeria, popular with students and locals alike
EXTRAS/NOTES	The lunch buffet, offered daily from 11:30-3:30, is not to be missed; all-you-can-eat, plus free soda refills for only $5.95!
OTHER ONES	• Evanston: 1012 W. Church St., 60201, (847) 328-0031

—Heather Augustyn

Eastern Style Pizza

Killer Philly Cheese Steaks

$

2911 W. Touhy Ave., Chicago 60645
(west of California Ave.)
Phone (773) 761-4070 or (773) 761-4033

CATEGORY	Pizza/Sandwich Shop
HOURS	Daily: 10:30 AM–10 PM
GETTING THERE	Street parking.
PAYMENT	VISA MasterCard
POPULAR FOOD	Pizza by the slice and grinders (esp. cheese steaks and meatball).
UNIQUE FOOD	Gyros Grinder—combines the best of both worlds!
DRINKS	Sodas
SEATING	About 20 seats
AMBIENCE/CLIENTELE	Little ambience—it's about the food. Expect lots of Chicago cops.
EXTRAS/NOTES	Eastern Style has probably the best Philly Cheese Steak sandwich in town. You usually need two sittings to polish off one of their footlong sandwiches. They have very good pizza, as well.
OTHER ONES	• Skokie: 3560 Dempster St., Skokie 60076, (847) 679-6455

—Scott Durango

"Cooking is like love. It should be entered into
with abandon or not at all."
—Harriet Van Horne

Heartland Café

Vegans and vegetarians unite! Carnivore? You're invited too.

$$

7000 N. Glenwood Ave., Chicago, 60626

(at Lunt Ave.)

Phone 773-465-8005

www.heartlandcafe.com

CATEGORY	Vegan, vegetarian, bohemian, artsy. Carnivores are welcome too.
HOURS	Mon-Thurs 7 AM-10 PM Fri: 7 AM-11 PM Sat: 8 AM- 11 PM Sun: 8 AM-10 PM
GETTING THERE	Street Parking isn't bad at all. There is also a free lot on the corner of Glenwood and Estes.
PAYMENT	VISA MasterCard AMERICAN EXPRESS
POPULAR FOOD	There's something special about every dish on this unique and endless menu of everything from Lentil Burgers and tofu stuffed quesadillas to broiled Alaskan Steelehead Salmon with cous cous. Just about everything is popular here.
UNIQUE FOOD	Cornmeal battered olives, chardonnay chicken, buffalo soba, deep fried black bean cheese jalapeno ravioli ... the list goes on and on.
DRINKS	Heartland offers a full bar and one of the largest beer menus I've ever seen. Domestics, world beers and tap selections run the gamut from pear cider and Dixie voodoo lager to Guinness, red stripe, and Amstel light. As for non-alcoholic beverages they offer fresh squeezed juices, smoothies, floats, and shakes as well as organic bottled juices, soy milk, rice milk and organic fair trade coffee drinks.
SEATING	During the summer months, Heartland offers an outdoor patio that you have to enter through the restaurant. You won't find too many people inside when it's warm outside. The dining room inside seats 80+ comfortably and there are a few seats around the bar.
AMBIENCE/CLIENTELE	Even if you're not a hippie, you might feel like one at Heartland. The vibe is ultra-laid back, positive and somewhat serene. No need to dress up here, just roll out of bed and bring a healthy appetite.
EXTRAS/NOTES	Check out art by local artists in the main dining room and near the bar. These politically motivated creations are thought-provoking and they make great conversation pieces. On your way out, browse the shelves at the "Heartland General Store" for books, clothing, CDs, healthy foods and juices, magazines, toys, earth friendly soaps, lotions, and other toiletries.

—*Michelle Burton*

"Our lives are not in the lap of the gods, but in the lap of our cooks."
—*Lin Yuntang Importance of Living*

Hema's Kitchen

Does your Indian grandmother want to make dinner? No?! Try Hema's.

$$

6406 N. Oakley Ave., Chicago 60645
(north of Devon Ave.)

Phone (773) 338-1627

CATEGORY	Indian/Pakistani
HOURS	Mon–Sat: 11 AM–10:30 PM
	Sun: noon–10 PM
GETTING THERE	Metered street parking or #155 bus
PAYMENT	VISA MasterCard AMERICAN EXPRESS DISCOVER
POPULAR FOOD	Sag Paneer—spinach with homemade cheese, Dal Dahkni—yellow lentils, Chicken Tikka Massala
UNIQUE FOOD	Amazingly hot and delicious Vindaloo
DRINKS	Sodas, Mango lassi, Massala tea, and lots and lots of water
SEATING	Only a few tables
AMBIENCE/CLIENTELE	Homey ambience wih many loyal regulars
EXTRAS/NOTES	Seriously, this is Hema's kitchen. If you expect more than four people, I highly recommend you call ahead and give warning—otherwise you will have to vie with Hema's family for seating. Her grandchildren sometimes get playful and expect you to entertain them! If you are looking for Northern Indian and Pakistani cuisine with a homey feel, this is your place. Hema herself makes a hard sell (you'll end up with flaky samosas, parathas, rice, and mango lassis if you're not careful), and with that smile and food that good, who can really say no? She is renowned for her Vindaloo; and while she often tries to warn new customers about the heat in this dish, in the end, all she can do is provide a pitcher of water with the meal. She will adjust the spice to your taste, without mocking you—but if you're up for it, Hema will generally accept a challenge to make the Vindaloo as hot as it can be. Consider yourself warned.
OTHER ONES	• 2411 N. Clark, Chicago 60614, (773) 529-1705

—Emily B. Hunt

Taxi Cabs

Wise up, wino. Driving drunk is never safe. So if you've had one too many and are too cool for public transit, call a cab:

Ace Cab (773) 381-8000
American United Cab (773) 248-7600
Checker Taxi (312) 243-2537
Sun Taxi (773) 736-3399
Yellow Cab Company (312) 829-4222

Lincoln Noodle House

A real deal Korean meal.

$

5862 N. Lincoln Ave., Chicago 60659

(east of Sacramento Ave.)

Phone (773) 275-8847

CATEGORY	Korean
HOURS	Mon–Sat: 10 AM–10 PM
GETTING THERE	Free lot, street parking, #11 bus
PAYMENT	VISA MasterCard
POPULAR FOOD	Bi-Bim-Bap, Soon-Du-Bu—make sure to get the egg, and O-moo Rice
UNIQUE FOOD	Off-the-menu items, too (see note)
DRINKS	Buckwheat tea
SEATING	Small tables to accommodate 61
AMBIENCE/CLIENTELE	Generally Korean clientele; can get noisy when the T.V. is on in front.
EXTRAS/NOTES	There are two English menus with photos of the food, but what the people around you are eating is probably not what you are going to get. If you have to ask, "what is that?" they probably won't serve it to you. This may be annoying to the adventurous, but the old standbys really are quite good.

—*Emily B. Hunt*

Linette's Jamaican Kitchen

Jamaican and Caribbean fare in a warm, communal setting.

$$

7366 N. Clark St., Chicago 60626

(south of Jarvis Ave.)

Phone (773) 761-4823

CATEGORY	Jamaican
HOURS	Mon–Thurs: 10:30 AM–9 PM
	Fri/Sat: 10:30 AM–11 PM
	Sun: 10 AM–4 PM
GETTING THERE	Street parking or #22 bus
PAYMENT	VISA MasterCard
POPULAR FOOD	Curry chicken, Jerk chicken/pork, peppered shrimp and beef, chicken, and veggie patties
UNIQUE FOOD	Ox Tail and Cocoa Bread
DRINKS	Sorrell, Irish Moss, and various Jamaican brand sodas
SEATING	Twenty seats
AMBIENCE/CLIENTELE	Very casual. Frequented by Jamaican/Caribbean locals.

—*R. Nelson Balbarin*

"Part of the secret of a success in life is to eat what you like
and let the food fight it out inside."

—*Mark Twain*

120

Mariegold Bakery & Fast Food

Filipino fast food for the connoisseur on the go.

$

5752 N. California Ave., Chicago 60659

(north of Lincoln Ave.)

Phone (773) 561-1978

CATEGORY	Filipino
HOURS	Mon–Sat: 8 AM–8 PM
	Sun: 8 AM–6 PM
GETTING THERE	Street parking, #11 or #93 buses
PAYMENT	Cash only
POPULAR FOOD	Crispy Pata—deep-fried pork hock; Adobo; Kare Kare—a stew of oxtail and peanut butter
UNIQUE FOOD	Dinaguan (a.k.a. "chocolate meat")—a pork blood stew
DRINKS	Sodas, and traditional Filipino drinks such as halo halo and sago
SEATING	Six small tables to accommodate 15-20
AMBIENCE/CLIENTELE	Very casual atmosphere. Patrons are local Filipinos and some Asian students from nearby Mather High School.

—*R. Nelson Balbarin*

I Heart India

As soon as my sister moved to Delhi, my mother insisted on telling every waiter in Indian restaurants that her daughter has lived there. It felt a little like ordering Mexican food in high school Spanish.

But the apple doesn't fall too far from the tree. Now I too like revealing my knowledge of Southern Indian cooking (based on a Food Network TV tour) to anyone who listens. "Did you know that women in Hyderbad earn an income by cutting piles of papadum dough with a piece of string threaded between their big toes? They let it dry in the sun—all while watching their children outside." When people don't seem impressed, I try improving my street cred by letting it slip that my sibling lives in India.

It's exciting to practice my food-based Hindi vocabulary every chance I get, especially at the ever-present all-you-can-eat lunch-buffet. Nearly every Indian restaurant offers these elaborate medleys of aromatic curries and spicy tandooris to gaze and graze upon. The banquets offer up to a dozen or two items, usually for a mere $5.95 or $6.96 from between 11 AM to 3 PM daily. Here's are some of my favorites:

Standard India
The buffet is always hot and fresh and the service is excellent! Tons of bars, clubs and alternashops nearby. (*917 W. Belmont,* (773) 929-1123)

Moti Mahal
Buffet is small, but the food is good and service is warm and friendly, lots of bars, restaurants, and shops nearby. Very unassuming and relaxed. Buy specialty spices or a knickknack at the gift shop in the room next door. (*Belmont: 1035 W. Belmont,* (773) 348-4392)

Star of India
Good buffet, large dining room, friendly service, lots of bars and clubs nearby. (*3204 N. Shefield,* (773) 525-2100)

NORTHWEST SIDE

WICKER PARK

Ann Sather Restaurant

(see page p. 53)
Swedish
1448 N. Milwaukee Ave., Chicago 60622
Phone (773) 394-1812

The Bongo Room

Bucktown breakfast cafe nourishes the chirpy early birds and the bone-weary all-nighters
$$
1470 N. Milwaukee Ave., Chicago 60622
(at Honore St.)
Phone (773) 489-0690 • Fax (773) 227-2584

CATEGORY	B'fast/lunch hipster eatery
HOURS	Mon-Fri: 8 AM-2:30 PM Sat/Sun: 9 AM-2 PM
GETTING THERE	Metered parking and street parking, both somewhat difficult
PAYMENT	VISA MasterCard AMERICAN EXPRESS DISCOVER
POPULAR FOOD	The Breakfast Burrito stuffed fluffy scrambled eggs and guacamole, and then covered with cheese and sour cream is hands down the house favorite. The spicy dill breakfast potatoes are addictive as well.
UNIQUE FOOD	Unique twists on old favorites: Calypso French Toast, stuffed with addictive banana mascarpone cheese, served drenched with a light mocha cream and a three-apple brioche French Toast. Brilliant pancake renditions change frequently.
DRINKS	No liquor served
SEATING	Small and cozy
AMBIENCE/CLIENTELE	Trendy, on-the-move Wicker Park artists stand outside waiting in line for hours on an every-other-day basis, just to get a bite of the famous bittersweet cocoa espresso pancakes. This long-standing neighborhood haunt wins all the "Best Breakfast" awards in the local 'zines, and continues to pack the house with a carousel of brooding artists, perky yuppies and new-age devotees. Comfy booths, piping hot coffee and a smokin' wait staff round out the I-never-wanna-leave vibe.
OTHER ONES	• The sister restaurant, Room 12, just opened in the South Loop

—*Misty Tosh*

"Fake food —I mean those patented substances chemically
flavored and mechanically buled out to kill the appetite and
deceive the gut—is unnatural, almost immoral, a bane to
good eating and good cooking."

—*Julia Child*

Cold Comfort Café & Delicatessen

Best damn deli West of NYC!

$$

2211 W. North Ave., Chicago 60647
(between N. Leavitt St. and N. Bell Ave.)
Phone (773) 772-4552 • Fax (773) 772-4553

CATEGORY	Café/Deli
HOURS	Tues–Sat: 8 AM–4 PM Sun: 9 AM–3 PM
GETTING THERE	Street parking, Blue line, Damen stop, and #72 bus
PAYMENT	VISA MasterCard AMERICAN EXPRESS
POPULAR FOOD	Chicken soup with matzo ball, Dr. Hardy's Lox Omelet.
UNIQUE FOOD	West Town Ham & Cheese, Reuben Quesadilla
DRINKS	Sodas, coffee, tea, espresso drinks
SEATING	Seven or eight tables, which seat 25-30 people
AMBIENCE/CLIENTELE	A recent addition to Wicker Park, though you wouldn't know it from the décor—stained wood interior, subtly hanging sign above the door. Patrons tend to be twenty- to thirty-something professionals. Average customer can spend seven bucks on a modestly sized (yet highly delicious) sandwich without giving it a second thought.
EXTRAS/NOTES	Cold Comfort operates in part like a traditional deli, meaning that pretty much every ingredient that goes into their food (mustards and sauces, meats and cheeses, gourmet crackers, potato chips, sides, and desserts) is on sale individually in bulk quantity.

—Chris Stapleton

Earwax Café and Video

Look at your fellow diners: Is the sideshow motif a coincidence?

$$

1564 N. Milwaukee Ave., Chicago 60622
(south of W. North Ave.)
Phone (773) 772-4019

CATEGORY	Café
HOURS	Daily: 8 AM-10:30 PM
GETTING THERE	Metered street parking, Blue line, Damen stop, #50, 56, and 72 buses.
PAYMENT	VISA MasterCard
POPULAR FOOD	Sweet Potato and Black Bean Quesadilla and Seitan Reuben Sandwich
UNIQUE FOOD	Barbecued Seitan Burrito; Homemade Granola and Yogurt
DRINKS	Specialty sodas, Italian sodas with Torani syrup, espresso drinks, teas; milkshakes and smoothies.
SEATING	Three booths, nine tables, three bar seats—which equal a capacity of about 30-36 total.
AMBIENCE/CLIENTELE	Best described as carnivalesque; bold color scheme, walls adorned with vintage hangings that once promoted carnival freak show attractions. Clientele consists mainly of local artists, musicians, and college students.

EXTRAS/NOTES On the second floor, Earwax Café offers video and DVD rentals. Their collection is made up of hard-to-find, foreign, and cult films, documentaries, plus the latest from Hollywood.

—Chris Stapleton

Flash Taco

The place to be at 3 AM after a long night of drinking.

$

1570 N. Damen Ave., Chicago 60622
(south of W. North Ave.)
Phone (773) 772-1997 • Fax (773) 772-2423

CATEGORY	Taco Stand/Burrito Stand
HOURS	Mon–Fri: 9 AM–5 AM
	Sat: 9 AM– 6 AM
	Sun: 9 AM– 3 AM
GETTING THERE	Street parking, Blue line, Damen stop, or # 50, 56, and 72 buses
PAYMENT	Cash only
POPULAR FOOD	Burritos, burritos, and more burritos
UNIQUE FOOD	Pambazos—bread dipped in red molé, fried with chorizo, potatoes, and carrots
DRINKS	Sodas, Hawaiian Punch, lemonade, horchata, Agua de Tamarindo
SEATING	Counter space for standing
AMBIENCE/CLIENTELE	Bare bones Mexican joint which plays host to late-night revelers.
OTHER ONES	• Lincoln Park: 2556 N. Clark St., Chicago 60614, (773) 248-3901

—Jennifer Chan

Hilary's Urban Eatery

HUE, to those in the know.

$$$

1500 W. Division St., Chicago 60622
(east of N. Milwaukee Ave.)
Phone (773) 235-4327 • Fax (773) 235-4730

CATEGORY	Heinz 57
HOURS	Mon: 8 AM-10 PM
	Weds-Sun: 8 AM-10 PM
GETTING THERE	Free lot, street parking, Blue line, Division stop, or #70 bus.
PAYMENT	VISA MasterCard AMERICAN EXPRESS DISCOVER
POPULAR FOOD	Curried Chicken Salad Sandwich also weekend brunch.
UNIQUE FOOD	Salmon Cakes with Macaroni and Cheese.
DRINKS	Sodas, juices, full-service coffee bar
SEATING	40 tables during regular hours, 75 during peak hours
AMBIENCE/CLIENTELE	Expect soft music and hip young clientele.
EXTRAS/NOTES	HUE covers all the bases with a pleasant waitstaff, warm, homey atmosphere, and really yummy food!

—Kelly Hutchison

Hollywood Grill

A great place for people watching and breakfast anytime.
Since 1936
$$
1601 W. North Ave., Chicago 60622
(at Ashland Ave.)
Phone (773) 395-1818

CATEGORY	Diner
HOURS	24/7
GETTING THERE	Street parking or #9 and 72 buses.
PAYMENT	VISA MasterCard AMERICAN EXPRESS DISCOVER
POPULAR FOOD	Breakfast foods, burgers, and anything with bacon.
UNIQUE FOOD	Mexican breakfast items and a large variety of omelettes.
DRINKS	Sodas, juices, coffee, tea, milkshakes, beer, and wine
SEATING	Plenty of tables and booths plus a good-sized counter to seat 120 total.
AMBIENCE/CLIENTELE	Classic diner with '50s décor. Eclectic clientele—blue-collar workers, third-shifters, the occasional pimp, late-night breakfast cravers.
EXTRAS/NOTES	Check out the rotating dessert carousel!

—*Melanie Dunlap*

La Pasadita

Best pinche taqueria north of the Rio Grande.
$
1132 N. Ashland Ave., Chicago 60622
(south of W. Division St.)
Phone (773) 384-6537

CATEGORY	Mexican-Taquería
HOURS	Daily: 9:30 AM–3:30 AM
GETTING THERE	Street parking, Blue line, Division stop, or #9, 56, and 70 buses
PAYMENT	Cash only
POPULAR FOOD	Traditional, homemade burritos, tacos, tortas, and chiles relleno. Try the steak tacos—tasting is believing.
UNIQUE FOOD	Parilladas, which is a lit skillet with steak, chicken, Mexican sausage, hot dog halves, peppers, and onions, accompanied by rice, beans, salsa, and tortillas—relatively expensive, but enough for up to four people.
DRINKS	Fountain and canned sodas as well as Jarritos—heavily-carbonated Mexican sodas, consumed to take the edge off the blisteringly-hot chili sauces.
SEATING	Plenty of room to accommodate the whole crowd.
AMBIENCE/CLIENTELE	Check out the wall murals and the TV that's always tuned to Univision. Patrons are mostly working-class Hispanic families, neighborhood dwellers, late-night drinkers taking a break from the alcohol and

taqueria aficionados in search of the perfect torta.

EXTRAS/NOTES Yes, it is a hole-in-the-wall. Yes, management's decision to "expand" the franchise with storefronts literally across the street from the original evidences questionable business acumen. Yes, the austere interior contributes little to a comfortable dining experience. Getting past that, La Pasadita does bare bones Mexican as well as or better than anyone, with well-prepared dishes, helpful and generous service, and tremendous value (tacos for less than two bucks, burritos for about four). It's worth the trip to Wicker Park every time and if you already live there, then aren't you the lucky one!

OTHER ONES • Next door and across the street

—Paul Breloff

Leo's Lunchroom

Grungy '70s trailer home ambience meets sophisticated American cuisine.

$$

1809 W. Division St., Chicago 60622

(west of N. Wood St.)

Phone (773) 276-6509

CATEGORY	Café/Sandwich Shop
HOURS	Tues–Sat: 8 AM–10 PM
	Sun: 8 AM–9 PM
GETTING THERE	Street parking; #70 bus.
PAYMENT	Cash only
POPULAR FOOD	Holy Cow and Reuben sandwiches and breakfast.
UNIQUE FOOD	Try the Georgia Reuben, made with turkey instead of corned beef.
DRINKS	Sodas, juices, mineral water, coffee, tea, hot cocoa, BYOB.
SEATING	Good sized counter and tables inside to seat 20. Outdoor patio in warm weather seats 20 as well.
AMBIENCE/CLIENTELE	Expect to see Indie rockers, conceptual artists, dudes working on their scripts in this spot, casual atmosphere reminiscent of another era, another locale.
EXTRAS/NOTES	If you want to splurge a bit, Leo's is the cheapest place around for weekly dinner specials like salmon roulade and coffee-and-peppercorn-crusted sirloin (less than $20).

—Scott Durango

Luc Thang Noodle

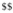

Catch-all Asian cuisine with a large variety of dishes.

$$

1524 N. Ashland Ave., Chicago 60622

(at W. Pierce Ave.)

Phone (773) 395-3907

CATEGORY	Thai/Chinese-General
HOURS	Sun–Thurs: 11 AM–10 PM

	Fri/Sat: 11 AM–11 PM
GETTING THERE	Street parking or #9 and 72 buses.
PAYMENT	VISA [MasterCard]
POPULAR FOOD	Daily lunch special for $5.55 includes egg roll, soup, entrée, and soda; Pad Thai; Spring Rolls.
UNIQUE FOOD	Filipino Pancit, vegetarian curry soups, deep fried red snapper.
DRINKS	Sodas, tropical drinks (jack fruit, guanabana, avocado) coffee, and tea
SEATING	Twelve tables
AMBIENCE/CLIENTELE	Neighborhood locals, families, and single diners come to this place for a laid-back atmosphere. Expect a soft-spoken staff, easy-listening music over the speakers, and a few pieces of Asian decorative art.
EXTRAS/NOTES	Don't forget to save room for dessert—steamed banana in coconut milk, yum!

—*Melanie Dunlap*

Penny's Noodle Shop

Fast, consistent Thai food right under the el tracks
$$
1542 N. Damen Ave., Chicago 60622
(south of W. North Ave.)
Phone (773) 394-0100 • Fax (773) 394-1316

CATEGORY	Thai
HOURS	Tues–Thurs/Sun: 11 AM– 10 PM
	Fri/Sat: 11 AM–10:30 PM
GETTING THERE	Street parking or Blue line, Damen stop #50, 56, and 72 buses
PAYMENT	VISA [MasterCard]
POPULAR FOOD	Pad Thai, spring rolls, and Thai Ravioli.
UNIQUE FOOD	Barbecued Pork Soup
DRINKS	Sodas, Thai iced coffee and tea, coffee, and tea
SEATING	Eight counter seats, 28 tables
AMBIENCE/CLIENTELE	Generally younger crowd from the neighborhood. Lively music mixes piped in at the perfect background level. Very clean with sleek furnishings.
OTHER ONES	• Lincoln Park: 950 W. Diversey Pkwy., Chicago 60614, (773) 281-8448
	• Lakeview: 3400 N. Sheffield Ave., Chicago 60657, (773) 281-8222

—*Melanie Dunlap*

Piece

Trendy pizzeria-brewpub for hipsters who can tolerate sports
$$$
1927 W. North Ave., Chicago 60622
(at N. Winchester Ave.)
Phone (773) 772-4422

CATEGORY	Trendy, hipster eatery

HOURS	Mon-Sun: 11:30 AM-2 AM
GETTING THERE	Metered street parking
PAYMENT	VISA MasterCard AMERICAN EXPRESS DISCOVER
POPULAR FOOD	Piece is known for its pizza.
UNIQUE FOOD	Piece brews its own beer. Anyone who likes the viscosity of his or her stouts thicker than oil will love the Incinerator. Those partial to lighter fare will enjoy the Golden Arm.
DRINKS	Full bar and brewery. Drink specials throughout the week including three-dollar well drinks on Sundays.
SEATING	A staggering amount of tables
AMBIENCE/CLIENTELE	Exposed brick and rafters line the walls and ceiling, all topped off by a skylight that begs for Batman to crash down through it. Over by the bar, T-shirts are for sale. There is artwork on the walls, also for sale.
EXTRAS/NOTES	Since arriving on the scene in 2001, Piece has made its mark with its own signature minimalist print ad campaign, used to humorous effect in publicizing specials that commemorate everything from Saint Patrick's Day to March Madness. To illustrate, on April 15, they waved the sales tax from every order, all day. It's not all style and no substance, either, as Piece's genial wait staff and delectable pizza team up to provide a rewarding dining experience.

— *Josh Cox*

Pontiac Café

Eat up, have a drink, get a suntan.
$$
1531 N. Damen Ave., Chicago 60622
(south of W. North Ave.)
Phone (773) 252-7767 • Fax (773) 252-6665

CATEGORY	Café
HOURS	Mon–Fri: 3 PM–2 AM
	Sat: 11 AM–3 AM
	Sun: 11 AM–2 AM
GETTING THERE	Metered street parking, Blue line, Damen stop, or #50, 56, and 72 buses
PAYMENT	VISA MasterCard
POPULAR FOOD	Great 1/2 lb. burgers.
UNIQUE FOOD	Marinated Steak Salad or the Pear and Brie sandwich.
DRINKS	Full bar; sodas, iced tea, lemonade; coffee.
SEATING	Bar seating, plus 18 tables indoors and huge outdoor patio to seat 80, weather permitting.
AMBIENCE/CLIENTELE	Locals hang out on the patio for great people watching. This place looks like a bar, sounds like a bar—it is a bar, with great food to boot.
EXTRAS/NOTES	Up for a little Golden Tee, anyone?

—*Courtney Arnold*

"Who bothers to cook TV dinners? I suck them frozen."
—*Woody Allen*

Smoke Daddy

Want some live beats with your down-home eats?

$$$

1804 W. Division Ave., Chicago 60622

(at N. Wood St.)

Phone (773) 772-6656

www.thesmokedaddy.com

CATEGORY	Music joint with great food
HOURS	Mon-Wed: 11:30 AM-midnight
	Thurs-Sun: 11:30 AM-1 AM
GETTING THERE	Street parking (watch for zone postings) and metered parking
PAYMENT	VISA MasterCard AMERICAN EXPRESS DISCOVER
POPULAR FOOD	Everybody loves Smoke Daddy's BBQ Baby Back ribs.
UNIQUE FOOD	Smoked sweet potatoes and sweet potato fries piled high, mac 'n cheese, collard greens, smoked corn on the cob—tough to find in this part of town!
DRINKS	Full bar serves up a variety of cocktails, domestic beer, and imports.
SEATING	The stage is a teeny, tiny platform in the window and there are several booths along the wall. Most folks opt for booth seating, but there is also a fair amount of seating at the bar.
AMBIENCE/CLIENTELE	People come here for the food, amazing live bands and the laid-back vibe—it's a lounge, restaurant and live music venue all rolled up into one hopping, um, club? Whether you're dressed in your most comfortable grunge gear or your trendiest duds, you will fit in no matter what. The crowd is a mix of everything from artsy types to 9-5ers desperate for some down-home cooking and a little jazz or rockabilly.
EXTRAS/NOTES	T-shirts, caps and Smoke Daddy's famous sauces are for sale.

—Michelle Burton

Sultan's Market

Don't bother looking at the menu—you'll be ordering the falafel...

$

2057 W. North Ave., Chicago 60647

(west of N. Damen Ave.)

Phone (773) 235-3072

CATEGORY	Lebanese
HOURS	Mon–Sat: 9 AM–9 PM
GETTING THERE	Street parking, Blue line, Damen stop, and #72 bus.
PAYMENT	VISA MasterCard AMERICAN EXPRESS
POPULAR FOOD	Falafel sandwich and spinach pie
UNIQUE FOOD	Freshly baked Middle Eastern pastries, like Baklava.
DRINKS	Sodas and juices from around the world and bottled water
SEATING	Sultan's is almost strictly take-out though there are two counter areas with about 10 seats total and four or five sidewalk tables in spring and summer.

AMBIENCE/CLIENTELE	Ambience and cordial attitude of the owner (who's likely making your sandwich!) make Sultan's Market inviting. Mostly neighborhood passersby.
EXTRAS/NOTES	Sultan's Market is a small grocery store as well as a café, and is gradually expanding in both directions. They offer a wide variety of Middle Eastern specialty products, such as tahini, grape leaves, and fine olive oils (at amazing prices) in addition to staples like candy and cigarettes. Convenient ATM right inside.

—Chris Stapleton

Underdogg

Fabulous char burgers anytime—turkey and veggie burgers, too!

$

1570 1/2 N. Damen Ave., Chicago 60622
(south of W. North Ave.)
Phone (773) 384-4030 • Fax (773) 384-2621

CATEGORY	Hot Dogs/Burger Joint
HOURS	Sun–Thurs: 10 AM–4 AM
	Fri/Sat: 10 AM–5 AM
GETTING THERE	Metered street parking, Blue line, Damen stop, #50, 56, and 72 buses
PAYMENT	Cash only
POPULAR FOOD	Char Cheddar Burger—one of the best in the city
UNIQUE FOOD	Grilled Chicken Pita Sandwich
DRINKS	Sodas, iced tea, Hawaiian Punch
SEATING	Sixteen spots
AMBIENCE/CLIENTELE	Daytime crowd is a mix of locals and lunchers; late-night clubbers grab a burger, dog, or cheese fries to cushion their stomachs before heading home or back to the bars.
EXTRAS/NOTES	Very cool, ultra-hip underground space featuring exposed brick and copper walls. Neighborhood photos date back to 1900.

—Michelle Burton

UKRANIAN VILLAGE

Bella's Pizza and Restaurant

I ate it in the womb and wish I could in the tomb.

$$

1952 W. Chicago Ave., Chicago 60622
(at N. Damen Ave.)
Phone (773) 252-0505 • Fax (773) 252-0060

CATEGORY	Pizza/Italian-General
HOURS	Mon–Thurs: 11 AM–12:30 AM
	Fri/Sat: 11 AM–1:30 AM
	Sun: noon–12:30 AM
GETTING THERE	Street parking or #50 and 66 buses
PAYMENT	VISA MasterCard AMERICAN EXPRESS DISCOVER

POPULAR FOOD	Pizza
UNIQUE FOOD	Linguini and Shrimp Diablo (made with a spicy alfredo sauce)
DRINKS	Sodas, juices, and beer
SEATING	Booths and tables to seat 60
AMBIENCE/CLIENTELE	Crowd's mostly young couples and families, but you'll see some middle-agers, too.
EXTRAS/NOTES	The best pizza this side of heaven.
OTHER ONES	• Belmont Central: 5925 W. Diversey Ave., Chicago 60639, (773) 745-3800

—Verloren Perdido

Cleo's

Hipster dive with surprisingly good American fare. Succulent and stylishfood.
$$
1935 W. Chicago Ave., Chicago 60622
(east of N. Damen Ave.)
Phone (312) 243-5600

CATEGORY	Bar & Grill
HOURS	Mon-Fri: 5 PM-2 AM
	Sat: 5 PM-3 AM
	Sun: 11 AM-2 AM
GETTING THERE	Street parking readily available or the #50 and 66 busses
PAYMENT	VISA [MasterCard] [AMERICAN EXPRESS] [DISCOVER]
POPULAR FOOD	Chili, but the grilled chicken breast steals the show.
UNIQUE FOOD	Buffalo Shrimp Kabob—not for the faint of heart, but the brave shall be rewarded.
DRINKS	Full bar, one dozen beers on tap, small assortment of premium liquor
SEATING	100, including bar, tables, and couch seats
AMBIENCE/CLIENTELE	This is a neighborhood bar in an up-and-coming trendy area so the crowd is primarily style-conscious twenty-somethings.
EXTRAS/NOTES	Call to find out about the occasional live jazz some Tuesday nights. Free food to cure those late-night munchies on Saturdays from 11 PM to 1 AM. Cigars and cigarettes for sale.

—Jaime Vázquez

Flo

Flo forgets the fluff and focuses on the food.
$$$
1434 West Chicago Ave., Chicago 60622
(at N. Ashland Ave.)
Phone (312) 243-0477

CATEGORY	Popular breakfast spot during the day—sangria, margaritas and dinner at night!
HOURS	Tues-Sun: 9:30 AM-2:30 PM
	Tues-Sat: 5:30 PM-11 PM
GETTING THERE	Metered and street parking

PAYMENT	VISA MasterCard AMERICAN EXPRESS DISCOVER
POPULAR FOOD	Regulars love the "Eggs Flo" made with poached eggs, fresh spinach, smoked turkey and hollandaise with Asiago cheese on an English muffin.
UNIQUE FOOD	Flo serves up an awesome Frito Pie. Yes, I said Frito Pie—it's actually a mix of corn chips, beans, chili sauce and cheese. Hey, don't knock it 'til you try it.
DRINKS	Coffee, tea, juices, beer, cocktails, sangria, margaritas, wine, and full bar
SEATING	The quarters are a bit close in this cool brick storefront, but Flo is so laid-back, you'll hardly notice. Seats 50+
AMBIENCE/CLIENTELE	It's all about the creative fare and artsy vibe here. No need to put your guard up here. Just relax.
EXTRAS/NOTES	Check out the ever-changing wall of art by local artists while you wait for a seat. This funky eatery hasn't gone yuppie. Their answer to gentrification?: Offer up some doggie biscuits for the cute little pooches that accompany many of Flo's new neighbors.

—Michelle Burton

Lorraine's Diner

Eating at Lorraine's is like visiting Grandma's: good, simple food arriving in generous portions.

$$

1959 W. Chicago Ave., Chicago 60622
(corner of N. Damen Ave.)
Phone (312) 491-9230

CATEGORY	Diner
HOURS	24/7
GETTING THERE	Street parking or # 50 and 66 buses
PAYMENT	Cash only
POPULAR FOOD	Biscuits and gravy and the meatloaf sandwich
UNIQUE FOOD	Hand-made soup of the day
DRINKS	Soda, juice, coffee, tea, and hot chocolate
SEATING	Counter and booths to accommodate approximately 24 patrons.
AMBIENCE/CLIENTELE	From the clientele to the curtains, Lorraine's Diner looks refreshingly like an old lady's kitchen.

—Chris Stapleton

Thai Village

Thai food at its best—you'll leave wanting more!

$$

2053 W. Division St., Chicago 60622
(west of N. Damen Ave.)
Phone (773) 384-5352 • Fax (773) 384-6474

CATEGORY	Thai
HOURS	Tues–Sun: 11 AM–10 PM
GETTING THERE	Metered street parking, or Blue line, Division stop, #50 and 70 buses

PAYMENT	VISA MasterCard AMERICAN EXPRESS
POPULAR FOOD	Gang Garhee—yellow curry, red potatoes, and your choice of meat or tofu in coconut milk or Panang Curry—red curry with bell peppers, coconut milk, bamboo shoots, basil, meat or tofu
UNIQUE FOOD	Gang Mhotapo—spinach and pork in tamarind curry with coconut milk
DRINKS	Sodas, juice, Thai Iced Tea and Coffee, coffee, and tea
SEATING	Accommodates 60-70
AMBIENCE/CLIENTELE	Comfortable and inviting; laid back mix of people from all over.
EXTRAS/NOTES	Check out the lunch specials. For $4.95 you get soup, an appetizer, and a large entrée portion.

—*Michelle Burton*

HUMBOLDT PARK

Flying Saucer

Laid-back food at a leisurely pace.

$$

1123 N. California Ave., Chicago 60622

(south of W. Division St.)

Phone (773) 342-9076 • Fax (773) 342-9077

CATEGORY	Heinz 57
HOURS	Tues–Fri: 7:30 AM–10 PM
	Sat: 8 AM–10 PM
	Sun: 8 AM–3 PM
GETTING THERE	Street parking, Blue line, Western stop, and #52 bus
PAYMENT	VISA MasterCard DISCOVER
POPULAR FOOD	Pierogi with various fillings, salads, and quesadillas.
UNIQUE FOOD	Huevos Volando, a gigantic serving of eggs, ancho chili sauce, pico de gallo, black beans, and sour cream over tortillas.
DRINKS	BYOB
SEATING	29 seats and 7 counter spots, tightly packed.
AMBIENCE/CLIENTELE	Hipsters, posers, and occasional yuppies; generally laid-back clientele and staff lead to slow but friendly service.
EXTRAS/NOTES	Don't be too surprised if, during peak hours, you don't end up with exactly what you ordered. All the food is good, but don't be afraid to speak up—the staff will graciously correct problems. Eating is supposed to be an adventure, right?

—*Emily B. Hunt*

"I'm at the age when food has taken the place of
sex in my life. In fact I've just had a mirror put
over my kitchen table."

—*Rodney Dangerfield*

LOGAN SQUARE

Fat Willy's Rib Shack

*Real, wood-smoked BBQ that'll make
even a vegetarian drool.*

$$

2416 W. Schubert Ave., Chicago 60647
(west of N. Western Ave.)
Phone (773) 782-1800 • Fax (773) 782-1818
www.fatwillysribshack.com

CATEGORY	Southern Barbecue
HOURS	Sun–Thurs: 11:30 AM–10 PM
	Fri/Sat: 11:30 AM–11 PM
GETTING THERE	Street parking, lot behind theater ($2 discount) or #49 bus
PAYMENT	VISA MasterCard
POPULAR FOOD	BBQ and sandwiches
UNIQUE FOOD	Awesome mac and cheese, grilled corn, zesty BBQ
DRINKS	Sodas, coffee, tea, or BYOB
SEATING	Accommodates twenty patrons at a time
AMBIENCE/CLIENTELE	Expect a casual atmosphere with movie goers and neighborhood locals too.
EXTRAS/NOTES	Fat Willy's is a great place to eat before or after catching a flick at City North. They make all their own sauces and marinades. Don't forget to save room for the New Orleans Chocolate Pecan Pie!

—*Tal Litvin*

The Hot Spot

Packed with sunbeams, bambinos, and hipsters
$$$

2824 W. Armitage Ave., Chicago 60647
(at California Ave.)
Phone (773) 770-3838 • Fax (773) 770-3840

CATEGORY	Neighborhood breakfast and lunch spot.
HOURS	Mon–Fri: 7 AM-2 PM
	Sat–Sun: 8 AM-2 PM
GETTING THERE	Street and metered parking is pretty easy to find
PAYMENT	VISA MasterCard
POPULAR FOOD	The "Logan" berry sour cream pancakes, made with imported lingon berries, are out of this world. Served with honey butter (so good you could drink it) and homemade apple berry compote; regulars know that the best way to eat 'em is by slathering them in butter and dunking accordingly.
UNIQUE FOOD	Greek-owned and operated, there is an interesting Mediterranean influence throughout the entire menu, especially in the lunch offerings. Straying a bit from the norm, the delicious Texas-style country fried steak is smothered in mushroom gravy, and dished up alongside a couple of eggs and thick, chunky fried potatoes.
DRINKS	Specialty coffees, teas, sodas and varied waters are served.

SEATING	Seats about 45 people.
AMBIENCE/CLIENTELE	With a cute diner style bar and loads of booths, The Hot Spot is definitely quaint, but they do have a large back room with tables that can be pulled together for larger groups, parties and special events. With write-up after glorious write-up, this remote hood was aching for this style of eatery and the crowds have flocked to this comfy, super casual neighborhood mecca. With coffee that is strong and hot, a helpful staff and the walls splashed in sunshine, it all makes for a delightful day at the office (and lots of regulars have claimed it as such).

—*Misty Tosh*

Johnny's Grill

Remember Seinfeld's Soup Nazi?

$

2545 N. Kedzie Blvd., Chicago 60647

(south of N. Milwaukee Ave.)

Phone (773) 278-2215

CATEGORY	Diner
HOURS	Daily: 6 AM–10 PM
GETTING THERE	Street parking, Blue line, Logan Square stop, or #56 bus
PAYMENT	Cash only
POPULAR FOOD	Raisin toast and corned beef hash.
UNIQUE FOOD	Gyros and Perch Plate
DRINKS	Sodas, juices, shakes, coffee, tea, and hot chocolate
SEATING	Counter seats around twenty people.
AMBIENCE/CLIENTELE	100% diner, though more accurately described as a "greasy spoon". Expect a quiet spot with, blue-collar workers and the occasional young artist.

—*Chris Stapleton*

Lula Cafe

My Sunday brunch love affair

$$

2537 N. Kedzie Ave., Chicago 60647

(north of W. Fullerton Ave.)

Phone (773) 489-9554 • Fax (773) 772-0521

www.lulacafe.com

CATEGORY	Café
HOURS	Mon: 7 AM–10 PM
	Wed/Thurs: 7 AM–10 PM
	Fri: 7 AM–midnight
	Sat: 9 AM–midnight
	Sun: 9 AM–9 PM
GETTING THERE	Metered street parking or #56 bus
PAYMENT	VISA MasterCard AMERICAN EXPRESS DISCOVER
POPULAR FOOD	Brunch and dinner specials will rock you.
UNIQUE FOOD	Moroccan Chickpea Sweet Potato Tangine with Saigon Cinnamon and Cous Cous, Tineka—a spicy peanut butter on multigrain bread.

DRINKS	Sodas, juice, coffee, tea, chai, espresso drinks, hot chocolate, smoothies, and liquor license in the works…
SEATING	Dining room seats 44.
AMBIENCE/CLIENTELE	Patrons are a curious mix—primarily young crowd; Lusterware; local art; local music; intimate setting.
EXTRAS/NOTES	Lula specializes in organic and locally grown food.

—Leah Moyers

Red Apple Restaurant

Hardcore Polish buffet and hangover
cure boasts mystery meats, salads, soups, and desserts.

$$

3121 N. Milwaukee Ave., Chicago 60618
(south of W. Belmont Ave.)
Phone (773) 588-5781 • Fax (773) 588-3975
www.redapplebuffet.com

CATEGORY	Polish/Buffet/Kids Welcome
HOURS	Sun–Thurs: 11 AM–9 PM
	Fri/Sat: 11 AM–9:30 PM
GETTING THERE	Street parking and #56 bus
PAYMENT	VISA MasterCard AMERICAN EXPRESS DISCOVER
POPULAR FOOD	Pierogis, schnitzels, and sauerkraut like Babka (Grandma) used to make
UNIQUE FOOD	Buffet runs the gamut from light fruits and dill-dashed salads, to un-trendy pork and veal creations to suit the hardiest carnivores.
DRINKS	Full bar stocks Polish brewskis rivaling the best German beers.
SEATING	About 30 booths
AMBIENCE/CLIENTELE	Family restaurant with late 20th Century diner-style décor You'll find many a single widow in the late hours. Plastic flowers implied, but not displayed. Lite rock pipes in to please Air Supply fans and '80s-philes.
EXTRAS/NOTES	All you can eat for less than eight bucks—including free soup and ice cream! Private rooms available for large groups.
OTHER ONES	• Norwood Park: 6474 N. Milwaukee Ave., Chicago 60631, (773) 763-3407

—Elsa Wenzel

Café Bolero

An authentic Cuban restaurant
with live jazz three times per week.

$$

2252 N. Western Ave., Chicago 60647
(south of W. Fullerton Ave.)
Phone (773) 227-9000 • Fax (773) 227-9026
www.cafebolero.net

CATEGORY	Cuban
HOURS	Mon-Thurs: 11 AM-11 PM Fri/Sat: 11 AM-midnight Sun: 11 AM-10 PM
GETTING THERE	Street parking, Blue line, Western stop, #52 and 74 busses
PAYMENT	VISA MasterCard AMERICAN EXPRESS DISCOVER
POPULAR FOOD	Fried plantains, rice and beans, arroz con pollo (rice with chicken), empanadas, tamales
UNIQUE FOOD	Oxtail stew, goat stew, hamburgers stuffed with feta cheese, yucca
DRINKS	Sodas, juices; freshly squeezed sugar cane juice, tropical shakes (batidos)
SEATING	Accommodates 100
AMBIENCE/CLIENTELE	Expect both neighborhood and Cuban-craving diners, from young/established professionals to locals.
EXTRAS/NOTES	This Cubanesque restaurant in an unsuspecting part of trendy Bucktown is the perfect spot to relax and enjoy the fried plantains, dig into some tasty rice and black beans, and sip a Cuba Libre. The smaller room in the back is alive three nights per week with jazz. Don't miss Tuesday nights; Latin jazz will take you to an island oasis in the middle of Chicago.

—Jamie Popp

Café Laguardia

Trendy Cuban restaurant in the heart of Bucktown.
$$$
2111 W. Armitage Ave., Chicago 60647
(west of N. Damen Ave.)
Phone (773) 862-5996 • Fax (773) 862-8009
www.cafelaguardia.com

CATEGORY	Cuban
HOURS	Mon-Sat: 11 AM-11 PM Sun: noon-8 PM
GETTING THERE	Street parking, Blue line, Western stop, #49, 50, and 73 busses
PAYMENT	VISA MasterCard AMERICAN EXPRESS DISCOVER
POPULAR FOOD	Croquettes, fried plantains, empanadas
UNIQUE FOOD	Yucca and fried pork appetizers
DRINKS	Full bar—try mango margaritas, martinis, caipirinha, beer, wine, and café con leche
SEATING	75 in the dining room, fifteen in the bar/lounge areas
AMBIENCE/CLIENTELE	Both families and young, trendy professionals, depending on the time of day; nightclub atmosphere (i.e.- zebra print walls, etc.)
EXTRAS/NOTES	If you walked through the door not knowing that it was a family-owned restaurant, you'd think Café Laguardia was a trendy nightclub. Inside the doors are wild animal prints and a lush décor with tropical plants and leather furniture. The swanky bar to the right of the entry and the restaurant to the left are two distinct features of the place: well, until you try a tempting caipirinha—the Brazilian cocktail!

—Jamie Popp

El Presidente Restaurant

Greasy, spacious, affordable—what more could you want at 4 AM?

$$$

2558 N. Ashland Ave., Chicago 60614
(south of W. Wrightwood Ave.)
Phone (773) 525-7938

CATEGORY	Mexican-General
HOURS	24/7
GETTING THERE	Street parking or #9 bus
PAYMENT	
POPULAR FOOD	Carne Asada tacos and burritos.
UNIQUE FOOD	Menudo and Pozole for that authentic touch, burgers and fries for the less adventuresome
DRINKS	Canned sodas, Jarritos, juices, licuados, horchata, Mexican Chocolate, coffee, tea, and milk
SEATING	23 tables and booths
AMBIENCE/CLIENTELE	Look for Marvel Super Heroes video game, juke box, and quarter machines with chicle, bouncy balls, etc.. Expect a very mixed clientele, from locals who know their Mexican food to middle-of-the-night, after-bar crowd.
EXTRAS/NOTES	The menu, a proofreader's nightmare, makes for great reading after a few too many…

—*Courtney Arnold*

Irazu Costa Rican Restaurant

Leaves you wondering why you've never tried Costa Rican food before.

$

1865 N. Milwaukee Ave., Chicago 60647
(east of N. Western Ave.)
Phone (773) 252-5687

CATEGORY	Costa Rican
HOURS	Mon–Sat: 10 AM–9 PM
GETTING THERE	Street parking and #56 bus
PAYMENT	Cash only
POPULAR FOOD	Tostoned con Mojo—fried green plantains with garlic, Yucca with garlic (fried or boiled)
UNIQUE FOOD	18 different shake flavors (like oatmeal and passion fruit)
DRINKS	Coffee, tea, Hibiscus Iced Tea, and Horchata
SEATING	Twenty inside and fifteen outdoors
AMBIENCE/CLIENTELE	Many Latino families and college kids frequent this building clean little building that's popular for its unique menu items and prices.
EXTRAS/NOTES	Stick with breakfast items, sandwiches, tacos, etc. and you'll be amazed at just how inexpensive the menu is. But if you feel like splurging a bit, you can't beat Grilled Steak of Mixed Rice with Shrimp, still under ten bucks!

—*Chris Stapleton*

Healthy Cheap-Eats, American Style

Eating well when you are eating out isn't as much of a challenge as you may think! And eating cheap doesn't mean you have to be short-changed nutritionally. If you know what to look for, you can have a well-balanced meal full of vitamins, minerals, and other healing nutrients—no matter where you choose to eat.

Coffee Shops and Diners
Yep, you can eat at a diner and not feel guilty. Take eggs, for example, which have never been proven to cause high cholesterol. They contain exceptionally nourishing protein and compounds that help prevent age-related macular degeneration—and are especially healthy poached. Get 'em with rye bread, which adds a variety of top-notch grains and nutrients to the diet. Sip soup of all sorts, especially ones made with beans, peas, and veggies. Fiber-rich oatmeal lowers cholesterol and is a low fat way to start your day. Coleslaw made with cabbage lowers high blood pressure and cancer risk. And our favorite, tuna fish, contains heart-friendly oils. Even your garnish can be healthy: A mineral-rich melon slice alkalizes the system and reduces fatigue.

Salad Bars
For a balanced plate, select the darkest green lettuce for maximum magnesium for heart and bone health, broccoli and cauliflower for folic acid to prevent heart disease, sweet red peppers to lower cancer risk, carrots to slow aging, celery for fiber, and chickpeas for protein and little fat. Add onions to reduce inflammation. Avoid the junky refined oils in most salad dressings and pick blue cheese dressing, with a garnish of pumpkin seeds for zinc and prostate health and nuts for extra minerals.

Hungry yet?

—*Molly Siple*

Margie's Candies
A completely original ice cream theme park.
Since 1921
$
1960 N. Western Ave., Chicago 60647
(north of N. Milwaukee Ave.)
Phone (773) 384-1035 • Fax (773) 252-8500
www.margiescandies.com

CATEGORY	Ice Cream Parlor/Diner
HOURS	Sun–Thurs: 9 AM–midnight Fri/Sat: 9 AM–1 AM
GETTING THERE	Metered street parking, Blue line, Western stop, #49, 56, and 73 buses.
PAYMENT	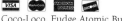
POPULAR FOOD	Coco-Loco, Fudge Atomic Buster, Jumbo, Turtle Tummy Buster, Zombie, Skater Delight, and

Bucktown Special Sundaes—all served in an opulent white clamshell, on a silver tray with accompanying wafer cookies and urn of homemade fudge sauce.

UNIQUE FOOD	The World's Largest Terrapin, with fifteen scoops of ice cream—comes with a box of Margie's special candies as a reward for the attempt.
DRINKS	Sodas, shakes, malts, and heavenly hot chocolate.
SEATING	Accommodates 54
AMBIENCE/CLIENTELE	Come for the dessert, stay for the creepy doll collection. Everybody loves Margie's!
EXTRAS/NOTES	The Beatles and Al Capone have all been to Margie's! Local kids bring in their "straight A" report cards for a free ice cream cone. If you still have room left after your sundae, why not try the Sirloin of Beef Dinner, just $5.50. Seating is tight, so expect a (worthwhile) wait on weekends.

—*Leah Moyers*

My Pie Pizzeria

(see page p. 41)
Pizza
2010 N. Damen Ave., Chicago 60647
Phone (773) 394-6904

North Point Café & Grill

Can't decide between Polish, Mexican, and Pizza? You don't have to!
$
2234 W. North Ave., Chicago 60647
(at N. Bell Ave.)
Phone (773) 395-1111

CATEGORY	Polish/Mexican-General/Pizza
HOURS	Mon–Sat: 8 AM–8 PM Sun: 8 AM–7 PM
GETTING THERE	Free lot, Blue line, Damen stop, and #72 bus
PAYMENT	VISA MasterCard
POPULAR FOOD	Grilled Chicken Pita and Jalapeño Poppers.
UNIQUE FOOD	Golabki— cabbage rolls filled with meat and veggies, Pyzy—potato balls made with pork and topped with fried onions, Flaki—tripe soup
DRINKS	Sodas, coffee, tea, and espresso drinks
SEATING	Fifteen tables, ample counter space and outdoor patio in warm weather
AMBIENCE/CLIENTELE	One sparsely decorated, wide-open room with a bar-style counter; mixed clientele
EXTRAS/NOTES	What North Point lacks in charm, it makes up for with its cheap, good food. With a seemingly themeless and totally diverse menu, it's the perfect place for potheads and pregnant women! Don't forget to ask about the "sweet of the day"…

—*Chris Stapleton*

Roong Petch Thai Restaurant

In a city awash with Thai restaurants, Roong is one of the best.

$$

1633 N. Milwaukee Ave., Chicago 60647

(north of W. North Ave.)

Phone (773) 252-3488 • Fax (773) 252-4386

www.roongthai.com

CATEGORY	Thai
HOURS	Mon–Thurs: 11:30 AM–10:30 PM
	Fri–Sat: 11:30 AM– 11:30 PM
	Sun: 3:30 PM–10:30 PM
GETTING THERE	Street parking, Blue line, Damen stop, or #50, 56, and 72 buses
PAYMENT	VISA MasterCard AMERICAN EXPRESS DISCOVER
POPULAR FOOD	Pad Thai with Tofu (naturally!); 0-0-7 Secret Stir-Fry.
UNIQUE FOOD	Basil Seafood Combination.
DRINKS	Full bar, wine list, sodas, lemonade, Thai Iced Coffee and Tea, coffee, and tea
SEATING	Accommodates 30 customers
AMBIENCE/CLIENTELE	Atmosphere is intimate, but not uncomfortably so; simple décor—candle-lit tables, dimmed track lighting, and a single shadow puppet projected against the main wall.
EXTRAS/NOTES	This place is good all around. Roong is family run, and everyone is extremely friendly.
OTHER ONES	• 1828 W. Montrose, Chicago 60613; (773) 989-0818

—*Chris Stapleton*

Toast

(see page p. 47)

All day breakfast nook for yuppies

2046 N. Damen Ave., Chicago 60647

Phone (773) 772-5600)

IRVING PARK

El Llano Restaurant

Colombian ranch-style meat and potatoes for homesick South American cowboys.

$$$

3941 N. Lincoln Ave., Chicago 60613

(at W. Byron St.)

Phone (773) 868-1708

CATEGORY	Colombian
HOURS	Daily: 11 AM–10 PM
GETTING THERE	Street parking or #11 and 50 buses.
PAYMENT	

POPULAR FOOD	Daily lunch and dinner specials ($4.95 and $6.95)—steak or chicken pounded and spiced into submission, rice, beans, salad, and fried yucca or banana
UNIQUE FOOD	Intoxicating Kahlua flan and traditional desserts.
DRINKS	Tropical juices (mango and more) in water or milk and sodas
SEATING	29 tables, to fit 100 people
AMBIENCE/CLIENTELE	Saddles, wind chimes, and other ranch remnants evocative of rural Colombia add to the lofted, exposed brick interior and breezy atmosphere. Highlight just might be the friendly, bilingual staff.
EXTRAS/NOTES	Norteamericanos who equate South American food with tacos learn a delicious lesson in geography at El Llano. Aside from specials, most other meals are $9.95—though the soups make a hearty dinner at $4.95.

—Elsa Wenzel

El Potosi Taquería

Muy bien, muy delicioso, muy cheapo!
$
3710 N. Elston Ave., Chicago 60618
(east of Kimball Ave.)
Phone (773) 463-2517

CATEGORY	Mexican-Taquería
HOURS	Daily: 10 AM–10 PM
GETTING THERE	Street parking and #82 bus.
PAYMENT	Cash only
POPULAR FOOD	Burritos, tacos, tortas
UNIQUE FOOD	Breakfast and menudo on weekends
DRINKS	Sodas, horchata, milkshakes, and carrot juice
SEATING	A few indoor tables and outdoor seating.
AMBIENCE/CLIENTELE	Reminiscent of the roadside taco stands in Mexico, this spot is popular with Hispanic neighbors.
EXTRAS/NOTES	Portions are generous, ingredients are fresh, food is made to order, and the menu is large. Good, authentic Mexican food.

—Catherine Keich

Abbey Pub's Lambay Island Dining Room

The archetypical Irish hangout.
$$
3420 W. Grace St., Chicago 60618
(at N. Elston Ave.)
Phone (773) 478-4408 • Fax (773) 539-6118
www.abbeypub.com

CATEGORY	Irish
HOURS	Daily: 11 AM–2 AM
GETTING THERE	Free lot, street parking, or #82 bus.
PAYMENT	

POPULAR FOOD	Shepherds Pie, fish 'n chips, Lambay Burger, Blarney Chicken Sandwich, all-day breakfast
UNIQUE FOOD	Curried Irish sausage and chips
DRINKS	Sodas, juices, Irish/American beers, Irish whiskeys
SEATING	Booths, tables, and outdoor seating to accommodate 100 total
AMBIENCE/CLIENTELE	This is an Irish pub; traditional green wih brass fixtures. Popular with the neighbors.
EXTRAS/NOTES	You can hear live music most nights in the pub, with traditional Irish music in the restaurant on Sunday nights. Rugby matches are shown on T.V. Sunday afternoons.

—Catherine Keich

NORTH PARK

Tre Kronor

Ready for an authentic Swedish experience?

$$

3258 W. Foster Ave., Chicago 60625
(west of N. Kedzie Ave.)
Phone (773) 267-9888

CATEGORY	Swedish
HOURS	Mon–Sat: 7 AM–10 PM
	Sun: 9 AM–3 PM
GETTING THERE	Street parking; #92 bus.
PAYMENT	VISA MasterCard AMERICAN EXPRESS DISCOVER
POPULAR FOOD	Potato and beef-and-pork sausages, pastries, and Pannekaker (Swedish pancakes) with Lingon
UNIQUE FOOD	Gravalax—cured salmon; pickled herring, Swedish meatballs, and fruit soup.
DRINKS	Swedish beer and wine, juice, coffee, and tea
SEATING	50 in main dining room; 50 outside in warm weather; 35 upstairs in private dining room.
AMBIENCE/CLIENTELE	Familiar, hedonistic, comforting, reliable, and always welcoming; clientele changes depending on festivities (Holiday buffet dinner during December); usually filled with Swedish families, churchgoers, old folks, and other regulars.
EXTRAS/NOTES	The name means "three crowns," referring to the official crest of Sweden. The décor is entirely Swedish, with stencils and paintings of playful tomten (gnomes). If you want great food at great prices, Tre Kronor is the spot—through entrée prices go up quite a bit at dinner. You'll leave saying, "that hit the spot!"

—Sara Allen

Is That A Tamale in Your Pocket, Or Are You Just Happy to See Me?

When out for a night on the town but operating on a fixed budget, one is faced with several critical decisions, such as finding a decent, affordable meal. Bars can get expensive but, still, you have to eat.

When really strapped for cash, you may be tempted to skip dinner and head straight for the local watering hole, despite the fact that somewhere deep down you know that, after a few drinks, you'll be famished.

If you find yourself in this position, especially when out in the Wicker Park/Bucktown area, there is a perfect, yet oft-ignored alternative to the over-priced, over-crowded late-night restaurants: the roving tamale vendor.

Generally, tamale vendors are Latino men who have already worked an 8+ hour day but still find the energy go from bar to bar, somewhat timidly clutching a tamale-laden Igloo cooler, graciously selling their wares.

As for the tamales themselves, what I've gleaned from a conversation held in an awkward creole of Spanish, English, and hand gestures, is that the tamales are prepared during the day by the vendor's family. More importantly, they are delicious, simple, and filling. The tamales are sold in packs of eight, which go for no more (and usually no less) than four dollars. They come in three varieties: pork, chicken, and cheese, though it should be mentioned that one of the basic ingredients in tamale batter is a small quantity of lard, sometimes duck fat, meaning that the cheese tamales might not be the thing for strict vegetarians.

Eight tamales can easily feed two or three people; which means that if you're out with friends, a good late night tamale supper might end up costing you under $1.50!

—*Chris Stapleton*

NORWOOD PARK

Superdawg Drive-In
Don't you dare call it a "hot dog"!
Since 1948
$
6363 N. Milwaukee Ave., Chicago 60646
(east of N. Nagle Ave.)
Phone (773) 763-0660
www.superdawg.com

CATEGORY	Hot Dog Stand
HOURS	Mon–Thurs: 11 AM–1 AM
	Fri/Sat: 11 AM–2 AM
GETTING THERE	Free lot or #56A and 91 buses
PAYMENT	Cash only
POPULAR FOOD	Superdawg, Whoopskidawg, Whooperburger

UNIQUE FOOD	Supershrimp and Superfish
DRINKS	Pop (if you call it soda, you're obviously not local!), fountain drinks, coffee, tea.
SEATING	Dine in your car or sit at the few outdoor picnic tables.
AMBIENCE/CLIENTELE	Not much for scenery on busy Milwaukee and Nagel Ave., but it doesn't matter at this spot with nostalgic, great service.
EXTRAS/NOTES	How can you resist a restaurant with a huge statue of a cheetah-pelt wearing hot dog on the roof, and where the waitresses bring trays to set on your car window? The all-beef Superdawg comes Chicago-style, with all the trimmings, nestled in a bed of Superfries, in its own fun-to-read box. The thick, decadent shakes and malts will make you sigh with pleasure (especially vanilla, bound to convert even the most strident chocolate lover). From the friendly service, to the mouthwatering food, to the sweet 50s style, Superdawg is no fakey, Johnny Rockets retro joint—it's the real thing to "the bottom of [its] pure beef heart."

—*Claire Zulkey*

EAST VILLAGE

Privata Café

Italian-Mexican fusion with a strong
Mediterranean influence—nothing compares.
$$
1938 W. Chicago Ave., Chicago 60622
(east of N. Damen Ave.)
Phone (773) 394-0662 • Fax (773) 394-1827

CATEGORY	Italian/Mexican
HOURS	Mon–Thurs: 5 PM–10:30 PM Fri/Sat: 5 PM–11:30 PM Sun: 3 PM–10:30 PM
GETTING THERE	Metered street parking, Blue line, Chicago stop, or #66 bus.
PAYMENT	VISA MasterCard AMERICAN EXPRESS
POPULAR FOOD	Chipotle Black Bean Pesto—featuring smoked jalapeño peppers, black beans, cilantro, basil, feta cheese, and pine nuts
UNIQUE FOOD	Grilled Sicilian Octopus with Summer Salsa, served over cous cous
DRINKS	Sodas, juice, Hibiscus Water; coffee, tea, espresso, cappuccino, or BYOB.
SEATING	Accommodates 60 comfortably.
AMBIENCE/CLIENTELE	This hip and artsy storefront is humming with creative energy. Expect a laid-back, youngish crowd, mixed with professionals and neighborhood types.
EXTRAS/NOTES	Artwork by local artists is available for sale. Privata plays an international mix of music nightly—Italian, Spanish, French, you name it!

—*Michelle Burton*

Chains We Like

The words "chain" and "restaurant" usually signify a place where the pictured menu items all seem to be the same off-yellow color, places where you can buy a steak that resembles beef, though actually tastes a lot like gentrification, places that, in short, have all the creativity and charm of a septic tank.

Every now and then, however, a restaurant is successful despite its saturation across the land. Sure, each probably employs a Regional Manager (a.k.a., the guy in the short sleeve dress shirt with the over-long tie) who keeps everything on the up and up, but still, quality is quality. Since Chicago has no shortage of chains, we thought we'd mention the few that we think are worthy.

Baja Fresh
There are tons of great Mexican restaurants in Chicago, but when it comes down to needing a big ass burrito and trough of soda, no one beats Baja Fresh. They cook everything fresh, they keep a clean and familial environment and their food is really, really good. Lot's of low-fat options and large portions of steak and chicken make this a consistent fave.
www.bajafresh.com

Cold Stone Creamery
Yuppies love the place, so do stoners, rock stars, regular people, and those of us who have been conditioned by a certain Battlestar Galactica named coffee chain to pay more for quality. What used to cost fifteen cents at Thrifty now costs four bucks at Cold Stone…and it's worth it.
www.coldstonecremery.com

Hungry Howies
It's not just pizza with a flavored crust, it's delicious pizza with a flavored crust that is delivered to your door. Need we say more?
www.hungryhowies.com

Joe's Crabshack
It's a little pricey around the dinner hour—not to mention crowded—but if you've got a little extra money and a craving for crab, this is the place. The downside to Joe's is the stupid song and dance they force upon their servers, but it is offset by some bomb-ass barbecue crab.
www.joescrabshack.com

Sonic Drive-In
A bastion of fine Midwestern and Southern dining is right around the corner, thanks be to whatever god you believe in. Real honest to goodness girls on roller-skates bring you tasty hot dogs, fat cheeseburgers, and some of the best damn malts around. Plus, for those of you watching your cholesterol, they're grilled chicken sandwiches are very good, very big, and don't taste like they've been vulcanized by grease.
www.sonicdrivein.com

White Castle
One word: Slyders. Buy a bunch. Eat 'em.
www.whitecastle.com

WEST SIDE

LITTLE ITALY

Hawkeye's Bar and Grill

20-cent wings, dollar tacos—wash it down with a $2 bud.

$$

1458 W. Taylor, Chicago 60607
(Between Laflin and Loomis)
Phone (312) 226-3951
www.hawkeyesbar.com

CATEGORY	Restaurant bar with DirecTV – sports, sports and more sports
HOURS	Mon-Fri: 11 AM–2 AM Sat: 11 AM-3 AM Sun: noon-2 AM Kitchen closes at 11 PM
GETTING THERE	They do offer a free lot, but if it's full find a meter or try a side street. Whatever the case, you won't have any trouble parking.
PAYMENT	VISA MasterCard AMERICAN EXPRESS DISCOVER
POPULAR DISH	Country fish fry Fridays are popular here, but the "Works Burger" reigns supreme.
UNIQUE DISH	Caribbean jerk chicken salad, Jamaica catfish platter and giant stuffed potatoes with your choice of over a dozen ingredients.
DRINKS	Full bar—beer, wine, sparkling wine, cocktails, margaritas, the works!
SEATING	Enough room for around 200, not including the outdoor patio.
AMBIANCE/CLIENTELE	It's always party time at Hawkeye's, especially during the hot summer months. Dress casual—very casual—and you'll fit right in.
EXTRAS/NOTES	Ok, here's something you don't find everyday at a sports bar—besides serving up damned good food, they also offer shuttle service to many of Chicago's main venues and free wireless internet service. Yes, this sports bar is a hotspot—in more ways than one!

—Michelle C. Burton

Sweet Maple Cafe

Southern-style breakfast makes you feel all warm and fuzzy inside.

$$

1339 Taylor St., Chicago 60607
(between Throop and Loomis)
Phone (312) 243-8908

CATEGORY	Low-key neighborhood eatery.
HOURS	Daily: 7 AM-2PM
GETTING THERE	Parking isn't bad at all—you'll have no problems finding a meter or parking on a side street.
PAYMENT	VISA MasterCard AMERICAN EXPRESS
POPULAR DISH	A stack of fluffy Banana-Strawberry Pancakes with sweet maple syrup
UNIQUE DISH	The establishment in itself is a unique addition to an area saturated with Italian restaurants and eateries. Cheddar grits, spicy sausage and cornmeal biscuits

with gravy are tough to come by in this part of town. The closest you're going to get to anything Italian is the Tomato Garlic soup—a must if it's available.

DRINKS It's all about the morning cuppa java here.

SEATING The small, cozy space seats around 40 or so, comfortably. Weekends are rather hectic and seating can get pretty cramped. If you can visit during the week, go for it!

AMBIENCE/CLIENTELE A nice mix of locals (young and old) and students from nearby UIC. The atmosphere is casual and friendly.

EXTRAS/NOTES Sweet Maple has been featured on "Check Please," a local show about restaurants in and around Chicago. Since then, this low-key neighborhood eatery has become one of Chicago's most popular breakfast spots.

—*Michelle Burton*

GREEKTOWN

Greek Islands Restaurant
The largest restaurant in Greektown serves the loudest Opa!
$$$$
200 South Halsted, Chicago, 60661
(at Adams)
Phone (312) 451-1436 • (312) 454-0937
www.greekislands.net

CATEGORY Fun, casual family/group dining

HOURS Sun-Thurs: 11 AM-midnight
Fri-Sat: 11 AM-1 AM

GETTING THERE Free valet

PAYMENT [VISA] [MasterCard] [AMERICAN EXPRESS] [DISCOVER]

POPULAR DISH Baked lamb, Athenian salad, garden vegetables and Chicken Shishkabob

DRINKS A full bar is available, but ask the waiter what kind of wine would compliment your meal for the full experience.

SEATING 400 seats, with numerous dining rooms, each cozy and adaptable for a dinner date or larger parties. This is the largest Greektown restaurant and private parties can also be booked for up to 130 people.

AMBIANCE/CLIENTELE Here, every night seems to be a holiday, and every table is engaged in celebration. Walking into the restaurant, you will notice the ivory stone floors and walls that are accented by light blue painted shutters and shelves lining the interior. Knick-knacks and pottery are planted on every shelf, and as traditional Greek music plays in the background, it's easy to feel transplanted into another culture. Wine glasses are clanked, laughter fills the air and "Opa!" is shouted by the animated waiters at nearly every other table. The food is served in a simple, comfortable manner, making the dining experience more like that of a good friend's dinner party. It's fun to try different

appetizers and dishes, and the waiters enjoy giving suggestions and having a satisfied guest. You definitely should give yourself a good two to three hours here, especially on a packed Saturday night, to enjoy the scenery, have a wonderful dinner and feel like you've been an extra in the taping of "My Big Fat Greek Wedding" for the evening. The scene is loud, very welcoming and interactive.

EXTRAS/NOTES T-shirts and olive oil are available for sale. Pipes and cigars are allowed by the bar areas only.

OTHER ONES • Lombard, IL: 300 E. 22nd St., Lombard, IL 60148, (630) 932-4545

—Mindy Golub

Tourist trapped? Taste this!

Whether you have friends in town, are a tourist yourself, or feel the need to explore some of Chicago's most famous sights and neighborhoods, you ought to know what your food options are before you go. At some locations you're bound to overpriced tourist food, but at others you do, you really do have options!

Comiskey Park
Ok, so the area around Wrigley Field is more hospitable to pre- and post-gamers. However, Comiskey has better stadium food, hands down, and you can get basically anything you like: ribs at **the Bullpen Sports Bar**, jalapeno poppers at the **Jose Cuervo Cantina**, and cheesecake at the **South Side Sweet Shop**. Of course the good old, traditional favorite is the kosher hot dog or Polish sausage, topped with mouthwatering grilled onions and mustard. Oh, and it goes without saying that peanuts, both at Comiskey and Wrigley, are cheaper when you buy them outside the stadium. *(Bridgeport: 333 West 35th St., Chicago 60616, (312) 674-1000)*

Wrigley Field
Wrigley Field relies on charm and overpriced beer to get by; they don't have to provide good food. Hot dogs here are merely utilitarian. They're fine, but nothing spectacular. If you want to get your eat on after the game, a good bet is to run to **John Barleycorn**, 3524 N. Clark St., Phone (773) 549-6000, which serves up respectable bar food and likely won't be as crowded as other Wrigleyville establishments. *(Wrigleyville 1060 W. Addison St., Chicago 60613, (773) 404-CUBS)*

Art Institute of Chicago
The Art Institute has a suitable, but rather drab, cafeteria in its basement. However, for a terrific dining experience to accompany your art appreciation, dine in the gallery's courtyard. The food is actually only o.k., and whetting your whistle at the bar can really ratchet up your tab, but sitting in the courtyard, taking in some sun as you listen to the tinkly fountain and consider the priceless art is idyllic. *(South Loop 111 S. Michigan Ave., Chicago 60603, (312) 443-3600)*

Navy Pier
Navy Pier, like any true tourist spot, can really ream you for food—and, of course, the best can also be the most costly. Unless you're intent upon dining at the Pier, your best bet is to buy an ice cream or pretzel and stroll as you take in the great view. Or,

for a quick bite just off the Pier's lead tourist attractions, head to **America's Dogs** (312) 595-5541; **Carnelli's Deli** (312) 595-5540; or **Greek Express** (312) 245-9994. Navy Pier: *700 E Grand Ave # 123, Chicago 60611*

Lincoln Park Zoo

The Lincoln Park Zoo is one of a dying breed of zoos. For one thing, it's free, and it offers a city charm that most fancy, sterile, polished-up zoos don't have anymore. Even better, it has some great food options. To round out a leisurely stroll through the impressive architecture and landscaping of the zoo, head to **Café Brauer**, which offers solid dining options for a reasonable price, with excellent views in a gorgeous building. Even big kids will enjoy it, as Café Brauer boasts a beer garden as well. *(Lincoln Park: 2200 N. Cannon Dr., Chicago 60614, (312) 742-2355, www.lpzoo.com)*

Buckingham Fountain

Another summer-only site, Buckingham Fountain (yes, the one of "Married With Children" fame) offers old-style entertainment as families linger around this 1927 landmark, admiring the lake and skyline by day and enjoying the colors of the water show in the evenings. There are plenty of food options in the area, but if you can find an Italian Ice vendor or, better yet, one of the sugary, fresh-squeezed lemonade stands, you're in for a treat. Buckingham Fountain is in South Loop, bounded by Lake Shore, Balbo, Columbus, and Jackson Drives in Grant Park.

The Marshall Field's Walnut Room

Although the blandish food is mostly suited to tourists and the ladies-who-lunch, the price is decent for this beautiful room in Chicago's historic Marshall Field's department store. Enjoy the view of the city during the warm months, and check out the gigantic Christmas tree during the holidays. Traditional afternoon tea, and live music! *(Loop/Downtown: 111 N. State St., 7th Floor, Chicago 60602, (312) 781-3125)*

Pilsen

There is no address or telephone number as such, but if you ever find yourself in the Hispanic area of Chicago be sure to track down the mango vendors. These magicians take this wonderful fruit, carve it ingeniously so you can pick the pieces off neatly and delicately, and even flavor it for you with lime juice or cayenne pepper. It's a fantastic treat that's not to be missed. The Pilsen neighborhood is bounded approximately by Roosevelt, Pershing, and Western.

Museum of Science and Industry

The Museum of Science and Industry has been slowly modernized over the years, but its food options are still fairly antiquated. The bad news is that you don't really have any choices because, unlike the other museums, Science and Industry is removed from other dining options. You're pretty much stuck with cafeteria fare, but hey, you can always pretend you're back in the fifth grade. If you're feeling particularly adventuresome, buy some freeze-dried astronaut food in the Henry Crown Space Pavilion gift shop! *(Hyde Park: 5700 S. Lake Shore Dr., Chicago 60637, (773) 684-1414)*

If you don't feel like facing down the usual Museum of Science and Industry fare, the Hyde Park area offers a surprising array of affordable ethnic restaurants, such as:

Jalapeno's Cafe & Cantina
For comforting traditional "made from scratch" Mexican food and margaritas to take the edge off the kids' screaming. *(Hyde Park: 1660 E. 55th St., Chicago 60615, (773) 643-5500)*

Nile Restaurant
Reasonably priced, comforting Middle Eastern standards. *(Hyde Park: 1611 E. 55th St., Chicago 60615, (773) 324-9499)*

Kikuya Japanese Restaurant
A wide selection of Japanese food and sushi, but without chi-chi prices. *(Hyde Park: 1601 E. 55th St., Chicago 60615, (773) 667-3727)*

Caffe Florian
For those who don't like to be pigeonholed, Caffe Florian offers a huge selection of varied style foods, from Italian to burgers, and an even larger beverage menu. It's a favorite with University of Chicago students, so you know the price is right. *(Hyde Park: 1450 E. 57th St., Chicago 60637, (773) 752-4100)*

Museum Campus: Field Museum and Shedd Aquarium
The options at the Field Museum of Natural History and the Shedd Aquarium are really nothing to speak of. A perfectly fine McFast Food restaurant rests in the basement of the Field for those who are either starving or non-discriminating, and there's a pleasant Corner Bakery overlooking the famous lobby, but the fishy smell at the Shedd is enough to turn any stomach. If you are visiting during the summertime, the ideal situation is to get your museum on and then head to one of the myriad outside stands to enjoy food on the go as you marvel at the sparkling lake and skyline. *(Field Musuem: 1400 S. Lake Shore Dr., Chicago 60605, (312) 922-9410. Shedd Aquarium: 1200 S. Lake Shore Dr., Chicago 60605, (312) 939-2438).*

If you feel like taking a quick stroll to find cheap eats elsewhere in the neighborhood, some walkable options are:

Kitty O'Shea's
A true Irish gem— and yes, that means down to the food! South Loop: 720 S. Michigan Ave. (at the Hilton Chicago), Chicago 60605, (312) 294-6860

—Claire Zulkey

Parthenon
Not leaving with a doggie bag? You're not doing it right!
$$$$
314 South Halsted, Chicago, 60661
(at Jackson)
Phone (312) 726-2407 • Fax (312)-726-3203

CATEGORY	Casual, historic dinner spot
HOURS	Sun-Fri: 11 AM-1 AM
	Sat: 11 AM-2 AM
GETTING THERE	Street parking and lots of meters
PAYMENT	VISA MasterCard AMERICAN EXPRESS DISCOVER
POPULAR DISH	Flaming Saganaki, grilled octopus, braised lamb, rotisserie lamb
UNIQUE DISH	A whole roasted suckling pig that feeds twelve is

available, as well as lamb's head, but they ask that you call ahead for those. They want to give it to you fresh, after all!

DRINKS Full bar, but be warned: wine is not served by the glass, only by the bottle, so bring a designated driver or take public transportation.

SEATING Seating is available for 300, so any size party is welcome. Reservations are accepted for parties of six or more, and private parties can be reserved for up to 150 people.

AMBIENCE/CLIENTELE If there is such a thing as Greek comfort food, this is where to find it. Vast painted murals line the dark wooden-framed walls in the dining room, and the entrance floor is covered in green marble. The dining room really strategically packs in the tables, so it is not uncommon to talk to the next table. Appetizers are served on small salad plates so that parties of any size can order multiple selections to taste and share. Dinner portions are just right, although trying the appetizers is a must, but come hungry either way. The dining room is loud, yet intimate, and most patrons start at the lounge with a drink while waiting for a table. The closeness of the seats, the darker setting and the flavorful food are enough to forget about the outside world, and make you believe you have a lovely Greek grandmother cooking for you in the kitchen.

EXTRAS/NOTES T-shirts, pants, and coffee mugs are sold. Rumors from the owners that have been passed on to the patrons include the Parthenon as being the oldest restaurant in Greektown and the inventor of flaming saganaki.

—Mindy Golub

PILSEN

Kristoffer's Café and Bakery

Coffeehouse cum Mexican kitchen inspires artistic development
$$
1733 S. Halsted St., Chicago 60608
(at 18th St.)
Phone 312-829-4150 • Fax 312-829-4172
www.kristofferscafe.com

CATEGORY Coffee shop/Mexican diner

HOURS Mon-Fri: 8 AM-8 PM
Sat-Sun: 9 AM-5 PM

GETTING THERE Free street parking and metered parking are easy to find.

PAYMENT Cash Only

POPULAR DISH The Mexican tamales are delicious little corn-husks stuffed with green pepper's and cheese and the Mayan-style tamales (stuffed with Pork or Beef) are hauntingly addictive. No one else in Chicago serves them quite like this, plus for a buck fifty each, you

	can chow down on a whole platter without breaking the bank.
UNIQUE DISH	Well known for their various tres leches cakes, this intensely moist and buttery concoction is soaked in three different kinds of milk, usually sweetened condensed milk, evaporated milk and heavy cream. (Of course, like most incredible bakers, owner/baker Cristina Chavarria will not commit to any certain milk for the recipe, and just pulls the 'ole one-two, half nod, half shake move. I'm sure she's terrified that tres leches thieves are on the make.) Then, coated with homemade whipped cream (I had the Kaluah flavored version), it's tossed in the refrigerator for hours until it has properly absorbed the milk. When it finally hits the table, the chilled cake has a heavenly sponge-like texture, almost slurpably wet with sweetened milk. It'll literally leave your mouth agape with its unique taste. The kaluah coffee flavor only pops out slightly in the whipped topping, and the final kablamm! in your mouth is at the end, when the little coffee bean pops and crunches around with the moist cake, the oozing sugared milk and the velvety whipped cream.
DRINKS	BYOB and full coffee bar
SEATING	Seating for 45
AMBIENCE/CLIENTELE	Since its inception over a year ago, this café/coffee-lounge has become a regular hangout for Pilsen artists, local Mexican families, and savvy Internet geeks on the never-ending hunt for free wi-fi. The spacious kitchen slings out Mexican specialties (Mayan tamales, simple quesadillas and breakfast burritos) all at a budget-friendly price point. The rotating display of art (all for sale by local artists) and the library like tables make this one of the more comfortable places to wile away an afternoon. There is an open-mic night every last Friday of the month and with a BYOB policy, things have the potential to get rowdy. Thankfully, ever-present owner Cristina Chavarria keeps all of the could-get-raucous artists under control with her patient, and charmingly warm attitude.

— *Misty Tosh*

"I will not eat oysters. I want my food dead.
Not sick, not wounded, dead."

—*Woody Allen*

Pilsen:
Hot Today and Hot Tamale

Pilsen (west of Canal Street, south of 16th Street, east of Damen and north of the Chicago River) was named after a town, Plzen, in the western Czech Republic that is famous for its beer—Pilsner. It's no wonder, then, that the Pilsen neighborhood was home to the famous Shoenhofen Brewery. Just south of the O'Leary cottage, the brewery, and the entire Pilsen neighborhood, managed to survive the great Chicago fire. In the years that followed, the cultural tapestry of the neighborhood became richer as German, Irish, Bohemian, Polish, and Lithuanian immigrants made their homes in Pilsen. Then, during in the 1950s, the neighborhood demographics began to change. Latino immigrants arrived in the area; and, today, Pilsen is the largest Latino neighborhood in Chicago! A variety of Mexican restaurants find their home in here, many of which have been serving Chicago's community for decades. The following list includes just a few of the great restaurants you'll find in this historic neighborhood:

Nuevo Leon
Named after the Mexican state, this restaurant has been in business for over 40 years. Bring your own beer and enjoy an appetizer of nachos heaped with beans, guacamole, cheese, and sour cream, strategically placed on each chip. Before the meal, servers frequently bring either a cup of chicken soup or single pork taco to warm up the appetite. Mole sauce is spicy and sweet, served over chicken breast with a side of savory beans and rice. Enchiladas can be filled with beef, chicken, pork, or cheese and are smothered in red or green sauce. Wash it all down with a cold glass of horchata, a cinnamon sweet rice beverage. (*Pilsen: 1515 W. 18th St., Chicago 60608, (312) 421-1517*)

Taqueria El Milagro
The El Milagro Tortilla Factory is located next door to this restaurant, so you know the tortillas are fresh! The pork in red sauce has just the right amount of kick, and tastes like it has been simmering all afternoon. Flavorful stews of pork, beef, chili, ox tail, and even tongue can be eaten in a burrito or taco. Tamales are exceptional, and can be ordered filled with meat, such as pork, or as a dessert filled with raisins and corn meal. (*Pilsen: 1927 S. Blue Island Ave., Chicago 60608, (312) 433-7620 also in* Little Village: 3050 W. 26th St., Chicago 60623, (773) 847-9407)

Cuernavaca Restaurant
This restaurant features a bar with an extensive Mexican beer list, piña coladas, and margaritas. Hearty fajitas, baked chicken, barbecued ribs, and burritos will leave you asking for the doggie bag. Spicy fries are the perfect complement to a cold cerveza. (*Pilsen: 1160 W. 18th St., Chicago 60608, (312) 829-1147*)

Playa Azul
This restaurant is known for its seafood. Located across the street from a tortilla factory, Playa Azul serves shrimp and fresh fish dishes. The shrimp with hot peppers, cilantro, onions, and tomatoes is the specialty of the house and has just the perfect kick. Tortillas, rice, beans, sour cream, and avocado are served on the side. A variety of soups and salads, as well as Mexican beers, are also available. (*Pilsen: 1514 W. 18th St., Chicago 60608, (312) 421-2552 also in* Uptown: 4005 N. Broadway St., Chicago 60613, (773) 472-8924)

Tacos Don Chon

Located next to the el, this family-owned-and-run business features savory tacos. Try the steak tacos, which are filling and won't let you down. Tostadas and quesadillas are also served on weekdays for the grab-it-and-go crowd. On weekends, the menu includes superb soups and barbecue beef tacos. (*Pilsen: 1743 W. 18th St., Chicago 60608, (312) 432-1186*)

Aztecas Tacos

Although there are other Aztecas Tacos on the same block, owned by the same family, this location offers less fast-food fare and more sit-down options. Breaded beef and chicken stews are excellent and authentic. Fish soups are hearty, huge, and filled with morsels. Mexican beers, margaritas, and other liquors are offered. (*Pilsen: 1836 S. Blue Island Ave., Chicago 60608, (312) 733-0219*)

—Heather Augustyn

SOUTH
SIDE

Dixie Kitchen & Bait Shop

Culinary juke joint featuring fresh delta cooking and Southern hospitality.

$$$

5225 S. Harper Ave., Chicago 60615
(west of S. Lake Park Ave.)
Phone (773) DO-DIXIE (363-4943) • Fax (773) 363-7786
www.dixiekitchenbaitshop.com

CATEGORY	Southern American
HOURS	Sun–Thurs: 11 AM–10 PM Fri/Sat: 11 AM–11 PM
GETTING THERE	Street parking, metered lot, or #6 bus
PAYMENT	VISA MasterCard AMERICAN EXPRESS DISCOVER
POPULAR FOOD	Blackened or grilled catfish, Johnnycakes, peach cobbler, pecan pie
UNIQUE FOOD	Fried green tomatoes, gumbo, jambalaya, crawfish etouffee, Shrimp Creole, bread pudding with whiskey sauce.
DRINKS	Sodas, Voodoo and Dixie brand beers, bayou-themed drink list
SEATING	Tables to seat 75
AMBIENCE/CLIENTELE	Mostly business crowd at lunchtime; anyone and everyone in the evenings.
EXTRAS/NOTES	Dixie Kitchen transports you to the best of old-time Southern culture with carefully collected, authentic décor, zydeco and blues music, and a menu true to its Louisiana Bayou roots. T-shirts, Dixie Kitchen B-B-Q sauce, and gift certificates are available for sale.
OTHER ONES	• Evanston: 825 Church St., Evanston 60201, (847) 733-9030

—Valerie Wallace

Edwardo's Natural Pizza Restaurant

Come hungry, leave needing to unbutton your pants.

$$

1321 E. 57ᵗʰ St., Chicago 60637
(east of Kimbark Ave.)
Phone (773) 241-7960 • Fax (773) 241-6570
www.edwardos.com

CATEGORY	Pizza
HOURS	Sun–Thurs: 11 AM–10 PM Fri/Sat: 11 AM–11 PM
GETTING THERE	Street parking
PAYMENT	VISA MasterCard AMERICAN EXPRESS DISCOVER
POPULAR FOOD	Stuffed and thin crust pizzas, sandwiches, and salads
UNIQUE FOOD	International Pizzas—including chicken and barbecue sauce, taco beef and refried beans, and pesto with walnuts
DRINKS	Sodas

SEATING	Five booths, seven tables
AMBIENCE/CLIENTELE	Like a little Italian restaurant, complete with red checked tablecloths; you'll see neighborhood locals and University folk alike.
EXTRAS/NOTES	You can't go wrong with the lunch special—a salad, personal stuffed pizza, and soda for $5. Of all Chicago pizzas, their stuffed sausage is my personal favorite (and the only thing I ever order). The desire to fit into your pants may be the only thing stronger than the desire to eat this pizza.
OTHER ONES	• Printer's Row: 521 S. Dearborn St., Chicago 60605, (312) 939-3366
	• Old Town: 1212 N. Dearborn St., Chicago 60610, (312) 337-4490
	• Lincoln Park: 2662 N. Halsted St., Chicago 60614, (773) 871-3400 (carry-out only)
	• Suburban locations, as well. Check their website.

—Veronica Carolyn Bond

Maravillas Restaurant

Mexican food like tuya mama used to make.
$$
5211 Harper Ave., Ste. G, Chicago 60615
(west of S. Lake Park Ave.)
Phone (773) 643-3155

CATEGORY	Mexican
HOURS	Mon–Sat: 9 AM–11 PM
	Sun: 10 AM–10 PM
GETTING THERE	Metered parking in Harper Court, behind Hollywood Video.
PAYMENT	VISA MasterCard AMERICAN EXPRESS (minimum $10)
POPULAR FOOD	Burritos, tacos, menudo, tortas with every filling imaginable, including chorizo and avocado.
UNIQUE FOOD	American standbys like burgers, hot dogs, and pizza puffs
DRINKS	Sodas, juices, Jarritos, horchata, liquados, and beer
SEATING	A handful of booths.
AMBIENCE/CLIENTELE	Cafeteria-style set-up; Mexican serapes, sombreros, etc. decorate the walls.
EXTRAS/NOTES	Maravillas offers satisfying south-of-the-border comfort food for judgmental imports—the trendier, downtown "Mexican" restaurants don't even come close. It's a great place to order take-out for large numbers of people, and your food will be ready in less than ten minutes. Not to mention the fact that the burritos are as big as your head. I swear.

—Veronica Carolyn Bond

Medici

"The Med," because University of Chicago students prefer monosyllabic words.
$$
1327 E. 57ᵗʰ St., Chicago 60637
(east of Kimbark Ave.)
Phone (773) 667-7394

CATEGORY	Heinz 57
HOURS	Mon–Thurs: 11 AM–11:30 PM
	Fri: 11 AM–midnight
	Sat: 9 AM–midnight
	Sun: 9 AM–11:30 PM
GETTING THERE	Street parking, or Metra station at 57th and Lake Park Ave
PAYMENT	VISA MasterCard
POPULAR FOOD	Burgers (meat and veggie) with a variety of toppings; sandwiches; spinach lasagna; chicken quesadillas
UNIQUE FOOD	Specialty pizzas—create your own, or try the Garbage Pizza, a Med classic with sausage, ground beef, pepperoni, Canadian bacon, peppers, onions, and mushrooms, or the Eggs Espresso, made in an espresso maker, with your choice of toppings
DRINKS	Homemade lemonade, sodas, shakes, malts, floats, iced coffee, and hot apple cider, seasonally
SEATING	Downstairs dining room accommodates around 40. Additional seating upstairs. Outside patio in decent weather (meaning about two days out of the year).
AMBIENCE/CLIENTELE	Two blocks from University of Chicago, this everything-and-anything spot is frequented by students. So expect a very laid back atmosphere. accompanied by classical, jazz, and even pop music.
EXTRAS/NOTES	Bring a pen to leave your mark on the walls, or use a provided knife to carve a message into your tables. The Med is great for casual dates. They also just opened a bakery two doors down which sells their enormous filled and plain croissants all day long.

—Veronica Carolyn Bond

The Nile Restaurant

Classic Middle Eastern fare.
$$
1611 E. 55th St., Chicago 60615
(west of Hyde Park Blvd.)
Phone (773) 324-9499 • Fax (773) 324-9062

CATEGORY	Middle Eastern-General
HOURS	Mon–Sat: 11 AM–9 PM
	Sun: noon–8 PM
GETTING THERE	Street parking, Metra station at 55th St. and Lake Park Ave., or #6 and 55 busses.
PAYMENT	VISA MasterCard AMERICAN EXPRESS DISCOVER
POPULAR FOOD	Chicken shawerma, shish kebabs, falafel, hummus, baba ghannooj, and pita sandwich
UNIQUE FOOD	Combination plates large enough to serve two people
DRINKS	Sodas, carrot juice, and Middle Eastern coffee
SEATING	Eight tables
AMBIENCE/CLIENTELE	Expect to see locals and University students.
EXTRAS/NOTES	Carry-out and delivery available.

—Veronica Carolyn Bond

Noodles Etc.

It's noodles, and then some.

$$

1460 E. 53rd St., Chicago 60615

(east of Blackstone Ave.)

Phone (773) 947-8787 • Fax (773) 947-0818

www.noodlesetc.com

CATEGORY	Pan-Asian
HOURS	Mon–Sat: 11 AM–10 PM
	Sun: 11 AM–9:30 PM
GETTING THERE	Street parking, metered parking in Harper Court, Metra station at 53rd St. and Lake Park Ave., or #6 bus
PAYMENT	VISA MasterCard AMERICAN EXPRESS DISCOVER (minimum $10)
POPULAR FOOD	Pad Thai, Spring Rolls, curry chicken or beef, fried rice, and desserts
UNIQUE FOOD	Lots of appetizers can be combined to make a meal. For dessert try mango, plum wine, or coconut ice creams.
DRINKS	Soda, lemonade, fruit drinks, Jamaican sodas, Thai iced coffee and tea, Vietnamese coffee, and teas
SEATING	About eight booths
AMBIENCE/CLIENTELE	Crowd here is mostly college students and members of the neighborhood.
EXTRAS/NOTES	Thai students say this is the most authentic Thai food in the neighborhood.
OTHER ONES	• University of Chicago campus: 1333 E. 57th St., Chicago 60637, (773) 684-2801

—Veronica Carolyn Bond

Salonica

Home style diner with a Greek twist.

$$

1440 E. 57th St., Chicago 60637

(west of Blackstone Ave.)

Phone (773) 752-3899 • Fax (773) 752-4841

CATEGORY	Diner-Greek
HOURS	Daily: 7 AM–10 PM
GETTING THERE	Street parking, Metra station at 57th St. and Lake Park Ave., or #6 bus.
PAYMENT	VISA MasterCard (minimum $15)
POPULAR FOOD	Breakfast, burgers, grilled cheese, club sandwich, and open faced sandwiches with mashed potatoes and gravy
UNIQUE FOOD	Large gyros, mousaka, baby beef liver with grilled onions, saganaki, and other Greek specialties
DRINKS	Sodas, juices, iced tea, coffee, tea, and hot chocolate
SEATING	Booths to seat around 60
AMBIENCE/CLIENTELE	Diner set-up. Mostly frequented by Hyde Park locals and University students.
EXTRAS/NOTES	Breakfast at Salonica is served all day—with combinations of pancakes, waffles, French toast,

eggs, bacon, sausage, potatoes, and other essentials to get you kick-started whenever you need it. Delivery is available, as is catering for your event needs.

—*Veronica Carolyn Bond*

Valois Restaurant

If your mom made it, chances are Valois does too. Since 1926

$

1518 E. 53rd St., Chicago 60615

(at Harper Ave.)

Phone (773) 667-0647

CATEGORY	Diner
HOURS	Daily: 5:30 AM–10 PM
GETTING THERE	Metered lot behind adjacent Hollywood Video, street parking, or take #1 and 6 busses.
PAYMENT	Cash only
POPULAR FOOD	Roast beef, hot turkey, mashed potatoes, and salads
UNIQUE FOOD	Filling breakfast including eggs, hash browns, pancakes, sausages, and grits—under $10 for two people!
DRINKS	Sodas, juices, coffee, and tea
SEATING	About 20 tables
AMBIENCE/CLIENTELE	Neighborhood feel dominates here with local patrons and murals of Hyde Park landscapes painted on the walls.
EXTRAS/NOTES	It's Vuh-loyz—use the proper, French pronunciation, you're saying it wrong! University of Chicago sociology student Mitchell Dunier conducted his doctoral research at here, studying the social connections and relationships between the men who frequented the restaurant. His book, Slim's Table, as well as a visit to the Valois are excellent examples of academia as it applies to actual life. A good experience for anyone considering the U. of C.

—*Veronica Carolyn Bond*

WOODLAWN

Tre's Original Pancake Shoppe

Upscale American breakfast and diner fare to feed both body and soul.

$$

1528 E. 63rd St., Chicago 60637

(at Blackstone Ave.)

Phone (773) 256-0006 • Fax (773) 256-1987

CATEGORY	Coffee Shop/Diner
HOURS	Tues–Fri: 7 AM– 3 PM
	Sat/Sun: 7 AM–5 PM
GETTING THERE	Free lot or # 6 and 28 busses.

PAYMENT	
POPULAR FOOD	Pancakes!
UNIQUE FOOD	Southern fried chicken smothered in creamy onion gravy, served with a Belgian waffle.
DRINKS	Sodas, juice, coffee, and tea
SEATING	Large dining room accommodates 130.
AMBIENCE/CLIENTELE	This very inviting diner is mostly frequented by families and neighborhood locals.
EXTRAS/NOTES	On Sundays, don't miss the Soul Food Brunch, featuring live jazz from 2-5 PM!

—Valerie Wallace

SOUTH SHORE

BJ's Market & Bakery
(see page p. 166)
Southern American
1156 W. 79th St., Chicago 60620
Phone (773) 723-7000

L & G Family Restaurant
Baby, you ain't had breakfast until you've had it here!
$
2632 E. 75th St., Chicago 60649
(west of Exchange Ave.)
Phone (773) 374-3098

CATEGORY	Diner
HOURS	Daily: 5 AM–10 PM
GETTING THERE	Street parking, Metra station at Windsor Park, or #71 bus
PAYMENT	Cash only
POPULAR FOOD	The breakfast, man, the breakfast!
UNIQUE FOOD	International skillets—Greek, Jewish, Mexican, and Gypsy
DRINKS	Soda, juice, coffee, tea, and hot chocolate
SEATING	Enough room to seat 110 comfortably.
AMBIENCE/CLIENTELE	You'll see a crowd of families, couples, and mechanics (who usually hold down the counter seats).
EXTRAS/NOTES	The breakfast is enough to feed a small army, and delicious enough that you wouldn't dare share it!
OTHER ONES	• South Deering: 10401 S. Torrence Ave., Chicago 60617, (773) 721-0811

—L. Pat Williams

The Absolutely Fabulous History of Bubble Drinks— a Tall (but Tasty) Tale

Five thousand years ago, in a land far, far away, some noble people were apparently boiling water under a tree. When a leaf dropped into the pot, tea was born! It was revolutionary. Some even called it liquid jade.

Skip a few thousand years, and the practice is a popular, global phenomenon. Soon, people were adding sugar and milk; then after some really serious Eureka moments, iced tea was created. It took approximately 4,720 years before someone, supposedly from Taiwan, came up with the idea to add tapioca balls into the chilled, sweetened milk-tea.

Everything I have said so far is hearsay or legend—back then it was hard enough to find good writing materials, let alone the time to write anything down, what with all that under-tree water boiling to do. The one singular truth is that they put those quarter-inch tapioca balls into their drinks to save money! Why fill to the brim with good tea when you can throw in one, two, maybe three-dozen tapioca balls and there you go—two ounces of tea in an eight-ounce glass. Ingenious!

To add to the insanity, the balls themselves are so easy to make. Simply take some tapioca starch, mix it with hot water and caramel to form a thick paste, and run this through a sieve that will determine the size of the balls. Or roll it in your hands, if you have the time. The most difficult part, of course, was to invent a straw that could handle all that tapioca. Now, all you really have to do is decide which flavor you want—you don't even have to care about all the years of hard work it took to get to where we are now. Bum!

For the historically inclined or tapioca curious, embark on your own Absolutely Fabulous Taste of Bubble Tea at the following locations:

Joy Yee's Noodle Shop: 2159 S. China Pl., Chicago, (312) 328-0001

521 Davis St., Evanston, (847) 733-1900

Lee Wing Wah Restaurant: 2147 S. China Pl., Chicago, (312) 808-1628

Ken-Kee Restaurant: 2129-A S. China Pl., Chicago, (312) 326-2088

Ten Ren Tea & Ginseng Co. Ltd.: 2247 S. Wentworth Ave., Chicago, (312) 842-1171

Noodle Zone: 5427 N. Clark St., Chicago, (773) 293-1089

AVALON PARK

BJ's Market & Bakery

Healthy, wholesome "food for the soul" served in abundance, cafeteria-style.

$

8734 S. Stony Island Ave., Chicago 60617
(south of 87th St.)
Phone (773) 374-4700 • Fax (773) 374-9200

CATEGORY	Southern American
HOURS	Mon–Thurs: 11 AM–9 PM
	Fri/Sat: 11 AM–10 PM
	Sun: 11 AM–8 PM
GETTING THERE	Free parking lot or take the #28 and 87 busses.
PAYMENT	VISA MasterCard AMERICAN EXPRESS
POPULAR FOOD	Rotisserie smoked chicken, vegetarian sampler (choice of any four sides), banana pudding, and sweet potato pie
UNIQUE FOOD	Mustard-Fried Catfish (signature dish), rib tips, greens with smoked turkey, sweet potato fries, seven fresh vegetable, fruit, and pasta salads
DRINKS	Sodas, iced tea, and lemonade
SEATING	Large dining room to seat 209 and private dining room accommodates 20-60.
AMBIENCE/CLIENTELE	This is a family-style with plenty of sun and comfortable booths. It's mostly families and couples, with additional business crowd at lunchtime.
EXTRAS/NOTES	Whole cakes and pies are available for sale, in addition to catering options for your home, office, or event. Check out the Sunday Buffet!
OTHER ONES	• Evergreen Park: 9645 S. Western Ave., Chicago 60643, (773) 445-3400
	• South Shore: 1156 W. 79th St., Chicago 60620, (773) 723-7000

—Valerie Wallace

CHATHAM

Soul Vegetarian East

Soulful home cooking the way Mama NEVER made it!
$$

205 E. 75th St., Chicago 60619
(at Indiana Ave.)
Phone (773) 224-0104
www.kingdomofyah.com/SV

CATEGORY	Soul Food/Vegetarian
HOURS	Mon–Thurs: 6 AM–10 PM
	Fri: 6 AM–11 PM
	Sat: 8 AM–11 PM
	Sun: 8 AM–9 PM

GETTING THERE	Street parking (watch for zoning on side streets), Red line, 79th St. stop, or #75 bus.
PAYMENT	VISA MasterCard ($10 minimum)
POPULAR FOOD	Grilled corn bread, BBQ Twists, luncheon and dinner specials
UNIQUE FOOD	Carrot Supreme salad, Hebrew Toast (egg-less "French Toast alternative), and homemade soy ice cream
DRINKS	Micro-brewed sodas, juice bar, and herbal teas
SEATING	Nine tables in dining room, four in front room, accommodating 52 total.
AMBIENCE/CLIENTELE	Check out the African-themed paintings on the walls. This spot is very community-oriented—most customers and employees seem to know one another; warm and friendly.
EXTRAS/NOTES	Soul Vegetarian East was founded 20 years ago to provide an alternative African-root cuisine that allows the community to return to a harmonious, meat-free diet like in the Garden before the Fall. Don't expect twig-and-berry hippie fare; what they serve up is real, soul-satisfying comfort food that's full of flavor and free of guilt! Ingredients are fresh and delicious (salad vegetables are actually the vibrant colors that they are supposed to be!), and all baking is done on the premises. Splurge a little and go for the Daily Dinner plate (usually a protein entrée, grain, and vegetable, plus soup or salad and corn bread). Homemade salad dressings and specialty items are available for sale by the pound, so why not bring some home? Also, check out the adjacent Boutique Afrika, a lovely little shop with Afro-centric items galore.
OTHER ONES	• Washington D.C.; Atlanta; St. Louis; W. Africa; S. Africa; Israel

—Courtney Arnold

BEVERLY

Landmark

Top Notch Beef Burger

Serving up authentic Old-Fashioned American burgers since the early 1940s

$$

2116 W. 95th Street, Chicago, 60643

(Hamilton, near Western Ave.)

Phone (773) 445-7218

www.topnotchbeefburger.com

CATEGORY	Old School restaurant/diner
HOURS	Mon-Thurs: 8 AM–8 PM Fri-Sat: 7:30 AM–8:30 PM
GETTING THERE	Street and metered parking available
PAYMENT	Cash only
POPULAR DISH	The half-pound deluxe burger with all the trimmings and thick French fries—fresh cut daily
UNIQUE DISH	It's all about the juicy round-steak burger here and

	the turkey burger is as unusual as it gets here.
DRINKS	Sodas and thick n' hearty 1950s milkshakes
SEATING	Booth and counter seating for 50+. Saturdays are super busy, so expect a 15-20 minute wait, which isn't too shabby for this popular Beverly staple.
AMBIANCE/CLIENTELE	Keep it loose around the waist, because you will definitely be stuffed after your milkshake and deluxe burger.
EXTRAS/NOTES	Check out the ever-changing wall of art by local artists while you wait for a seat. Top-Notch offers the ultimate burger experience in a kitschy 1950s environment perfect for families, large groups of friends or couples looking to pig out together!
OTHER ONES	• Oaklawn: 4720 W 95th St., Oaklawn, IL 60458, (708) 422-5544

—Michelle Burton

Chinatown:
The Year of the Pig Out

From paper dragons to porcelain cups of oolong tea, Chicago's Chinatown has offered authentic Chinese culture and cuisine to tourists and natives alike since the early 1900s. Bounded on the north by Cermak Road, on the south by 35th Street, on the west by Halsted Street, and on the east by the Dan Ryan Expressway, the roughly forty restaurants in Chinatown's ten blocks cook up familiar fare as well as exotic delicacies for tens of thousand of visitors each year. So grab a set of chopsticks, follow the scent of ginger and soy, and get ready to eat!

Chinatown wasn't always located in its current and familiar location. The first Chinatown was located at the crossroads of Van Buren and Clark Streets. But in 1905, when rents became too high, the community was transplanted to its current site, around the intersection of Cermak and Wentworth, a neighborhood that had previously been occupied by Italian and Croatian immigrants. The Chinatown neighborhood was then, and is still, a way for recent Chinese immigrants to find work and housing and to comfortably acclimate to the language and customs of America. Immigrants from all regions of China and its surrounding countries live in the Chinatown neighborhood. Consequently, regional cuisine may vary from restaurant to restaurant and even on the same menu.

Although there are over 40 restaurants in Chinatown, the following list is a recommendation of some of the finest and most affordable:

Three Happiness Restaurant
Three Happiness was the first restaurant in Chicago's Chinatown to introduce dim sum, a style of dining where several smaller dishes are sampled, rather than one large entrée. Diners can select from a large variety of dim sum plates that rotate around the room on metal carts. The fried rice is pleasantly sweet since it is steamed in banana leaves and sprinkled with bits of meat and egg. The har gow, or shrimp dumpling, is another dim sum treat

not to be missed. At night, guests can enjoy karaoke on the first floor. (*Chinatown: 2130 S. Wentworth Ave., Chicago 60616, (312) 791-1228*)

Won Kow Restaurant
Won Kow has been serving Chicago since 1927 and features a large dining room on the second floor. Rather than order dim sum selections from passing carts, orders are placed individually so that the food arrives hot and tasty. Noodle and rice dishes are served, along with dim sum selections, such as shrimp toast, sticky rice rolls, and dumplings. Try the Cantonese roasted duck, served in moist, bite-sized pieces. The traditional hot and sour soup is perfectly tart and thick with ample tofu. (*Chinatown: 2237 S. Wentworth Ave., Chicago 60616, (312) 842-7500*)

House of Fortune
House of Fortune serves good ol' Chinese classics, such as pot stickers, egg rolls, Peking duck, and sizzling fried rice. You'll also find not-so-Chinese classics, such as T-bone steak and filet of sole. This restaurant's 100-item menu specializes in Cantonese and Mandarin cuisine. The décor here recalls the upscale elegance of Hong Kong hotels. (*Chinatown: 2407 S. Wentworth Ave., Chicago 60616, (312) 225-0880*)

Emperor's Choice
The Emperor's Choice is located in the heart of Chinatown and is extremely popular, despite being relatively small. Traditional selections, such as egg rolls and sesame chicken are available, as well as unique entrees, such as Mandarin ostrich. The seafood combination platter comes with ample scallops, squid, and shrimp, mixed with steamed, crunchy broccoli, carrots, and onions in a light sauce. Try the spicy soft-shell crab in season, or exotic shark fin soup that is made with shark-fin cartilage, which is considered an aphrodisiac. (*Chinatown: 2238 S. Wentworth Ave., Chicago 60616, (312) 225-8800*)

The Phoenix Restaurant
Considered by many to be the best food in all of Chinatown, The Phoenix Restaurant specializes in a dim sum brunch, served every day from 8 am to 3 pm. This restaurant's two floors accommodate up to 500, so groups are not a problem. In fact, there is even a small dance floor for parties that want to shake it between courses. The spring rolls are light and flaky and the seaweed-wrapped fried squid rolls are a dish you simply cannot find elsewhere. The menu boasts a wide selection and contains unique items, such as a pan-fried sea bass that is light and flavorful. (*Chinatown: 2131 S. Archer Ave., Chicago 60616, (312) 328-0848*)

—Heather Augustyn

SUBURBS
NORTHSHORE

EVANSTON

Aladdin's Eatery

"At Aladdin's eat good, eat healthy"

$$

622 Davis St., Evanston 60201

(at Chicago Ave.)

Phone (847) 475-1498

www.aladdinseatery.com

CATEGORY	Mediterranean
HOURS	Daily: 11 AM-10 PM
GETTING THERE	Street parking
PAYMENT	VISA MasterCard AMERICAN EXPRESS DISCOVER
POPULAR DISH	Aladdin's is best known for their hummus. They offer it solo as an appetizer or try the Hummos Pocket, Hummos Shawarma plate, Hummos Chicken plate, or Hummos Falaffel pita.
UNIQUE DISH	Aladdin's offers cheap, healthy food that is a favorite among vegetarians. The cheap prices also attract the local Northwestern students. Almost 100 items appear on their menu so it can be a little confusing or overwhelming. The staff is great at explaining the different dishes and making recommendations.
DRINKS	Freshly squeezed and natural juices are wildly popular. Also offers smoothies and a wide selection of herbal and regular tea, plus soda, iced tea, coffee, and lemonade. Not pricey.
SEATING	It has a small and cozy feel but can seat about 50. It's a good place for singles, couples, or large groups. There are different sections of seating so it's possible to be secluded if you desire or can be right in the middle of the action.
AMBIENCE/CLIENTELE	Very casual. Many local college students flock to Aladdin's so it has somewhat of a college hangout vibe. On weekends, it can get a little noisy, crowded, and service can be slow at high-peak times. The décor is so nice, you won't mind the chance to look around though. From the bold red walls to the eye-catching artwork and sculptures, the surroundings provide a nice atmosphere. Although by looking at the prices you might think otherwise, the food is great. With such a wide selection of food—which includes chili, rolled pitas, salads, salad pockets, and pitzas—even the most loyal customer probably hasn't tried everything on the menu! And don't forget to ask about their yummy desserts, these aren't listed on the menu.

—*Carrie Asato*

Blind Faith Café

A no-frills veggie haven just north of the city.

$$$

525 Dempster St., Evanston 60201

(east of Chicago Ave.)

Phone (847) 328-6875
www.blindfaithcafe.com

CATEGORY	Vegetarian/Vegan
HOURS	Mon–Thurs: 9 AM–9 PM
	Fri: 9 AM –10 PM
	Sat: 8 AM–10 PM
	Sun: 8 AM–9 PM
GETTING THERE	Street parking or take Purple line, Dempster stop.
PAYMENT	VISA MasterCard AMERICAN EXPRESS
POPULAR FOOD	Macrobiotic Plate, Mexican Breakfast (eggs with tortillas and salsa), whole grain pancakes, veggie burgers and chili, and quesadillas
UNIQUE FOOD	Tofu Satay, Seitan Fajitas, peanut butter and tofu soy shakes
DRINKS	Natural sodas, fruit and vegetables juices blended to order, spritzers, cider, coffee, and tea
SEATING	Full table service for 50 in the dining room and counter service for 30
AMBIENCE/CLIENTELE	Granola-crunchy cozy; beautiful quilt art on the walls; warm, burnished wood accents; plenty of windows; friendly service; diverse clientele—even the occasional celebrity.
EXTRAS/NOTES	Do not be mistaken, there is no nouveaux, veggie-chic bandwagon hopping at work here—Blind Faith has been around since 1979, so you know it's the real deal. The counter-service section is great for the solo diner, but there is a catch—you must bus and wipe down your own table when you're finished! T-shirts and bakery items (vegan cornbread, fruit pies, cookies, etc.) available for sale.

—*Victoria Cunha*

Cross-Rhodes

Traditional Greek fare for vegetarians and meat eaters alike.
$$
913 Chicago Ave., Evanston 60202
(north of Main St.)
Phone (847) 475-4475

CATEGORY	Diner-Greek/Family Places
HOURS	Mon–Thurs: 11 AM–9:30 PM (11:30 AM–10 PM during the summer)
	Fri/Sat: 11 AM–10 PM
	Sun: 4 PM–9 PM
GETTING THERE	Parking lot and street parking or take Metra and Purple line, Main stop, or #202 bus.
PAYMENT	Cash only
POPULAR FOOD	Greek chicken, spinach pies, and gyros
UNIQUE FOOD	Try the Greek fries with a vegetarian sandwich.
DRINKS	Sodas, beer, and wine
SEATING	Plenty of seating for up to 64 people
AMBIENCE/CLIENTELE	Atmosphere reminiscent of, well, a Greek diner—which it is; lots of families, kids.

—*Heather Augustyn*

Dixie Kitchen & Bait Shop

(see page p. 160)
Southern American
825 Church St., Evanston 60201
Phone (847) 733-9030

Jilly's Café

*Offering unique French cuisine for 17 years—an
Evanston tradition.*
$$$
2614 Green Bay Rd., Evanston 60201
(north of Central St.)
Phone (847) 869-7636
www.jillyscafe.com

CATEGORY	French
HOURS	Tues–Thurs: 11:30 AM–2 PM; 5 PM–9 PM
	Fri: 11:30 AM–2 PM; 5 PM–10 PM
	Sat: 5 PM–10 PM
	Sun: 10 AM–2 PM;5 PM–8 PM
GETTING THERE	Street parking or Metra, Central St. stop
PAYMENT	VISA MasterCard AMERICAN EXPRESS DISCOVER
POPULAR FOOD	Spinach salad, Caesar salad, crab cakes, bruschetta, shrimp linguini, rotini with grilled chicken
UNIQUE FOOD	Spring rolls with cherries and brie, turkey, bacon, brie, and apple club sandwich
DRINKS	Beer, wine, champagne, sodas, juices; mimosas for brunch, coffee, and teas
SEATING	Accommodates 55
AMBIENCE/CLIENTELE	Tables are close and cozy, but not cluttered. Limited seating keeps the "local" feel. Mix of neighborhood diners in the evening, and business/leisure diners at lunchtime.
EXTRAS/NOTES	Jilly's is like going to a friend's house, hanging up your coat, and staying awhile to get to know your neighbors. If you're planning on taking a date to Jilly's for a romantic dinner, keep in mind that menu prices go up quite a bit in the evenings. Also, plan to go early or stay late, or you won't get the privacy you're looking for. It's a great brunch place to take Mom.

—Jamie Popp

The Lucky Platter

An upscale diner with a unique, organic flair.
$$$
514 Main St., Evanston 60202
(east of Chicago Ave.)
Phone (847) 869-4064 • Fax (847) 869-3160
evanstonillinois.net/luckysite/

CATEGORY	Heinz 57
HOURS	Mon–Thurs: 7 AM–9:30 PM

	Fri/Sat: 7 AM–10 PM
	Sun: 7 AM–9 PM
GETTING THERE	Street parking or take Purple line, Main stop, or #202 bus
PAYMENT	
POPULAR FOOD	Sweet potato fries, jerk chicken, and creamy pumpkin soup
UNIQUE FOOD	Fried green tomatoes
DRINKS	Sodas, beer and wine, and limited liquor list
SEATING	Accommodates 100
AMBIENCE/CLIENTELE	Not your run-of-the-mill diner.
EXTRAS/NOTES	Make sure to sample the delicious, homemade cream sodas!

—Heather Augustyn

LuLu's

Their tagline says it best: dim sum and then sum.

$$

804 Davis St., Evanston 60201

(at Sherman Ave.)

Phone (847) 869-4343

www.lulusdimsum.com

CATEGORY	Pan-Asian
HOURS	Mon–Thurs: 11:30 AM–10 PM
	Fri/Sat: 11:30 AM–11 PM
	Sun: 11:30 AM–9 PM
GETTING THERE	Street parking or take Purple line, Davis stop.
PAYMENT	
POPULAR FOOD	Pot stickers, chicken salad with ginger dressing, and Pad Thai
UNIQUE FOOD	Crispy fried sesame balls and Korean Bibim Bop
DRINKS	Sodas, juice, lemonade, coffee, and a decent tea selection
SEATING	Seats approximately 40
AMBIENCE/CLIENTELE	This very friendly spot is always humming. Expect students and Evanston locals.

—Jen Lawrence

The Olive Mountain Restaurant

Serving Middle Eastern specialties beyond just hummus and pita bread.

$$

610 Davis St., Evanston 60201

(at Chicago Ave.)

Phone (847) 475-0380 • Fax (847) 475-0712

CATEGORY	Middle Eastern/Mediterranean/Kid Friendly
HOURS	Mon–Thurs: 11 AM–9:30 PM
	Fri: 11 AM–10:30 PM
	Sat: noon–10:30 PM
	Sun: noon–9 PM
GETTING THERE	Street parking or take Metra and Purple line, Davis stop.

PAYMENT	
POPULAR FOOD	Chicken shawerma and shish kabob beef
UNIQUE FOOD	Mediterranean pizzas; Pita Pockets and wraps; kids' menu of good ol' American standbys
DRINKS	Freshly squeezed juices; sodas; coffee, tea
SEATING	Seats 66
AMBIENCE/CLIENTELE	Middle Eastern music and artwork. This place attracts diners from all over the North Shore
EXTRAS/NOTES	Don't miss the luncheon specials, served until 3 PM daily: fifteen items to choose from, plus your choice of hummus, falafel, soup, or Lebanese salad, and a beverage—all for under six bucks! Desserts such as koulaj, kunafa, and baklava are not to be missed. Carry-out and delivery available.

—Jelene Britten

Philly's Best

(see page p. 61)
Sandwich Shop
815 Emerson St., Evanston 60201
Phone (847) 733-9000

Prairie Joe's

"Ozark Dave" says: Come 'n' Get It!
Comfort food with a twisted sense of humor.
$$
1921 Central St., Evanston 60201
(west of Green Bay Rd.)
Phone (847) 491-0391

CATEGORY	Diner/Kids Welcome
HOURS	Mon/Tues: 6:30 AM–3 PM
	Wed–Fri: 6:30 AM–7:30 PM
	Sat: 7 AM–3 PM
GETTING THERE	Metered street parking or take #201 and 213 busses.
PAYMENT	Cash only
POPULAR FOOD	Meatloaf, Sloppy Joe, and breakfast
UNIQUE FOOD	Feta cheese quesadillas, Carrot Burrito with hummus and feta and hominy specials
DRINKS	Yummy shakes and malts in multiple flavors, floats, sodas, coffee, tea, and hot cocoa
SEATING	Eighteen counter spots and tables and booths to seat 60
AMBIENCE/CLIENTELE	This homey diner is kid-friendly with a bizarro twist—check out that menu!
EXTRAS/NOTES	Be sure to try the Mexican breakfast items.

—Heather Augustyn

SUBURBS
NORTHWEST

ROSEMONT

Augie's Doggies
Add Ketchup and you'll be shot.

$

9467 W. Higgins Road, Rosemont, 60018
Phone (847) 698-4053

CATEGORY	Authentic Chicago Dog Diner
HOURS	Mon-Fri: 10 AM- 7 PM
	Sat: 11 AM- 7 PM
GETTING THERE	Free parking in adjacent lot
PAYMENT	VISA MasterCard
POPULAR DISH	The Jumbo Augie Dog is a gastronomical delight. Distinctive Chicago dogs are served up steam cooked in their natural casing. Prepared with the customary neon-green relish, mustard, chopped onions, hot peppers, and a dash of celery salt; these dogs are perfect hangover food. It is sacrilegious to put ketchup on these things, if you must do so, do it while hiding in the bathroom. To wash down this delicious monstrosity, try the Augie Lizzard, a shake made with Oreo, Heath, Reese's and Butterfinger. On Thursdays, Fridays, and Saturdays the special is the $2.50 slop slop sloppy Joe!
UNIQUE DISH	If you prefer to do the cooking yourself, you take Vienna Beef home for $6 a pound. They'll even give you a few tips on how to cook them.
DRINKS	Usual standards, no alcohol.
SEATING	This place is tiny. The only thing bare-bones about this hot dog joint is the joint. The place is small, and the available seating consists of about six tables and a dining bar.
AMBIENCE/CLIENTELE	It's a hot dog stand. Cops appear to love it, as well as hung-over hipsters and born and raised Chicagoans. The place is absolutely immaculate and the service more than friendly. If you go alone, don't expect not to get drawn into conversation with either the staff or regulars. Close your eyes and you may find yourself inside somewhat of a David Lynch movie. An eighty year old woman with a blue beehive might just appear next to you with an interesting story or two.
EXTRAS/NOTES	Augie's has been serving up the dogs for twenty years, the current owner purchasing it in February of 2005. Either this guy hasn't had enough time behind the counter to become jaded yet, or he is one of the friendliest damn people I have ever met. The service is personable, and they appear to know the cops by name. It could be because of the authentic Chicago monstrosities or the immaculate dining area that this place has such a loyal following. They serve burgers and sandwiches as well and you can take your pick from the menu that takes up an entire wall. Even though this place is described as a hot dog stand, you'll miss it if you're looking for something that resembles a roadside hut. It's located in something more along the lines of a strip mall. We'll forgive them.

—*Alana Sitek*

SKOKIE

The Bagel Restaurant & Deli

(see page p. 73)
Jewish/Deli
50 Old Orchard Center, Skokie 60077
Phone (847) 677-0100

Daily Grill

Casual elegance, quiet lunches. Code: Don't bring noisy kids!
$$$$
9599 Skokie Boulevard, Skokie 60077
(at Golf Road)
Phone 847-329-4334

CATEGORY	Upscale hotel restaraunt
HOURS	Sun-Thurs: 6 AM- 10 PM
	Fri/Sun: 6 AM- 2 AM
GETTING THERE	Valet parking and free lot
PAYMENT	VISA MasterCard DISCOVER
POPULAR DISH	The cobb salad, mesculin salad with pecans and dried cranberries, omelets and waffles
DRINKS	Full bar, coffee, and tea
SEATING	About 150, cozy, great for a lunch date or quiet business lunch/dinner
AMBIENCE/CLIENTELE	Walking into the Daily Grill automatically sets the mood for your meal: quiet, elegant, yet comfortable. Deep cherry wood covers the booths and the dining area is dimly lit by candlelight fixtures and the natural sunlight coming through the large foyer windows. The tables are nicely set with vintage-looking silverware and coffee is served in a sliver pot that resembles that of an English tea set. An open window to the kitchen gives the feeling of being a special guest at the chef's personal table. The food is presented elegantly, but not too over the top. But don't be fooled; there are also burgers and meatloaf and mashed potatoes on the menu. The salads are excellent, especially the cobb and the mesculin, and big enough for two people to share. Not like a typical fast lunch, it's all about taking time and enjoying a side of strawberries, fresh to order. The restaurant is also connected to a Doubletree hotel and is across the street from Old Orchard shopping center, making it a great destination for a longer lunch or if the mall's food court is too packed.
OTHER ONES	• The more upscale "The Grill on the Alley" is downtown on Michigan Avenue

— *Mindy Golub*

Eastern Style Pizza

(see page p. 117)
Pizza/Sandwich Shop
3560 Dempster St., Skokie 60076
Phone (847) 679-6455

Pita Inn

This is the Middle Eastern McDonalds,
but much better!
$

3910 West Dempster Street, Skokie 60076
(at Crawford Avenue)
Phone (847) 677-0211

CATEGORY	Low-key, casual, fast-food, take out, lunch and dinner
HOURS	Sun-Thurs: 11 AM-11 PM Fri-Sat: 11 AM-midnight
GETTING THERE	Free parking lot
PAYMENT	Cash, checks
POPULAR DISH	Falafel sandwich and chicken shawarma
UNIQUE DISH	The quality of food is unexpected for the ridiculously low price.
DRINKS	No alcohol, but great smoothies
SEATING	Room for 80 people
AMBIENCE/CLIENTELE	Welcome to the Middle Eastern version of McDonald's, except their food is actually quite good, and much healthier. Doesn't matter what you wear, if you're coming or going; just be ready to give your taste buds a workout. Filling the restaurant is the sound of Middle Eastern beats and the smell of lentil soup and fresh shawarma, which can also be seen behind the counter, rotating on a numerous spits. The food is great for take out, or to be eaten in the lightly decorated seating area, with Middle Eastern printed walls, tall vases and hanging plants. Bring an appetite because everything is so cheap, and the quality of the food is unbelievable. Walk in with $20 and walk out with a 5 to 7 course meal for two or three people. The hummus is a must-have, and the portions here are very nice, so it is easy to try numerous appetizers and entrees. Almost all of the entrees come with a heap of rice pilaf, lettuce and tomato wedges, and pita bread, which is a meal in itself! A voice behind the counter will call your number when the order is ready and make sure to grab a hot sauce and a yogurt tahini sauce to try on all of the food. If you've ever seen the Saturday Night Live skit with Jon Belushi when he is working the counter, "No Coke, Pepsi," this is similar to that fast-food joint, with a Middle Eastern influence.

—Mindy Golub

Do You Know the Way to Shermer? John Hughes and the Town that Wasn't There

There once was a little town outside Chicago where all the cool rich kids sat on one side of the lunchroom and the poor and geeky—though ultimately much hipper—kids sat on the other. This was the kind of suburban town where a shy girl just wanted to be with the popular boy and the geeky boy wanted to be with any girl. This was Anywhere, USA, circa 1980s. Though you will not find Shermer on any map—as Jay and Silent Bob discover in Kevin Smith's *Dogma*—you'll find its double in the town of Northbrook, IL, the real-life setting and inspiration for many of writer/director John Hughes films. Located 25 miles outside of Chicago, Northbrook (once called Shermerville) is Hughes' hometown. Though nearly all of Hughes' films take place in Shermer (with the blushing exception of *Maid in Manhattan*) Hughes' tales of high school angst hold a special place the Hungry City staff. So if you're in the mood for a little fieldtrip (and a bit of campy '80s nostalgia), take the Hungry? Shermer Tour.

Sixteen Candles –Samantha's (Molly Ringwald) sweet sixteen is anything but sweet when her family forgets her birthday. Adding to Samantha's embarrassment, the geekiest boy in school (Anthony Michael Hall) has a crush on her and her crush on the most popular boy in school (Michael Schofelling) seems unrequited. If all of this weren't bad enough, Samantha also must bear with horrendously embarrassing grandparents and foreign exchange student named Long Duc Dong (Gedde Wantabe),

Want to find it? High school scenes were filmed in East Niles High School in Skokie, IL, which is currently a part of Oakton Community College. *(7701 N. Lincoln Ave., Skokie, IL, 60077)*

Breakfast Club – Forced to spend a Saturday in detention, five students from different circles (Molly Ringwald, Anthony Michael Hall, Emilio Estevez, Ally Sheedy, Judd Nelson) discover they have more in common than they had ever thought. Who doesn't want be an airborne ranger?

Want to find it? Much of the film was shot in Hughes' alma mater, Glenbrook North High, in Northbrook, IL. *(2300 Shermer Rd. Northbrook, IL, 60602)*

Pretty in Pink – Adie (Molly Ringwald), an artistic girl from the poor side of town, falls for Blane (Andrew McCarthy), the new kid in school, but Blane's ultra-rich friend (James Spader) won't have it. Meanwhile Adie's New Wave best friend, Duckie (Jon Cryer), falls in love with her.

Want to find it? You'll have to go a long way since most of the high school scenes were filmed a the same L.A. high school as *Grease*

Ferris Bueller's Day Off – When high school senior Ferris Bueller (Mathew Broderick) plays hooky with his best friend (Alan Ruck) and girlfriend (Mia Sara), the principal (Jeffery Jones) decides to try and catch Ferris in the act and prevent him from graduating. Meanwhile, Ferris' jealous sister (Jennifer Gery) decides to show her parents that Ferris isn't the angel they think he is.

Want to find it? You might need to go on a cross-country road trip to see this one. Shermer scenes were shot in Northbrook (most of the high school scenes) as well as Long Beach, CA (Ferris' house) and Woodland Hills, CA (the principals office).

Weird Science - Desperate to finally get a girl, Gary and Wyatt (Anthony Michael Hall and Ilan Michael Smith) use their computer and a little bit of that old black magic to create the perfect woman, Lisa (model Kelly LeBrock). With Lisa's help the two geeks overcome their lack of confidence to get what they have always wanted: a little respect.

Did you know? Not only is this the third movie in which Anthony Michael Hall mentions a fictive girlfriend from Canada, but, like *The Breakfast Club*, this movie is also set in the fictitious Shermer High.

—Louis Pine

PARK RIDGE

Wally's

What do you have a taste for? Satisfy every craving here...
$$
1006 N. Northwest Hwy., Park Ridge 60068
(north of Oakton St.)
Phone (847) 825-2214 • Fax (847) 825-3102

CATEGORY	Heinz 57
HOURS	Mon–Sat: 11 AM–10 PM
	Sun: 11 AM– 9 PM
GETTING THERE	Free parking lot
PAYMENT	
POPULAR FOOD	Gyros, Italian beef sandwiches, and ribs.
UNIQUE FOOD	Seafood dinners, shish kebabs, fresh, and homemade soups
DRINKS	Sodas; milkshakes; coffee, tea.
SEATING	Booths and counter seating for 40; outdoor dining in Spring and Summer.
AMBIENCE/CLIENTELE	Nothing fancy—just a simple, clean store with easy listening music in the background; mostly families.
EXTRAS/NOTES	There are 145 items on the menu!

—Lisa Dumich

DES PLAINES

Barnaby's Family Inn

A cozy little dive to take the team after a big win.
Since 1968
$$
636 E. Touhy Ave., Des Plaines 60018

(just west of Mannheim Rd.)
Phone (847) 297-8866

CATEGORY	Family friendly eatery
HOURS	Mon–Fri: 9:30 AM–9 PM
	Sat: 11 AM–11 PM
	Sun: noon–9 PM
GETTING THERE	Free lot
PAYMENT	Cash only
POPULAR FOOD	Fries, burgers, chili, and pizza
UNIQUE FOOD	You could probably find everything on the menu somewhere else, but not as delicious.
DRINKS	Domestic beers, wine, sodas, coffee, and tea
SEATING	Large dining room seats upwards of 200
AMBIENCE/CLIENTELE	Dim lighting, bright, cheery service; full of regulars, mostly families who meet for weekly nights out
EXTRAS/NOTES	Barnaby's is the place your old little league coach used to take the team for pizza after winning the game. You can even bring a scout troop or birthday party for a "pizza tour" of the inner workings of the kitchen.
OTHER ONES	• Arlington Heights: 933 W. Rand Rd., Arlington 60004, (847) 394-5270
	• Niles: 7950 N. Caldwell Ave., Niles 60714, (847) 967-8600
	• Northbrook: 960 Skokie Blvd., Northbrook 60062, (847) 498-3900

—Stefan Woerle

Leona's

(see page p. 21)
Italian
1504 Miner St., Des Plaines 60016
Phone (847) 759-0800

Paradise Pup

Blink and you'll miss it—truly a best-kept secret!
$
1724 S. River Rd., Des Plaines 60018
(south of Riverview Ave.)
Phone (847) 699-8590 • Fax (847) 824-3294

CATEGORY	Hot Dog Stand/Burger Joint
HOURS	Mon–Sat: 11 AM–5 PM
GETTING THERE	Small lot
PAYMENT	Cash only
POPULAR FOOD	Char-grilled burgers and chicken sandwiches
UNIQUE FOOD	3-Layer Fries topped with sour cream, bacon, and cheese
DRINKS	Sodas, tea, and incredible shakes
SEATING	Counter for twelve people, plus outdoor seating in Spring and Summer.
AMBIENCE/CLIENTELE	This simple, unassuming spot's frequented by local devotees and visitors with a good recommendation.

—Lisa Dumich

Taquería Tepa

An ethnic food refuge in a neighborhood where diners and grills dominate.

$$

1916 Mannheim Rd., Des Plaines, 60018

(north of Touhy Ave.)

Phone (847) 375-TEPA (8372) • Fax (847) 375-8371

CATEGORY	Mexican
HOURS	Daily: 10 AM–10 PM
GETTING THERE	Free lot
PAYMENT	VISA MasterCard AMERICAN EXPRESS
POPULAR FOOD	Tortas, burritos, and desayunos (breakfast)
UNIQUE FOOD	Birra al EstiloJalisco (goat meat), menudo, and goat meat tacos
DRINKS	Mexican sodas, Jarritos, horchata, Mexican hot chocolate, malts, Mexican and domestic beer
SEATING	Accommodates 55-60
AMBIENCE/CLIENTELE	Mexican soccer décor theme; quick, attentive service; corporate lunch crowd, plus a steady flow of Latino regulars.
EXTRAS/NOTES	If you're looking for respite from the corporate/industrial status quo, stop on into Tepa. Here you can catch up on your tele novelas and, as the drama unfolds, munch on chips and hot-as-hell salsa (complimentary with meals). The meats are cut fresh daily, and tummy-warming soups and all-day-long breakfasts are the perfect remedy for the winter blues. Be sure to save room for a sweet, such as candied sweet potatoes, macaroons, or a dulce de leche bar. And while you're there, check out their selection of Mexican CDs, all available for sale.

—*Falcaõ*

SUBURBS
SOUTHWEST

OAK PARK

Buzz Café

*The strong coffee and heart-healthy
fare—now that's something to buzz about!*

$$

905 S. Lombard Ave., Oak Park 60304
(at Harrison)
Phone (708) 524-2899 • Fax (780) 570-1484
www.thebuzzcafe.com

CATEGORY	Coffeehouse/café—the place to be in Oak Park
HOURS	Mon-Fri: 6 AM-9 PM Sat: 7 AM-9 PM Sun: 8 AM-2 PM
GETTING THERE	Rock Star parking in front of the building and plenty of street parking nearby.
PAYMENT	VISA MASTERCARD AMERICAN EXPRESS DISCOVER
POPULAR DISHES	Mediterranean potato to start and then a Grilled Gourmet Organic Burger with plenty of fixin's. If you don't eat anything that has a face try a raspberry filled brie wedge and the Garlic Grilled Mushroom.
UNIQUE DISH	The all organic breakfast with organic eggs, toast, bagels or hash browns, organic bacon or sausage patties with fresh fruit.
DRINKS	BYOB—people usually bring libations for Jazz performances and to have with dinner later in the evening. But coffee, teas, juice and sodas get the most mileage here.
SEATING	The space is open and airy with seating for 30-35.
AMBIENCE/CLIENTELE	Located in the Harrison Street Arts District, Buzz is a place where locals, artists and professionals alike gather to discuss politics, listen to Jazz or storytelling and of course, to enjoy fresh and healthy fare at affordable prices. The atmosphere is laid-back, casual and super friendly. You can feel the positive energy from a mile away!
EXTRAS/NOTES	The walls are covered in art at this local café serving up delicious breakfast entrees, Sunday Brunch, lunch and family dinners (every Tuesday and Thursday night). Check out the Buzz store selling stuff like dolls, mugs, syrups and packaged coffees.
OTHER ONES	• Oak Park: 834 Lake St., Oak Park, IL 60304 (Inside the Oak Park Public Library), (708) 660-9500 or (708) 570-1484

—*Michelle Burton*

Erik's Deli

A taste of summer all year long.

$$

107 N. Oak Park Ave., Oak Park 60301
(south of Lake St.)
Phone (708) 848-8805 or, for carry-out (708) 848-8806 • Fax (708) 848-8892

CATEGORY	Deli
HOURS	Mon–Fri: 10:30 AM–10 PM
	Sat: 9 AM–10 PM
	Sun: 9 AM–9 PM
GETTING THERE	Street parking or take Blue and Green lines, Oak Park stop, and #309, 311, and 313 busses.
PAYMENT	VISA MasterCard AMERICAN EXPRESS DISCOVER
POPULAR FOOD	Burgers, chicken fingers, hot and cold sandwich classics
UNIQUE FOOD	Copenhagen Sauce—house honey-mustard vinaigrette with warm, homemade potato chips.
DRINKS	Fountain and bottled sodas, beer, and wine
SEATING	Accommodates 150.
AMBIENCE/CLIENTELE	Large indoor seating area made up of "outdoor" tables (complete with umbrellas), to evoke summertime throughout the year.
EXTRAS/NOTES	Located in the center of the classic Oak Park Ave. shopping district, Erik's has been serving up great food for 25 years. It has a family-friendly feel and a casual service style—order at the counter, and the staff will serve you at your table. Be sure to try the signature Copenhagen Sauce, an exclusive house recipe with an unparalleled taste. They are proud enough to sell it by the bottle, in addition to T-shirts and caps for the souvenir minded. Try the Build-Your-Own sandwich options, and don't forget about Erik's weekend brunch! Catering and take-out available.

—*Courtney Arnold*

Grape Leaves Restaurant

Fresh and healthy Middle Eastern cuisine with a home-cooked taste.
$
129 S. Oak Park Ave., Oak Park 60302
(south of Lake St.)
Phone (708) 848-5555

CATEGORY	Middle Eastern
HOURS	Mon–Sat: 11:30 AM–3 PM; 4:30 PM–10 PM
	Sun: 11:30 AM–9:30 PM
GETTING THERE	Street parking or take Blue and Green lines, Oak Park stop, or #311 bus.
PAYMENT	VISA MasterCard AMERICAN EXPRESS DISCOVER
POPULAR FOOD	Kabobs, falafel, dolmeh, shawarma sandwiches (chicken or red meat)
UNIQUE FOOD	Hard-to-find, authentic kibbeh—fried minced meatball made with cracked wheat and custard
DRINKS	Fresh juices, Turkish coffee, espresso drinks, coffee, tea, and sodas
SEATING	Room for around twenty people
AMBIENCE/CLIENTELE	Tiny, but cozy, space; near great Oak Park shopping.
EXTRAS/NOTES	Grape Leaves is often busy on weekends, but there's never a long wait—the owner poled customers on whether or not to expand the space, and the answer was a unanimous no! Sandwiches and entrees suit any appetite, while portions are reasonable enough to allow room for some of their tasty dessert.

Whatever you eat here, it will be fresh and healthful, and never greasy or oily. Catering and delivery available.

—*Courtney Arnold*

Lalo's

(see page p. 20)
Fun tourist trap
804 S. Oak Park Ave., Oak Park 60304
Phone (708) 386-3386

Leona's

(see page p. 21)
Italian
848 W. Madison, Oak Park 60302
Phone (708) 445-0101

"Researchers have discovered that chocolate produces some of the same reactions in the brain as marijuana. The researchers also discovered other similarities between the two but can't remember what they are."

—*Matt Lauer (on NBC's Today Show)*

STILL HUNGRY?

Our glossary covers many of those dishes that everyone else seems to sort of know but we occasionally need a crib sheet. As for ethnic dishes—we've only covered the basics.

adobo (Filipino)—a stew of chicken, pork, or fish traditionally flavored with garlic, soy sauce, white vinegar, bay leaves, and black peppercorns.

aduki beans—small, flattened reddish-brown bean; sometimes used as a confectionery.

affogato (Italian)—literally poached, steamed or plunged; actually scoops of assorted ice-cream "plunged" in espresso, often topped with whipped cream.

agua fresca (Latin America)—(also agua natural) flavorful drink that's somewhere between a juice and a soda. We like horchata and tamarindo!

albondigas (Latin American)—meatballs. In Mexico it's popular as a soup.

andouille (Cajun)—a course-grained smoked sausage of pork, chitterlings, wine, onions, and seasoning.

antojitos (Latin American)—appetizers (means "little whims").

ayran (Middle Eastern)—yogurt based drink, like lassi but flavored with cardamom.

au jus (French)—meat (usually beef) served in its own juices.

baba ganoush (Middle Eastern)—smoky eggplant dip.

baklava (Turkish)—sweet pastry-dessert with a bit of nut and spice.

bansan (Korean)—see panchan.

bao (Chinese)—sweet stuffed buns either baked or steamed; a very popular dim sum treat!

basbousa (Middle Eastern)—a Semolina cake of yogurt and honey.

bean curd (Pan-Asian)—tofu.

beignets—New Orleans-style donuts (sans hole) covered in powdered sugar.

bigos (Polish)—winter stew made from cabbage, sauerkraut, chopped pork, sausage, mushrooms, onions, garlic, paprika and other seasonings. Additional veggies (and sometimes red wine!) may be added.

bibimbap (Korean)—also bibibap, served cold or in a heated clay bowl, a mound of rice to be mixed with vegetables, beef, fish, egg, and red pepper sauce.

biryani (Indian)—meat, seafood or vegetable curry mixed with rice and flavored with spices, especially saffron.

black cow—frosty glass of root beer poured over chocolate ice cream.

blintz (Jewish)—thin pancake stuffed with cheese or fruit then baked or fried.

borscht (Eastern European)—beet soup, served chilled or hot, topped with sour cream.

GLOSSARY

bratwurst (German)—roasted or baked pork sausage.

bul go gi (Korean)—slices of marinated beef, grilled or barbecued.

bun (Vietnamese)—rice vermicelli.

café de olla (Mexican)—coffee with cinnamon sticks and sugar.

callaloo—a stew made with dasheen leaves, okra, tomatoes, onions, garlic, and meat or crab, all cooked in coconut milk and flavored with herbs and spices.

calzone (Italian)—pizza dough turnover stuffed with cheesy-tomatoey pizza gooeyness (and other fillings).

canapé—alternative to hors d'oeuvres; small bread pieces with savoury garnish on top (cheese, anchioves, etc.).

caprese (Italian)—fresh bufala mozzarella, tomatoes, and basil drizzled with olive oil and cracked pepper—a lovely salad or fixins' for a sandwich.

carne asada (Latin American)—thinly sliced, charbroiled beef, usually marinated with cumin, salt, lemon, and for the bold, beer; a staple of the Latin American picnic (along with the boom box).

carnitas (Mexican)—juicy, marinated chunks of pork, usually fried or grilled. Very popular as a taco stuffer.

carpaccio (Italian)—raw fillet of beef, sliced paper thin and served with mustard sauce or oil and lemon juice.

Cel-Ray—Dr. Brown's celery-flavored soda. Light and crisp—a must at any deli.

cevapcici—Yugoslavian sausages (yep, that's right).

ceviche (Latin American)—(also cebiche) raw fish or shellfish marinated in citrus juice (the citrus sorta "cooks" the fish), usually served with tostadas. Crunchy, tart delight that happens to be low in fat and cholesterol. It's rumored that ceviche is a new favorite with models. While ceviche may not give you Kate Moss' looks, you can at least eat like her. Note: If you are looking to reap the low fat benefits of ceviche steer clear of the tostadas that accompany it; they are deep fried and most certainly fattening.

challah—plaited bread, sometimes covered in poppy seeds, enriched with egg and eaten on the Jewish Sabbath.

cheese steak—see Philly cheese steak.

Chicago-style hot dog—you can't even see the bun or Vienna brand weenie. They're topped with onions, tomato, relish, green pepper, dill pickles, hot giardinara peppers, and celery salt.

Chicago Style Pizza—most distinguished by its thick, deep crust topped with chunks of tomato, compared to the original Neopolitan thin crust and silky smooth sauce—don't be afraid of a fork and knife with this classic behemoth.

chicharrones (Mexican/Central American)—fried pork rinds, knuckle lickin' good.

chicharrones de harina (Mexican/Central American)—same concept as above, only made from a flour dough. Usually in bright orange, pinwheel shapes.

chicken fried steak—it's STEAK—floured, battered and fried à la fried chicken.

chiles rellenos (Mexican)—green poblano chiles, typically stuffed with jack cheese, battered and fried; occasionally you can find it grilled instead of fried—¡que rico!

chili size—open-faced burger covered with chili, cheese, and onions.

chimichangas (Mexican)—fried, stuffed tacos.

chow fun (Chinese)—wide, flat rice noodles.

chorizo (Latin American)—spicy sausage much loved for its versatility. Some folks like to grill it whole and others prefer to bust it open, fry it up, and serve it as a side dish. Another favorite incarnation finds the chorizo scrambled with eggs for breakfast.

churrasco—charcoal grilled meat or chicken, usually served on a skewer.

cochinita pibil (Mexican)—grilled marinated pork, Yucatán style.

cocido (Spanish)—duck confit, chorizo, sausage, and preserved pork combined.

congee (Chinese)—(also jook) rice-based porridge, usually with beef or seafood.

corn dog—hot dog dipped in cornbread batter, usually served on a stick.

croque-madame (French)—grilled cheese sandwich, sometimes with chicken—no ham!

croque-monsieur (French)—sandwich filled with ham and cheese then deep-fried (occasionally grilled). Cholesterol heaven!

Cuban sandwiches (Cuban)—roasted pork sandwich pressed on Cuban rolls (which have a crusty, French-bread-like quality). Also see medianoche sandwiches.

cuitlacoche (Mexican)—Central Mexico's answer to truffles; technically, black corn fungus, but quite a delicacy!

dal (Indian)—lentil-bean based side dish with an almost soupy consistency, cooked with fried onions and spices.

dim sum (Cantonese)—breakfast/brunch consisting of various small dishes. Most places feature servers pushing carts around the restaurant. You point at what you want as they come by. Literally translated means: "touching your heart."

dolmades (Greek)—(also warak enab as a Middle Eastern dish) stuffed grape leaves (often rice and herbs or lamb and rice mixture).

döner kebab—thin slices of raw lamb meat with fat and seasoning, spit roasted with thin slices carved as it cooks.

dora wat (Ethiopian)—chicken seasoned with onions and garlic, sautéed in butter and finished with red wine.

dosa (South Indian)—(also dosai) oversized traditional crispy pancake, often filled with onion and potato and folded in half; bigger than a frisbee!

edamame (Japanese)—soy beans in the pod, popularly served salted and

steamed as appetizers. Pop 'em right out of the end of the pod into yer mouth.

eggs Benedict—poached eggs, typically served with Canadian bacon over an English muffin, with hollandaise sauce.

empanada (Argentinian)—flaky turnover, usually stuffed with spiced meat; a favorite appetizer at an asado. Other Latin American countries also make their own versions of this tasty treat.

escovietch (West Indian)—cooked small whole fish in a spiced oil and vinegar mixture, served cold.

étouffe (Creole)—highly spiced shellfish, pot roast or chicken stew served over rice.

falafel (Middle Eastern)—spiced ground chickpea fava bean balls and spices, deep fried and served with pita.

feijoada (Brazilian/Portuguese)—the national dish of Brazil, which can range from a pork and bean stew to a more complex affair complete with salted beef, tongue, bacon, sausage, and more parts of the pig than you could mount on your wall.

filo (Turkish and Mediterranean)—(also phyllo) thin pastry prepared in several layers, flaky and good.

flautas (Mexican)—akin to the taco except this puppy is rolled tight and deep fried. They are generally stuffed with chicken, beef, or beans and may be topped with lettuce, guacamole, salsa, and cheese. They resemble a flute, hence the name.

focaccia (Italian)—flatbread baked with olive oil and herbs.

fricassee—a heavy stew made of butter sauteed meat and stewed vegetable.

frites (Belgian/French)—also pommes frites, french or fried potatoes or "french fries".

galbi (Korean)—(also kal bi) marinated barbecued short ribs.

gefilte fish (Jewish)—white fish ground with eggs and matzo meal then jellied. No one—and we mean no one—under fifty will touch the stuff.

gelato (Italian)—ice cream or ice.

gnocchi (Italian)—small potato and flour dumplings served like a pasta with sauce.

gorditas (Mexican)—fried puffy rounds of corn meal dough topped with beans, chipotle sauce, and cheese.

goulash (Hungarian)—a rich beef stew flavored with paprika, originally based on Hungarian gulyás, a meat and vegetable soup; often served with sour cream.

gravlax (Swedish)—prized cured raw salmon (salt, sugar, dill), usually served paper thin over bread.

grits—staple breakfast side dish of grainy white mush topped with butter (or in joints where they really know what they're doing) a slice of American cheese.

gumbo (Creole)—rich, spicy stew thickened with okra (often includes crab, sausage, chicken, and shrimp).

gyros (Greek)—spit-roasted beef or lamb strips, thinly sliced and served on thick pita bread, garnished with onions and tomatoes.

haddock—(also Finnan Haddie) saltwater fish similar to Cod.

har gow (Chinese)—steamed shrimp dumplings.

head cheese—(not cheese!) a sausage made from bits of calf or pig head.

hijiki (Japanese)—a sun-dried and coarsely shredded brown seaweed.

hoagie—(also, Italian sandwiches, sub, grinder) huge flat oblong roll stuffed with deli meats and cheeses, pickled veggies, and onions.

horchata (Mexican/Central American)—cold rice and cinnamon drink, sweet and heavenly. One of the tastiest aguas frescas this side of the border.

huevos rancheros (Mexican)—fried eggs atop a fried tortilla with salsa, ranchero cheese, and beans.

humita (Chile/Argentina)—tamale.

hummus (Middle Eastern)—blended garbanzo beans, tahini, sesame oil, garlic, and lemon juice; somewhere between a condiment and a lifestyle.

hush puppies (Southern U.S.)—deep fried cornmeal fritter, in small golf ball size rounds. Originally used to be tossed to dogs to hush 'em up.

iddly (South Indian)—small steamed rice flour cakes served with coconut dipping sauce.

injera (Ethiopian)—flat, spongy, sour unleavened bread. Use it to scoop everything up when eating Ethiopian food, but be forewarned: it expands in your stomach.

jamaica (Mexican/Central America)—hibiscus flower agua fresca.

jambalaya (Creole)—spicy rice dish cooked with, sausage, ham, shellfish, and chicken.

jollof (West African)—a stew or casserole made of beef, chicken or mutton simmered with fried onion, tomatoes, rice and seasonings.

kabob (Middle Eastern)—(also shish kabob, kebab) chunks of meat, chicken, or fish grilled on skewers, often with vegetable spacers.

kamonan (Japanese)—noodles with slices of duck.

kataifi—a very light middle-eastern dough.

katsu (Japanese)—pork.

kielbasa (Polish)—smoked sausage.

kimchi (Korean)—fermented, pickled cabbage with vegetables, highly chilied- and garlicked-up. Some sweet, some spicy, some unbelievably spicy. Limitless variations.

knockwurst (German)—(also knackwurst) a small, thick, and heavily spiced sausage.

kohlrabi (German)—a mutant breed of cabbage and turnip originating from the mustard plant.

korma (Indian)—style of braising meat or vegetables, often highly spiced

and using cream or yogurt.

kreplach (Jewish)—small pieces of noodle dough stuffed with cheese or meat, usually served in soup.

kugels (Jewish)—literally a 'ball' of noodle dough with fruit filling then steamed.

kung pao (Chinese)—spicy-sweet Szechuan style of stir-fry, seasoned with hot peppers, ground peanuts, and soy sauce.

kutya (Ukrainian)—traditional pudding made with wheat-berries, raisins, walnuts, poppy seeds and honey.

lahmajune (Armenian/Turkish)—a meat (most often lamb) pizza.

larb (Thai)—minced chicken or beef salad spiced with lemon juice, sweet onion, mint leaves, and toasted rice powder, served in a lettuce cup or with cabbage.

lassi (Indian)—yogurt drink served salted or sweetened with rose, mango, or banana.

lebkuchen (German)—age old cookie made of honey, spices, Citron, and almonds.

limpa (Swedish)—moist rye bread.

lo mein (Chinese)—soft, flat noodles stir-fried with vegetables and, often, a protein item (beef, chicken, pork, shrimp, etc.).

lychee—red-shelled southeast Asian fruit served in desserts and as a dried snack (known as lychee nuts).

machaca (Northern Mexican)—shredded meat jerky, scrambled with eggs, tomatoes, and chiles.

macrobiotic—diet and lifestyle of organically grown and natural products.

makdoos (Middle Eastern)—miniature eggplant stuffed with walnuts and garlic, marinated with olive oil.

mandoo (Korean)—dumplings.

marage (Yemen)—vegetable soup.

mariscos (Pan-American)—seafood.

masala (Indian)—blend of ground spices, usually including cinnamon, cumin, cloves, black pepper, cardamom, and coriander seed.

matzo brie (Jewish)—eggs scrambled with matzo.

medianoche sandwich (Cuban, also midnight sandwich)—roast pork, ham, cheese and pickles pressed on a sweet roll.

mee krob (Thai)—salad appetizer covered in fried noodles.

menudo (Mexican)—soup made of tripe, hominy, and chile, stewed with garlic and spices. A hangover remedy, and what Mexican families eat before or after Sunday mass.

mofongo (Dominican)—mashed green plaintains with pork skin, seasoned with garlic and salt.

mole (Mexican)—thick poblano chile sauce from the Oaxacan region served over chicken or other meats. Most popular is a velvety black, mole negro flavored with unsweetened chocolate and raisins. Also available in a variety of colors and levels of spiciness depending on chiles and other flavors used (amarillo, or yellow, for example, uses cumin).

Monte Cristo sandwich—sliced turkey, swiss cheese, mustard, and ham sandwich, on French toast, fried, and dusted with powdered sugar. Served with sides ranging from syrup to jam to pickles.

moussaka (Greek)— alternating layers of lamb and fried aubergine (a.k.a. eggplant) slices, topped with Béchamel sauce, an egg and cheese mixture, and breadcrumbs, finally baked and brought to you with pita bread.

muffuletta—New Orleans-style hero sandwich stuffed with clod cuts and dripping with a roasted pepper and olive salad.

muj chien don (Vietnamese)—crispy squid in a little salt and pepper.

mulitas (Mexican)—literally, little mules; actually, little quesadillas piled up with meat, veggies, and other goodies.

mung bean—small green bean, eaten as a vegetable or used as a source of sprouts. May also be candied and eaten as a snack, or used to make bean curd.

musubi (Japanese)—rice ball, sometimes filled with bits of salmon or seaweed, or a sour plum. Hawaiian version features SPAM. Delicious grilled.

naan (Indian)—flat bread cooked in a tandoor oven.

niçoise salad (French)—salad served with all the accoutrements from Nice, i.e. French beans, olives, tomatoes, garlic, capers, and of course, tuna and boiled egg.

pad Thai (Thai)—popular rice noodle stir-fry with tofu, shrimp, crushed peanuts, and cilantro.

paella (Spanish)—a rice jubilee flavored with saffron and sprinkled with an assortment of meats, seafood, and vegetables, all served in a sizzling pan.

panchan (Korean)—the smattering of little appetizer dishes (kimchi, etc.) that magically appear before a meal of soontofu or barbecue; vinegar lovers rejoice.

paprikás (Hungarian)—paprika is the central ingredient in this dish made with bacon drippings, chicken stock and sour cream.

pastitsio (Greek)—cooked pasta layered with a cooked meat sauce (usually lamb), egg-enriched and cinnamon flavored Béchamel, grated cheese, and topped with a final layer of cheese and fresh breadcrumbs.

paskha (Russian)—sweet cheese mold served up during Easter.

pastitsio (Greek)—greek casserole with pasta, cheese, tomato, cinnamon, white sauce, and beef or lamb.

patty melt—grilled sandwich with hamburger patty and melted Swiss cheese.

pescado (Spanish)—literally means fish; can be served in a variety of ways, baked in hot rock salt (a la sal), coated in egg batter and fried (a la andaluza), pickled (en escabeche) and even cooked in wine with onions and chocolate and served with mushrooms (a la asturiana).

Philly cheese steak—hot, crispy, messy sandwich filled with thin slices of beef and cheese from…where else?…Philadelphia.

pho (Vietnamese)—hearty rice noodle soup staple, with choice of meat or seafood, accompanied by bean sprouts and fresh herbs.

phyllo (Greek)—meaning "leaf," super thin pastry dough common in Middle and Near Eastern dishes.

pico de gallo (Mexico)—(also salsa cruda) a chunky salsa of chopped tomato, onion, chile, cilantro. In Jalisco it's a jicama and orange salad sprinkled with lemon juice and chile powder.

pierogi (Polish)—potato dough filled with cheese and onion boiled or fried.

pigs-in-a-blanket—sausages wrapped in pastry or toasted bread then baked or fried; or, more informally, breakfast pancakes rolled around sausage links. Dip in syrup for extra fun!

piroshki (Russian)—a small turnover.

plantain (Central American)—cooking banana from tropical regions. When ripe and yellow it's often served fried as a breakfast side dish. While it's green and unripe it's used to make yummy chips available at neighborhood markets.

po' boy—New Orleans-style hero sandwich with seafood and special sauces, often with lemon slices.

Polish sausage—Not yer average frank. Plump and juicy, with just the right balance of sweetness and spice.

pollo a la brasa (Central/South American)—rotisserie chicken.

porgy—various deep-bodied seawater fish with delicate, moist, sweet flesh.

potato sausage (Swedish)—(also potato ring) traditional Swedish sausage of ground pork and beef mixed with potatoes and onions.

pozole (Mexican)—pork soup with corn, onions, hominy, and dried chiles. Sliced and diced cabbage and radishes are also used as garnish. Very popular come the Christmas season—so good it makes you wish it was Xmas everyday.

pulpo enchilado (Spanish)—octopus in hot sauce.

pupusa (Salvadorean)—round and flattened cornmeal filled with cheese, ground porkrinds, and/or refried beans, which is cooked on a flat pan known as a comal. The indigenous term literally means "sacred food." No doubt ancient civilizations concur with modern opinion that the pupusa is a sublime treat.

quark—German cottage cheese; actually similar to a softer, creamier cream cheese.

quesadilla (Mexican)—soft flour tortilla filled with melted cheese (and, sometimes, fancier fare).

raita (Indian)—yogurt condiment flavored with spices and vegetables (often cucumber) or fruits—the necessary core component to balance hot Indian food.

ramen (Japanese)—thin, squiggly egg noodle, often served in a soup.

Reuben (Jewish)—rye bread sandwich filled with corned beef, Swiss cheese, and sauerkraut and lightly grilled.

Riesling (German)—the most iconic of German white wines characterized by a sharp and fruity zing.

roti (Indian)—round flat bread served plain or filled with meat or vegetables.

rugalach (Jewish)—a tiny Hanukkah treat (cookie) filled with various fruits and nuts.

S.O.S.—creamed beef on toast and a staple of all U.S. military mess halls; affectionately called shit on shingles.

saganaki (Greek)—1/2 inch thick slices of kasseri cheese fried in butter or oil, then sprinkled with lemon juice and fresh oregano. Greek restaurants often present this appetizer in style by soaking it in brandy then lighting it up tableside. Opa!

samosa (Indian)—pyramid shaped pastry stuffed with savory vegetables or meat.

sashimi (Japanese)—fresh raw seafood thinly sliced and artfully arranged.

satay (Thai)—chicken or shrimp kabob, often served with a peanut sauce.

sauerbraten (German)—means "sour roast" but has some sweetness; usually very tender from slow cooking.

sauerkraut (German)—chopped, fermented sour cabbage.

schnitzel (English/Austrian)—thin fried veal or pork cutlet.

seitan (Chinese)—wheat gluten marinated in soya sauce with other flavorings.

shabu shabu (Japanese)—hot pot. Cook thin sliced beef and assorted vegetables in a big hot pot at your table—served with a couple of dipping sauces and rice.

shaved ice—Hawaiian snow cone. Ice with various juices/flavorings (from lime or strawberry to sweet green tea and sweetened condensed milk). Non-Hawaiian incarnations are called raspado and slush.

shawarma (Middle Eastern)—pita bread sandwich filled with sliced beef, tomato, and sesame sauce.

Sheboygan—US (Wisconsin) home of the most famous German sausage, bratwurst.

shish kabob—see kabob.

skordalia (Greek)—zippy sauce made of lemon, garlic, vinegar, parsley, pureed potatoe, and olive oil.

sloppy joe—loose, minced meat sandwich with sauce on hamburger bun.

smorrebrod (Danish)—a high class open-face sandwich; means "bread and butter".

soba (Japanese)—thin buckwheat noodles, often served cold with sesame oil-based sauce.

som tum (Thai)—green papaya salad.

soontofu (Korean)—boiling hot soup with soft tofu, your choice of protein elements (mushroom or kimchi for vegetarians, seafood, pork for non) served with a variety of kimchis and rice.

sopes (Mexican)—dense corn cakes topped with beef or chicken, beans, lettuce, tomato, and crumbled cheese.

souvlaki (Greek)—kebabs of lamb, veal or pork, cooked on a griddle or over a barbecue, sprinkled with lemon juice during cooking, and served with lemon wedges, onions and sliced tomatoes.

sorrel (Caribbean)—sweet hibiscus beverage served cold.

spanakopita (Greek)—filo triangles filled with spinach and cheese.

spaetzle—a German staple; small noodles or dumplings poached or fried and topped with gravy or sauce.

spanakopita—one of the most popular of phyllo based pies filled with spinach, onion, feta, eggs, and seasoning.

spelt—ancient type of wheat, commonly used to make flour without traditional wheat flavor.

spotted dick (British)—traditional pudding with raisins.

stollen (Germany)—fruitcake-lite, German style; still an excellent gift for despised in-laws at Christmas.

stroganoff—much maligned TV dinner favorite originally name for a Russian diplomat with thin slices of beef (onions, mushrooms) with a sour cream sauce.

strudel—a paper thin European pastry most commonly served sweet (apple) and sometimes savoury.

sushi (Japanese)—the stuff of midnight cravings and maxxed out credit cards. Small rolls of vinegar infused sticky rice stuffed with fresh, raw seafood, sweet omelette, or pickled vegetables, and held together with sheets of seaweed (nori).

Suzy Qs—(also Curly Qs) Spiral-cut french fries (they look sort of like those confetti spirals).

tabouli (Middle Eastern)—light salad of cracked wheat (bulgur), tomatoes, parsley, mint, green onions, lemon juice, olive oil, and spices.

tahini (Middle Eastern)—paste made from ground sesame seeds.

tamale (Latin American)—Latin America's contribution to nirvana. Each nation has its own take on the tamale, but in very basic terms it is cornmeal filled with meat and veggies wrapped in corn husk or palm tree leaves for shape, then steamed. There are also sweet varieties, notably the elote, or corn, tamale. A favorite during the holidays, the tamale is surely the sumptuous culprit of many a person's Yuletide bulge. Note: We understand that due to the tamales' versatility we cannot do it full justice in our definition. We can only encourage you to get your hands on some and indulge.

tamarindo (Mexican)—popular agua fresca made from tamarind fruit.

tandoori (Indian)—literally means baked in a tandoor (a large clay oven). Tends to be a drier form of Indian dish than, say, curries.

tapenade (Provençale italian)—chopped olive garnish; a delightful spread for a hunk of baguette.

taquitos (Mexican)—(also, flautas) shredded meat or cheese rolled in tortilla, fried, and served with guacamole sauce.

tempeh (Indian)—a substance made from soaking and boiling soy beans, inoculating with a fungus, packing into thin slabs and allowing to ferment. A great source of protein!

teriyaki (Japanese)—boneless meat, chicken, or seafood marinated in a sweetened soy sauce, then grilled.

thali (Southern Indian)—sampler meal comprised of several small bowls of curries and soup arranged on a large dish with rice and bread.

tikka (Indian)—marinated morsels of meat cooked in a tandoor oven, usually chicken.

tilapia—a white fish often served in the Tropics.

toad in the hole (British)—herb sausages baked in thick savory Yorkshire pudding mix.

tom kha kai (Thai)—coconut broth soup with galangal root, lime leaves, hot chilies, onion, mushrooms, and, often, chicken.

tom yum gung (Thai)—lemongrass hot-and-sour soup.

tong shui (Chinese)—medicinal soups.

torta (Mexican)—Spanish for sandwich or cake.

tostada (Mexican)—traditionally a corn tortilla fried flat; more commonly in the U.S. vernacular the frilly fried flour tortilla that looks like an upside down lampshade and is filled with salad in wannabe Mexican restaurants.

tzatziki (Greek)—the best condiment to come out of the Greek isles; fresh yogurt mixed with grated cucumber, garlic, and mint (or corriander, or both).

udon (Japanese)—thick white rice noodles served in soup, usually bonito broth.

vegan/vegetarian—"Vegan" dishes do not contain any meat or dairy products; "Vegetarian" dishes include dairy products.

warak enab (Middle Eastern)—see dolmades.

Welsh rarebit (British)—(also Welsh rabbit) toast topped with melted cheese cream, and ale, usually served with Worcestershire sauce (very hot and spicy).

wet fries—french fries with gravy on top.

wet shoes—french fries with chili and cheese on top.

yakitori (Japanese)—marinated grilled chicken skewers.

zeek (Southern U.S.)—catfish, shrimp, and tater salad.

Sara Evin Allen, 24, resides in Chicago and is indefinitely unoccupied. She is a self-proclaimed loud movie theater eater. Fondly curious of Dr. Pepper and Sour Patch Kids, she munches at the Kino like a true champ. Her most memorable moments, in dessert as in life, are when the crunch meets the gooey.

Mark Fitzgerald Armstrong grew up on Chicago's Far Southwest Side in the heavily industrial Calumet District that encompasses Northeastern Illinois' Southland and Northwest Indiana, where he was trained in attentiveness to fine culinary pleasures by his father, a Chicago high school history teacher, and his mother, a southwest suburban public middle school teacher of home economics, both excellent cooks upholding a tradition in Southern cooking dating back to Virginia's Tidewater plantation aristocracy. Mark first began writing about food in the mid-1980s when he interviewed Cathy Truett, founder and head of Atlanta area-based Chic–fil–A fast-food chain, as county report for the former evening daily Greenville Piedmont of Upstate South Carolina. In the late 1990s, Mark began writing about food extensively as writer for The Source's "In Da Hood" travel column.

Courtney Arnold, editor, holds an M.F.A. in Writing from the School of the Art Institute of Chicago and a Certificate in Mixology from the illustrious International Bartending School. One day soon she'll escape to Brazil, where she will perfect her Portuguese, dance the Samba, and finally finish writing that novel.

Hunter Arnold: Eats, drinks, has been called Mary.

Carrie Asato resides in Chicago's Lakeview neighborhood. When she's not eating at all the yummy area restaurants, she's writing, dancing, or working hard at her full-time job as a health editor.

Heather Augustyn is a writer living in Chicago with her husband, Ron, and son, Sid. She has lived in Chicago for almost nine years and has dined at many restaurants in a variety of neighborhoods. These days, Heather spends time raising her young son and enjoying every minute of it!

Nelson Balbarin is unemployed and willing to work for food, but he would prefer cash! He spends his days finding things to do and thinking of places to eat...if only he had money.

Heidi Barker is a network news producer based in Chicago. She escapes the trauma of breaking news by cooking, writing poetry, watching "Survivor", and continuing her quest to find the best turkey burger in Chicago.

Despite being a military brat, **Veronica Carolyn Bond** spent the majority of her formative years in New Mexico. An aspiring novelist and magazine journalist, she now divides her time between searching for unpretentious Mexican food, guiltlessly indulging in pop culture, and contemplating the purpose of her University of Chicago sociology/psychology degree.

Eliz Breakstone is working out her budget and dinner plans with her folks so that she can eventually eat her way through the restaurants of Chicago. She also keeps a food weblog, which you can see at www.deepfry.blogspot.com.

Being cheap, **Paul Breloff** was excited to contribute to a publication that validates his frugality. An advertising executive by day, Paul is plotting to quit soon and travel the world before he retreats to law school and hides from reality for three years.

As a transplant from sunny California, **Jelene Britten** is often asked why she moved to perpetually cold Chicago. Her answer: the vibrant city and its delicious selection of authentic ethnic food! Jelene plans to continue writing and feasting on savory meals wherever her travels take her.

Michelle Burton is a freelance writer and Chicago native with a serious love for all the creative cuisines this beautiful "City by the Lake" has to offer.

Jennifer Chan is a Public Relations executive who specializes in Food & Beverage and Hospitality clients.

Keidra Chaney is a freelance writer and editor whose work has appeared in Clamor Magazine, Colorlines, Bitch: Feminist Response to Pop Culture and Friction Magazine. She has a weakness for BYOB sushi restaurants.

Janet Cox of Michigan is the best chef on the planet. It only took her child **Josh** several thousand days to recognize this to be true.

Chicago native **Victoria Cunha** is an aspiring magazine writer, calls opera her version of top 40, and lives for new flavors of Frango mints (creme brulee is a current favorite). A resident of the Lakeview neighborhood on the north side of the city, she a perpetual yoga student and the proud owner of Tommy, an 8-year old shelter adopted cat.

Brian Diebold is a freelance writer from Chicago. His publishing credits include an extensive body of work for Barfly Newspaper, along with articles for various newspapers and magazines. He is currently holed up in Chicago plotting his scheme for world domination

Lisa Dumich is a freelance writer, travel consultant, and parrothead living and working in Chicago. She is passionate about Italy, Italian food, and, of course, cheeseburgers in paradise.

Melanie Dunlap is still searching for her calling. In the meantime, she is endeavoring to comfort herself with more than just food. If only the Cubs would win the World Series...

Scott Durango plays drums for Vida Blues, one of Chicago's hardest working blues-rock bands.

Sarah Eaton lives, works, and eats cheaply in Chicago. She is currently working on a number of projects, including stories, a novel, and paying back her student loans.

Lara Ehrlich is an aspiring novelist and playwright living in Chicago. She loves eating out, going to movies, reading classics, brushing cats at the local animal shelter, cooking, and karate. She also enjoys writing restaurant reviews.

Lydia Ellul moved to Chicago from Florida for two reasons—the food and the writing culture. When Lydia isn't working at her day job in research, she writes restaurant reviews and is finishing her children's book series. Lydia loves finding new restaurants and sampling global cuisines, so watch out Zagat's!

Trisha L. Falb is currently a graduate student at DePaul University, studying Public Relations and Advertising. Some of her previous places of employment include Steppenwolf Theatre Company, Home and Garden Television, and WCKG-FM, where she co-hosted a female version of the radio program "Loveline" last year.

Christopher Garlington is an avid chow hound and culinary adventurist. He is a freelance writer living in Chicago, is married, has 2.5 kids, a dog, a cat.

Jeff Fleischer has appeared in the Pioneer Press, Daily Southtown, Illinois Times, Today's Chicago Woman and Black Issues in Higher Education. A Chicago native, Fleischer served as Op/Ed and Politics Editor for U-WIRE and Editor in Chief of the Indiana Daily Student. He has also written several screenplays and edited four books.

Justin Goh is a stubborn, eternally curious kid trying his darndest to love everyone he knows. Hi guys! Please share your good company and

maybe your good food, your valuable time and maybe your latest gossip with the people you care about. Be open, live creatively and please give a damn. www.gardenvarietygenius.com

Mindy Golub is a 24 year-old communications professional by day, and an avid "get up and dance to music" chick by night. A Cubs fan year-round, she also enjoys chocolate, laughing hysterically, and staying out until dawn. Her personal pastime is shopping, especially for girly-girl shoes, vintage purses and various pink lipsticks.

Venita Griffin has written for Rolling Out, careerbay.com, Streetwise Chicago, and centerstage.net.

Michelle Hempel is a writer and English teacher who lives, works, and eats in Chicago. Someday she hopes to publish a bestseller that will bring her worldwide fame and popularity. In the meantime, she considers eating her way through the Windy City to be an honor and privilege.

After five Chicago winters, **Emily Hunt** recently fled to Hawaii where she reviews restaurants for the Honolulu Weekly. Her book-in-progress is on the experience of eating in Honolulu.

Kelly Hutchison enjoys ordering ornamental jewelry from several television shopping networks, and is especially pleased when her call is aired. She has added her reviews to this book with fond memories of her days outside the penitentiary when eating was something that did not involve plastic dinner sporks and ankle manacles.

Catherine Keich is a writer, indexer, and editor in Chicago. She's also highly critical, opinionated, and picky, attributes that help her tell other people where to go. When she's not spouting, she's splurging on Italian wines or…on one of the places she reviewed for this publication.

Beth Kohl lives in Lincoln Park with her husband and three daughters.

Jen Lawrence has studied cultural criticism, ethnography, architecture, and history. She has a unique appreciation for how a space affects the way we interact (and eat!) within it.

Tal Litvin comes from a generous family with big hearts. While he loves a good Italian Beef, he has also devoted himself to less indulgent causes, volunteering with a rehabilitation clinic for disabled youth and war veterans in Tel Aviv.

Colin Lohse is 7 feet tall and weighs in excess of 300 pounds (last time he was able to see the scale, anyway). Because he's as big as he is, he also has an extremely large brain. This means you should trust what he wrote for Hungry?Chicago. He also eats a hell of a lot, so if you want more advice than what's in this book, he's probably the huge guy sitting at the table next to you right now.

Mary Lou Mangan is an avid eater. After a brief stint in South Korea, where she suffered a three-week case of food poisoning, she returned stateside to fulfill her promise to write for Hungry?Chicago. She eagerly awaits the publication of Hungry?Korea, in which she hopes to review restaurants that serve dog.

Manuel Marquez is an agricultural laborer who recently moved to Chicago from the grape vines of California. He is currently attempting to become an acknowledged writer on the international culinary journalism circuit.

Carol Michael, a former Lincoln Park inhabitant, enjoys dwelling in neighborhood pubs sipping draft beers and watching sports. In her spare time, she enjoys writing, photography and watching MSNBC news. Carol has recently relocated to Philadelphia, where she is pursuing a prosperous career in the training industry.

A child of privilege, **Toni Miosi** squandered her family's sans-a-belt fortune in a single, reckless night at the bingo parlor. After attending a weekend seminar in Florida, she has seen her true potential and is working her way up a promising MLM pyramid in hopes of restoring the Miosi family name.

Leah Moyers is a grad writing student at The School of the Art Institute of Chicago. Her favorite foods are spinach tortellini, lemongrass chicken, peaches, pistachio ice cream, and any dessert involving bananas.

Sean O'Connor has been a Chicago dweller for eight years and is currently working as a waiter. He admits to having a serious dependency on dining out. In addition to being served by others, Sean enjoys writing, singing, traveling, and pretending that he is wealthy. He much appreciates the opportunity to contribute to "Hungry? Chicago".

Verloren Perdido is a writer who could not be identified at the time of publication. Every effort was made by the publisher to locate the correct name of this writer. If your work appears in this book under the Verloren Perdido, please contact the publisher at the address located on the copyright page.

Louis Pine wanders the West. You know, like Caine in "Kung Fu".

Jamie Popp holds a B.A. in Portuguese from U.W.-Madison and an M.S.J. from the Medill School of Journalism at Northwestern University. She worked for various international companies and wrote for food and wine magazines prior to receiving her M.S.J. Future plans include writing while globetrotting in search of her favorite vineyard.

. **Robyn Porter** is a writer who lives, loves, and eats in the city of Chicago.

Rich Rainey, a public relations writer, artist, campaign strategist, and part-time hobo is between jobs and eating cheaply all over the Midwest and East Coast. He's currently living in Cleveland, but plans on hopping the next cattle car back to Chicago once gainfully employed there.

Leanne Sharoff began her writing career by writing fortunes for fortune cookies. Her lucky numbers are 7, 11, and 27.

Alana Sitek is waiting for a nervous breakdown while living the life of "OFFICE SPACE". Writing is her only connection to the world of cool. Is that your Stapler? Is your name on it?

Kristy Stachelski is a Chicagoland native that almost moved to Manhattan, but ultimately couldn't stand the thought of leaving the Windy City behind. 2.5 years ago, she broke free from the chains of Suburbia, and has found sanity in city life ever since. She enjoys avid writing in her free time…along with dining and drinking at new and old favorite urban spots.

Christopher Stapleton, a remarkably talented young writer and enthusiastic patron of restaurants, spent his formative years in Portland, Maine. He made his home in Chicago in the summer of 2001, and has since established himself as a freelance writer. His work has appeared in the Chicago Tribune.

Kelly Svoboda moved to Chicago last year to pursue graduate journalism studies at Northwestern University. Though she's enjoyed eating her way around the city, she finds that, as a rule, the deep-dish pizza is way overrated. She resides in the Wrigleyville neighborhood and has written for various local publications.

A Los Angeles native who has recently relocated to Chicago, **Ondy Sweetman** is a twenty-something single-white-female seeking employment as a freelance writer. Ms. Sweetman holds a bachelor's degree in English from the University of San Diego and is considering working on her master's degree, due to an almost non-existent writer's market.

Misty Tosh Though busy creating indie films and my own food adventure TV shows (www.fatcakeproductions.com), what I really crave is my next food escape. One whisper of a secret village or any possibility of a slow-food style meal will launch me on a worldwide journey, meanwhile draining my bank account and leaving my responsibilities long forgotten. I'm a devout foodie eager to field gastronomic suggestions, but I do remain suspicious of outsiders intel on great food. "You've gotta really present a strong case to make a believer outta me." Check out my foodie site at: www.bigsweettooth.com

Benjamin Trecroci, 25, is a resident of Uptown. He graduated from Columbia College (2000-Journalism), and is currently employed by the Chicago Tribune (Preps Plus). Eating, for Benjamin, is top-priority and he refuses to let foo-foo to get in the way!

Jaime Vazquez is a freelance writer who enjoys eating so much, he does it several times a day. He hails from the Ukrainian Village in Chicago, the hipster neighborhood that could. He believes that people who read contributor bios are highly suspect. Highly suspect.

Mark Vickery is a writer and an editor for an investment research firm in downtown Chicago. He has been writing professionally for years, but has been quietly critical of dining establishments nearly his entire life--until now.

Valerie Wallace works for Urban Life Center, an educational non-profit for college students and groups who want to learn from the neighborhoods, cultural arts and voices of Chicago. Urban Life Center can be reached at www.urbanlifecenter.org.

Long a sufferer of Chicago winters, **Elsa M. Wenzel** is slowly cultivating a lifestyle of luaus and daily, barefoot meals of mangos and platanos. She attended the University of Iowa & the Medill School of Journalism, and recently worked at the Community Media Workshop.

Long a sufferer of Chicago winters, **Elsa M. Wenzel** is slowly cultivating a lifestyle of luaus and daily, barefoot meals of mangos and platanos. She attended the University of Iowa & the Medill School of Journalism, and recently worked at the Community Media Workshop.

Having lived in the Old Town/Gold Coast area for over 10 years, **Marcy Wrzesinski** is not shy of restaurants. Being a true Chicagoan, she fully appreciates a Chicago dog, Italian beef, or...of course, the Sunday morning Maxwell Street market....all for a memorable meal for well under $10....

L. Pat Williams is a prolific writer and Indie filmmaker. With self-help books, such as Ordinary Food, and provocative commentaries "Powell Left Home Without It," Williams has set the tone for 21st century writers. Currently, Williams is co-producing Homesick with Catrina N. Williams (2003) and Neo-Negroes: Slipping Into Darkness (2002).

Stefan Woerle is the son of immigrant parents who drove across the Bearing Straight in the mid-70's. His life's goal is to eat so much that a mumu becomes his only logical choice for clothing. He enjoys candle-lit dinners and long walks on the beach; Turn-offs include mean people and nuclear war.

Claire Zulkey loves eating, Chicago, and writing, so contributing to Hungry?Chicago was quite the marriage of convenience. She has written for Modern Humorist, McSweeney's Internet Tendency, Sweet Fancy Moses, the New York Morning News. Find out all about her at www.zulkey.com. Now!

We at the Hungry? City Guides love to find a great value eatery or meet a friend at that little-known bistro down the alley and behind the theater. That's why we created our Guides, to share the little dining and drinking secrets that the locals don't want you to know.

Unfortunately, discovering a fun new spot to eat is far from the minds of many Americans. A 2006 study found over 25 million Americans reported that they didn't have the resources to consistently put food on the table.*

The good news is there's a lot you can do to help. Whether it's time, money, or food donations, you can make a difference. Here are a few organizations we like:

America's Second Harvest
(www.secondharvest.org)

Chicago Anti-Hunger Federation
(www.antihunger.org)

Greater Chicago Food Depository
(www.chicagosfoodbank.org)

Northern Illinois Food Bank
(www.northernilfoodbank.org)

Plant a Row for the Hungry
(plantarow@dailyherald.com)

As you explore the world of eating in Chicago,
please remember those who are still hungry.

─── **Eat Well. Be Cool. Do Good.** ───

*www.hungerinamerica.org